INDEX TO
ITALIAN ARCHITECTURE

**Recent Titles in
the Art Reference Collection**

INDEX TO ITALIAN ARCHITECTURE

A Guide to Key Monuments and Reproduction Sources

COMPILED BY

EDWARD H. TEAGUE

Art Reference Collection, Number 13

GREENWOOD PRESS

New York • Westport, Connecticut • London

Library of Congress Cataloging-in-Publication Data

Teague, Edward H.
 Index to Italian architecture : a guide to key monuments and
reproduction sources / compiled by Edward H. Teague.
 p. cm.—(Art reference collection, ISSN 0193-6867 ; no. 13)
 Includes bibliographical references.
 ISBN 0-313-28436-9 (alk. paper)
 1. Architecture—Italy—Indexes. I. Title. II. Series.
NA111.T4 1992
016.72'0945—dc20 92-5350

British Library Cataloguing in Publication Data is available.

Library of Congress Catalog Card Number: 92-5350
ISBN: 0-313-28436-9
ISSN: 0193-6867

First published in 1992

Greenwood Press, 88 Post Road West, Westport, CT 06881
An imprint of Greenwood Publishing Group, Inc.

Printed in the United States of America

The paper used in this book complies with the
Permanent Paper Standard issued by the National
Information Standards Organization (Z39.48-1984).

10 9 8 7 6 5 4 3 2 1

For
Jeff and Janet Teague
and
Teresa T. Jackson

Contents

Preface

Throughout the centuries, the country of Italy has been home to many of the significant landmarks of architectural history. *Index to Italian Architecture: A Guide to Key Monuments and Reproduction Sources* is a reference tool that aims to facilitate access to pictures of these important monuments. The *Index* provides citations to illustrations of approximately 1,800 works of Italian architecture reproduced in more than 80 books likely to be available in libraries with architectural collections. Included are architectural, engineering, and planning works from most historical periods and styles. Citations to reproductions of exterior and interior views, plans, sections, and elevations are provided. Access is enabled by indexes to the building's site, architect, date, type, and name.

Like other illustration indexes, the *Index to Italian Architecture* does more than enable access to pictures. Since an illustration normally accompanies text, an illustration citation suggests a reference to textual information about a work. The *Site Index* also provides unique listings of works according to site, type, architect, and date that can be useful compilations for further architectural research.

User's Guide

The *Index to Italian Architecture* is organized into five parts. Parts II, III, IV, and V refer back to Part I for documentation about the work and illustration citation information.

Part I, the *Site Index*, is the principal index. It lists architectural works alphabetically according to specific location.

Part II, the *Architect Index*, alphabetically lists the architects, engineers, planners, and others responsible for works cited in the *Site Index*.

Part III, the *Chronological Index*, groups the works according to centuries and sites.

Part IV, the *Type Index*, organizes the works according to particular type of building or structure.

Part V, the *Work Index*, lists names and alternative names of works and parts of works.

Part I, Site Index

Works are listed alphabetically according to city, town, or other specific location. This arrangement parallels the organization of the indexes in the books indexed. An alternative name for the site is listed in parenthesis and is cross-referenced within the index. For each work, the following information is provided if available in the indexed source:

(1) Name of work and alternative name of work in parentheses
(2) Date of work
(3) Architect(s)
(4) Citation information organized according to exterior view, interior view, plan, section, or elevation.

A typical citation includes a code for the book in which the illustration appears and the page where the illustration can be found. The *List of Books Indexed* provides complete bibliographic information for the illustration source.

Part II, Architect Index

In this section works are listed by architects, engineers, planners, or other persons responsible for their design and building. A typical listing provides the name of architect, alternative name of the architect, life dates if available, and the works listed alphabetically. Each work is listed with its execution date and site so that reference to the *Site Index* can be made for illustration citation information. Cross-references for architect names are provided within the index.

Part III, Chronological Index

The Chronological Index provides access by date by arranging the works according to centuries and sites. Under each century/site heading, works are listed alphabetically by name with execution dates also provided. To find an illustration of 18th-century buildings in Venice, for example, one would search under "18th Century--Venice", select a work and site, and refer to Part I, the *Site Index*, for citation information.

Part IV, Type Index

Works are listed by architectural type, then site. Following this *Preface* is a list of terms used for the building, engineering, and planning types. Cross-references for building type names are also provided within the

index. To find an illustration of a cathedral, for example, one would search under "Religious Buildings--Rome" select a work and site, and refer to the Part I, the *Site Index*, for building and illustration information. Note that the *Work Index* may also be consulted for buildings whose names are generic building types, such as hospital, garage, temple, warehouse, and so on.

Part V, Work Index

Names and alternative names of works and parts of works as revealed in the indexed sources are listed alphabetically. Each work is listed with its site so that reference to the *Site Index* can be made for illustration information.

Books Indexed

The books indexed form a representative survey of the major periods of the history of architecture in Italy. The majority of books are titles in important monograph series: *The Great Ages of World Architecture, Living Architecture, New Directions in Architecture, History of World Architecture*, and *Pelican History of Art*. The *Encyclopedia of Architecture, Design, Engineering and Construction*, the *Encyclopedia of World Art* (17 volumes) and the *MacMillan Encyclopedia of Architects* are among the 89 titles indexed. The sources indexed are standard histories or surveys that are likely to be available in academic, public, and special libraries with art and architectural collections. Publication dates range from the late 1950s to 1991. Many have been reprinted or issued in later editions.

Indexing Methodology

Architectural works can be difficult to research because they can be cited under a variety of names. To allow for an easy transition from the citation to the indexed source, the name which appears in the indexed book is the name used in this book. If more than one name for a work, architect, or site appeared in the process of indexing, the *Encyclopedia of World Art* served as the authority for the name to use. Numerous cross-references are provided in the indexes to make searching easier.

Acknowledgments

I'm deeply appreciative of Jeanne Bunting, Robena Cornwell, Peter Faust, James M. Glenn, Lynn LaBauve, Miguel La Salvia, Hadley Littell, Sally M. Scott, and Michele Tennant for their patience, practical advice, and continued support during the development of this book. Special appreciation goes to Dale B. Canelas, Director of the University of Florida Libraries, for her commitment to professional development and scholarship.

List of Type Headings Used

Abbeys. See Religious Buildings
Academies. See Education &
 Research Buildings
Agoras. See Open Spaces
Agricultural Structures
Airport Buildings. See
 Transportation Structures
Amusement Parks. See Sports &
 Recreation Structures
Apartments. See Dwellings
Aqueducts. See Waterworks
 & Hydraulic Structures
Arches. See Monuments &
 Memorials

Banks. See Financial Institutions
Baptisteries. See Religious
 Buildings
Barns. See Agricultural Structures
Bars. See Restaurants
 & Other Eating Places
Basilicas. See Social
 & Civic Buildings
Baths. See Sports & Recreation
 Structures
Bridges. See Transportation
 Structures

Castles. See Military Structures
Cathedrals. See Religious
 Buildings
Cemeteries. See Funerary
 Structures

Chapels. See Religious Buildings
Churches. See Religious Buildings
City Planning
College Buildings. See Education
 & Research Buildings
Convention Centers. See Social
 & Civic Buildings
Correctional Institutions
Cultural Centers. See Social
 & Civic Buildings

Dams. See Waterworks & Other
 Hydraulic Structures
Department Stores. See
 Mercantile Buildings
Dwellings

Education & Research Buildings
Exhibition Buildings

Factories. See Industrial Buildings
Farms. See Agricultural
 Structures
Financial Institutions
Fire Stations. See Public Safety
 Buildings
Fortifications. See Military
 Structures
Fountains. See Waterworks &
 Other Hydraulic Structures
Funerary Structures

Galleries. See Exhibition

List of Books Indexed

Many of the books listed below are available in editions other than the ones cited. In most cases, a reprint or other edition may be consulted with success although the pagination for the desired illustration may be different.

ARC
The Architecture of Western Gardens: A Design History From the Renaissance to the Present Day. Edited by Monique Mosser and Georges Teyssot. Cambridge, Mass.: MIT Press, 1991.

BAK
Ball, Victoria K. *Architecture and Interior Design: A Basic History Through the Seventeenth Century.* New York: Wiley, 1980.

BAL
Ball, Victoria K. *Architecture and Interior Design: Europe and America from the Colonial Era to Today.* New York: Wiley, 1980.

BAR
Baroque and Rococo; Architecture and Decoration. Edited by Anthony Blunt & others. New York: Harper and Row, Publishers, 1978.

BEA
Benevolo, Leonardo. *Architecture of the Renaissance.* Boulder, Colo.: Westview Press, 1978.

BEN
Benevolo, Leonardo. *History of Modern Architecture.* Cambridge, Mass.: MIT Press, 1977.

BET
Benevolo, Leonardo. *The History of the City.* Cambridge, Mass.: MIT Press, 1980.

BOE
Boethius, Axel. *Etruscan and Early Roman Architecture.* (Pelican History of Art.) New York: Penguin Books, 1979.

BRA
Branner, Robert. *Gothic Architecture.* (The Great Ages of World Architecture.) New York: George Braziller, 1961.

BRO
Brown, Frank E. *Roman Architecture.* (The Great Ages of World Architecture.) New York: George Braziller, 1961.

BUR
Burkhardt, Jacob. *Architecture of the Italian Renaissance.* Chicago: University of Chicago Press, 1985.

CHA
Charpentrat, Pierre. *Living Architecture: Baroque Italy and Central Europe.* (Living Architecture.) New York: Grosset and Dunlap, 1967.

CON
Conant, Kenneth J. *Carolingian and Romanesque Architecture, 800 to 1200.* (Penguin History of Art.) Baltimore: Penguin Books, 1959.

COP
Copplestone, Trewin. *Twentieth-Century World Architecture.* London: Brian Trodd Publishing House, Ltd., 1991.

COT-1
Contemporary Architects. Edited by Muriel Emanuel. New York: St. Martins Press, 1980.

COT-2
Contemporary Architects. 2nd ed. Edited by Ann Lee Morgan and Colin Naylor. Chicago, London: St. James Press, 1987.

DAL
Dal Co, Francesco; Polano, Sergio. *Italian Architecture, 1945-1985.* (A + U Special Edition, March 1988.) Tokyo: A + U Publishing Co., Ltd., 1988.

DEF
De Fusco, Renato. *L'Architettura del Cinquecento.* (Storia dell'Arte in Italia.) Turin: Unione Tipografico-Editrice Torinese, 1981.

DEQ
De Fusco, Renato. *L'Architettura del Quattrocento.* (Storia dell'Arte in Italia.) Turin: Unione Tipografico-Editrice Torinese, 1984.

DEW
De Witt, Dennis J.; De Witt, Elizabeth R. *Modern Architecture in*

Europe; A Guide to Buildings Since the Industrial Revolution. New York: E. P. Dutton, 1987.

DIX
Dixon, Roger; Muthesius, Stefan. *Victorian Architecture.* (The World of Art.) New York: Oxford University Press,1978.

DOO
Doordan, Dennis P. *Building Modern Italy: Italian Architecture, 1914-1936.* New York: Princeton Architectural Press, 1988.

DRE
Drexler, Arthur, editor. *The Architecture of the Ecole des Beaux-Arts.* Cambridge, Mass.: MIT Press, 1977.

ELL
Elling, Christian. *Rome: The Biography of Her Architecture from Bernini to Thorvaldsen.* Boulder, Colo.: Westview Press, 1975.

ENA
Encyclopedia of Architecture: Design, Engineering and Construction. Joseph A. Wilkes, Jr., Editor-in-Chief. New York: John Wiley, 198.
ENA-1.	Volume 1.
ENA-2.	Volume 2.
ENA-3.	Volume 3.
ENA-4.	Volume 4.
ENA-5.	Volume 5.

ETL
Etlin, Richard A. *Modernism in Italian Architecture, 1890-1940.* Cambridge, Mass.: MIT Press, 1991.

EWA
Encyclopedia of World Art. New York: McGraw-Hill, 1959-1987.
EWA-1.	Volume 1.
EWA-2.	Volume 2.
EWA-3.	Volume 3.
EWA-4.	Volume 4.
EWA-5.	Volume 5.
EWA-6.	Volume 6.
EWA-7.	Volume 7.
EWA-8.	Volume 8.
EWA-9.	Volume 9.
EWA-10.	Volume 10.
EWA-11.	Volume 11.
EWA-12.	Volume 12.
EWA-13.	Volume 13.
EWA-14.	Volume 14.
EWA-15.	Volume 15.
EWA-16.	Volume 16
EWA-17.	Volume 17.

FLE
Fletcher, Banister F. *Sir Banister Fletcher's A History of Architecture on the Comparative Method.* 18th Edition. Revised by J. C. Palmes. New York: Scribner, 1975.

FRM
Frampton, Kenneth. *Modern Architecture, 1851-1945.* New York: Rizzoli, 1983.

GRE
Gregotti, Vittorio. *New Directions in Italian Architecture.* (New Directions in Architecture.) New York: George Braziller, 1969.

GRO
Grodecki, Louis. *Gothic Architecture.* (History of World Architecture.) New York: Harry N. Abrams, 1977.

GUI
Guidoni, Enrico. *Primitive Architecture.* (History of World Architecture.) New York: Harry N. Abrams, 1978.

HAT
Hamlin, Talbot F. *Architecture Through the Ages.* New York: Putnam, 1953.

HEW
Heydenreich, Ludwig; Lotz, Wolfgang. *Architecture in Italy, 1400-1600.* (Pelican History of Art.) Harmondsworth, Eng.; Baltimore, Md.: Penguin Books, 1974.

HIT
Hitchcock, Henry-Russell. *Architecture: Nineteenth and Twentieth Centuries.* (Pelican History of Art.) Harmondsworth, Eng.; Baltimore, Md.: Penguin Books,1963.

HOF
Hofstatter, Hans. *Living Architecture: Gothic.* (Living Architecture.) New York: Grosset and Dunlap, 1970.

JEA
Jencks, Charles. *Architecture Today.* New York: Harry N. Abrams, 1982.

JEL
Jencks, Charles. *Late Modern Architecture and Other Essays.* New York: Rizzoli, 1980.

JEN
Jencks, Charles. *The New Moderns; from Late to Neo-Modernism.* New York: Rizzoli, 1990.

JOE

Joedicke, Jurgen. *Architecture Since 1945; Sources and Directions.* New York: Praeger, 1969.

KLO

Klotz, Heinrich. *The History of Postmodern Architecture.* Cambridge, Mass.: MIT Press, 1988.

KOH

Kostof, Spiro. *The City Shaped: Urban Patterns and Meanings Through History.* Boston: Little, Brown, and Co., 1991.

KOS

Kostof, Spiro. *A History of Architecture: Settings and Rituals.* New York: Oxford University Press, 1985.

KRA

Krautheimer, Richard. *Early Christian and Byzantine Architecture.* (Pelican History of Art.) Baltimore, Md.: Penguin, 1975.

KUB

Kubach, Hans Erich. *Romanesque Architecture.* (History of World Architecture.) New York: Harry N. Abrams, 1975.

LAW

Lawrence, A. W. *Greek Architecture.* (Pelican History of Art.) Harmondsworth, Eng.; Baltimore, Md.: Penguin, 1973.

LLO

Lloyd, Seton; Muller, Hans Wolfgang; Martin, Roland. *Ancient Architecture: Mesopotamia, Egypt, Crete, Greece.* (History of World Architecture.) New York: Harry N. Abrams, 1974.

LOW

Lowry, Bates. *Renaissance Architecture.* (The Great Ages of World Architecture.) New York: George Braziller, 1962.

LOY

Loyer, Francoise. *Architecture of the Industrial Age, 1789-1914.* Geneva, Switzerland: Editions d'Art Albert Skira, 1983.

MAA

MacDonald, William L. *The Architecture of the Roman Empire. Volume I. An Introductory Study.* Revised edition. New Haven, Ct.: Yale University Press, 1982.

MAC

MacDonald, William L. *The Architecture of the Roman Empire. Volume II. An Urban Appraisal.* New Haven, Ct.: Yale University Press, 1986.

MAD
MacDonald, William L. *Early Christian and Byzantine Architecture.* (The Great Ages of World Architecture.) New York: George Braziller, 1962.

MAE
Macmillan Encyclopedia of Architects. Adolf K. Placzek, editor-in-chief. New York: Free Press, 1982.
 MAE-1. Volume 1.
 MAE-2. Volume 2.
 MAE-3. Volume 3.
 MAE-4. Volume 4.

MAN
Mango, Cyril. *Byzantine Architecture.* (History of World Architecture.) New York: Harry N. Abrams, 1976.

MAR
Martin, Roland. *Living Architecture: Greek.* (Living Architecture.) New York: Grosset and Dunlap, 1967.

MEE
Meeks, Carroll L. V. *Italian Architecture, 1750-1914.* New Haven, Ct.: Yale University Press, 1966.

MER
Merisio, Pepi; Turri, Eugenio. *Italy: One Hundred Cities.* London: Tauris Parke Books, 1991.

MID
Middleton, Robin; Watkin, David. *Neoclassical and 19th Century Architecture.* (History of World Architecture.) New York: Harry N. Abrams, 1980.

MIG
Mignot, Claude. *Architecture of the Nineteenth Century in Europe.* New York: Rizzoli, 1984.

MIL
Millon, Henry A. *Baroque and Rococo Architecture.* (The Great Ages of World Architecture.) New York: George Braziller, 1961.

MIM
Millon, Henry A. *Key Monuments in the History of Architecture.* New York: Harry N. Abrams, 1965.

MUR
Murray, Peter. *Renaissance Architecture.* (History of World Architecture.) New York: Harry N. Abrams, 1971.

NOB
Norberg-Schulz, Christian. *Baroque Architecture.* (History of World

Architecture.) New York: Harry N. Abrams, 1971.

NOL
Norberg-Schulz, Christian. *Late Baroque and Rococo Architecture.*
(History of World Architecture.) New York: Harry N. Abrams, 1975.

OUR
Oursel, Raymond. *Living Architecture: Romanesque.* (Living
Architecture.) New York: Grosset and Dunlap, 1967.

PEH
Pevsner, Nikolaus. *A History of Building Types.* Princeton, N. J. :
Princeton University Press, 1976.

PEV
Pevsner, Nikolaus. *Outline of European Architecture.* Baltimore:
Penguin Books, 1960.

PIC
Charles-Picard, Gilbert. *Living Architecture: Roman.* (Living
Architecture.) New York: Grosset and Dunlap, 1965.

RAE
Architecture of the Western World. Edited by Michael Raeburn. New
York: Rizzoli, 1980.

ROB
Robertson, Donald. *Greek and Roman Architecture.* (Great Ages of
World Architecture.) New York: George Braziller, 1969.

RUS
Russell, Frank. *Art Nouveau Architecture.* New York: Rizzoli, 1979.

SAA
Saalman, Howard. *Medieval Architecture; European Architecture, 600-
1200.* (The Great Ages of World Architecture.) New York: George
Braziller, 1962.

SAR
Salavatori, Antonio. *Architect's Guide to Rome.* London: Butterworth
Architecture, 1990.

SAV
Salavatori, Antonio. *Architect's Guide to Venice.* London: Butterworth
Architecture, 1990.

SCR
Scranton, Robert L. *Greek Architecture.* (The Great Ages of World
Architecture.) New York: George Braziller, 1962.

SCU
Scully, Vincent, J. *Modern Architecture; the Architecture of Democracy.* (The Great Ages of World Architecture.) New York: George Braziller, 1974.

SHA
Sharp, Dennis. *A Visual History of Twentieth Century Architecture.* Greenwich, Ct.: New York Graphic Society, 1972.

SMI
Smith, G. E. Kidder. *Italy Builds; Its Modern Architecture and Native Inheritance.* New York: Reinhold Publishing Co., 1955.

STA
Stierlin, Henri. *Encyclopedia of World Architecture.* London: Macmillan Press Ltd., 1979.

TAF
Tafuri, Manfredo. *History of Italian Architecture, 1944-1985.* Cambridge, Mass.: MIT Press, 1989.

TAM
Tafuri, Manfredo; Dal Co, Francesco. *Modern Architecture.* (History of World Architecture.) New York: Harry N. Abrams, 1979.

TRA
Trachtenburg, Marvin; Hyman, Isabelle. *Architecture, From Pre-History to Post-Modernism: The Western Tradition.* New York: Harry N. Abrams, 1986.

VAR
Varriano, John L. *Italian Baroque and Rococo Architecture.* New York: Oxford University Press, 1986.

WAP
Ward-Perkins, John B. *Roman Architecture.* (History of World Architecture.) New York: Harry N. Abrams, 1977.

WAR
Ward-Perkins, John B. *Roman Imperial Architecture.* 2nd ed. (Pelican History of Art.) Baltimore, Md.: Penguin Books, 1981.

WIA
Wittkower, Rudolf. *Art and Architecture in Italy, 1600-1750.* (Pelican History of Art.) Baltimore, Md.: Penguin Books, 1973.

WHI
White, John. *Art and Architecture in Italy: 1250-1400.* (Pelican History of Art.) Baltimore, Md.: Penguin Books, 1966.

WIT
Wittkower, Rudolf. *Studies in the Italian Baroque; the Collected Essays of Rudolf Wittkower.* Boulder, Co.: Westview Press, 1975.

WOR
World Atlas of Architecture. Edited by Julius Norwich. New York: G. K. Hall, 1984.

Abbreviations

&	and
axon.	axonometric
c.	century
ca.	circa
col.	color
drg.	drawing
ea.	early
elev.	elevation
eng.	engraving
ext.	exterior view
fig(s).	figure(s)
int.	interior view
la.	late
mid.	middle
no.	number
pl(s).	plate
S.	Saint(s), Santa, Sankt, etc.
sect.	section

PART I
Site Index

ABBIATEGRASSO

S. Maria Nuova, 12th c.
Ext.: EWA-12 pl. 47

S. Maria Nascente, ca. 1497
Bramante, Donato
Ext.: DEF 32

ABRUZZO

City Planning, 1917
Giovannoni, Gustavo
Plan: ETL 115

ACQUAROSSA

Zone F Building,
la. 6th c. B. C.
Ext.: BOE 63

ACRAGAS. *See* AGRIGENTO

AGLIATE

S. Pietro, ca. 875
Ext.: CON 65

AGLE

S. Marta, 1739
Michela, Costanza
Ext.: MAE-3 164

AGRIGENTO (ACRAGAS)

City Planning, 5th c. B. C.
Ext.: BET 123, 125,
EWA-7 pl. 236

Post Office, 1931-1934
Muzzoni, Angiolo
Ext.: ETL 314
Int.: ETL 315

Temple of Castor & Pollux,
6th-5th c. B. C.
Ext.: LLO 260, 316, 317

Temple of Concord (Temple F),
ca. 430-400 B. C.
Ext.: EWA-13 pl. 219, LLO
319, MAR 76-78, RAE
44-col., TRA 88
Int.: LAW fig. 100
Plan: MAR 79

Temple of Juno Lacinia
(Temple D),
6th-5th c. B. C.
Ext.: LLO 259
Int.: LLO 259

Temple of Zeus Olympieion,
ca. 480-470 B. C.
Ext.: LAW 147, LLO 344,
MAR 135
Plan: LAW 146, LLO 344,
ROB 123, SCR pl. 34B

ALATRI (ALATRIUM)

Etruscan Temple, 3rd c. B. C.
Ext.: FLE 266-drg.

Terrace Wall, 3rd c. B. C.
Ext.: BOE fig. 139

ALATRIUM. *See* ALATRI

ALBA FUCENS (ALBE)

Basilica, ea. 1st c. B. C.
Plan: BOE fig. 139

City Planning, ea. 1st c. B. C.
Plan: BOE fig. 172

Forum, ea. 1st c. B. C.
Plan: BOE fig. 139

Temple of Hercules,
ea. 1st c. B. C.
Plan: BOE fig. 139

ALBANO (ALBANUM)

Villa of Pompey, ca. 1st c.
Plan: WAP 61, WAR fig. 122

ALBANUM. *See* ALBANO

ALBE. *See* ALBA FUCENS

ALBEROBELLO

Houses, 11th c.
Ext.: CON 268

ALLESANDRIA

Anti-Tuberculosis Clinic
(Dispensario
Antituberolare), 1938
Gardella, Ignazio
Ext.: DEW 234, SHA 147,
SMI 168

Borsalino Employee Housing,
1952
Gardella, Ignazio
Ext.: SMI 123

Palazzo Ghilini, 1730-1733
Alfieri, Benedetto
Int.: NOR 306

ALMENNO SAN BARTOLOMEO

S. Tomaso in Lemine, 11th c.
Ext.: KUB 234, OUR pl. 105
Int.: KUB OUR pls. 106, 107
Plan: OUR 101, 102

ALZATE BRIANZA,
near COMO

Cassa Rurale e Artigiana,
1978-1983
Natalini, Adolfo;
Frassinelli, Giampiero;
Natalini, Fabrizio
Ext.: DAL125, TAF fig. 153

AMALFI

Cathedral
Ext.: MER 153-col.

AMELIA

Town Walls, ca. 1st c. B. C.
Ext.: WAP 39

ANCONA

Arch of Trajan, 113-115
Ext.: FLE 320, MAC pl. 58,
WAP pl. 102, WAR
fig. 109

Fish Market, 1946
Minnucci, Gaetano
Ext.: SMI 216

Le Grazie Cooperative Quarter,
1972-1975
Coper Studio
Ext.: TAF fig. 100

S. Ciriaco
Int.: MER 132-133-col.

AOSTA (ancient AUGUSTA
PRAETORIA)

City Planning, 24 B. C.
Plan: WAR fig. 102

Porta Praetoria, 25 B. C.
Ext.: WAP pl. 238
Plan: WAP pl. 238

Roman Walls

Ext.: MER fig. 1

S. Orso: Priory, 1494-1506
Ext.: HEW pl. 121

AQUILA

Academy of Fine Arts,
 1978-1982
Portoghesi, Paolo
Ext.: DAL 143

Fountain of the Ninety-Nine
 Conduits
Ext.: MER 147

S. Bernardino, 1525
Cola dall'Amatrice
Ext.: HEW pl. 191

Twin Cathedral,
 ca. 313-319 or later
Plan: KRA 9

AQUILEIA

Tomb of the Curii, mid. 1st c.
Ext.: MAC pl. 141

ARDEA, near ROME

Acropolis, ca. 5th c.
Plan: BOE 103

Acropolis: Terrace Wall,
 ca. 300 B. C.
Ext.: BOE 122
Plan: BOE 122

Basilica, 2nd c. B. C.
Ext.: BRO pl. 29
Plan: BOE 150

Tomb, ca. 300 B. C.
Int.: BOE 82

AREZZO

Duomo, founded 1290
Ext.: WHI pl. 9
Int: WHI pl. 9

Fraternita di S. Maria della
 Misericordia, 1433
Rossellino, Bernardo
Ext.: HEW pl. 33, MER 118

S. Annunziata

Int.: BUR 115-drg.
Plan: BUR 115-drg.

ARICCIA

Railway Viaduct, 1846-1853
Aleandri, Ireneo
Ext.: MEE fig. 155

S. Maria dell'Assunzione,
 1662-1664
Bernini, Gianlorenzo
Ext.: NOR-l 119, VAR 96,
 WIA pl. 64
Int.: NOB 120, VAR 100,
 WIA pl. 64
Plan: VAR 98, WIA 118

ARPINUM

Corbelled Gate, 305 B. C.
Ext.: BOE 120

ARTIMINO

Villa Medicea
Buontalenti, Bernardo
Ext.: DEF 192

ASSISI

Rocca Maggiore
Ext.: MER 122-123-col.

S. Francesco, 1228-1253
 Ext.: FLE 755, TRA 262,
 WHI pl. 1
 Int.: FLE 755, PEV 220, RAE
 118, TRA 262, WHI pl. 1
 Plan: PEV 218, TRA 262

ASTI

Duomo, begun after 1323
Ext.: WHI pl. 78

S. Pietro Baptistery
Ext.: MER 37-col.

AUGUSTA PRAETORIA.
See **AOSTA**

AVELLINO

Pallazo Abbaziale di Loreto
Vaccaro, Domenico Antonio

Ext.: VAR 271

AVEZZANO

Culture Center, 1970-1982
Portoghesi, Paolo
Ext.: DAL 143-col.

AVOLA

City Planning, 1757
Plan: KOH 144

BAGHERIA

Villa Palagonia, 1715
Napoli, Tommaso Maria
Ext.: NOR 315
Plan: EWA-2 fig. 299, NOR
315, VAR 286

Villa Valguarnera, 1721
Napoli, Tommaso Maria
Ext.: NOR 315

BAGNAIA

Villa Lante, 1566
Vignola, Giacomo Barozzi da
Ext.: ARC 26, LOW pl. 118

Villa Lante: Fountain of the
Moors
Vignola, Giacomo Barozzi da
Ext.: ARC 95-col.

Villa Lante: Garden, la. 16th c.
Vignola, Giacomo Barozzi da
Ext.: EWA-8 pl. 433,
FLE 829
Plan: ARC 28-29, 91

BAGNOLO PIEMONTE

City Hall, 1975-1979
Gabetti, Roberto;
Isola, Aimaro
Ext.: DAL 83-col.

Dairy Factory ('La Tuminera',
1980-1982
Gabetti, Roberto;
Isola, Aimaro
Ext.: DAL 84-col.

Villa of Vettor Pisani,

1542-1544
Palladio, Andrea
Ext.: MAE-3 354

BAIA

Temple of Mercury,
1st c. B. C.
Ext.: WAP 125

Temple of Venus, ca. 125
Ext.: WAR fig. 97

BARI

S. Nicola, ca. 1085-1132
Ext.: CON 265, EWA-12
pl. 223, FLE 482, MER
161-col., SAA pl. 65
Int.: CON 264, FLE 482,
SAA pl. 67
Plan: CON 266, FLE 483,
SAA pl. 66

BELLUNO

Casa del Balilla, 1933
Mansutti, Francesco;
Miozzo, Gino
Ext.: ETL 436

BELRIGUARDO

Farm Buildings
Ext.: SMI 26

BENEVENTO

Arch of Trajan, 114
Ext.: FLE 322, WAP 87

Roman Theater (Grottoni)
Ext.: MER 154-col.

BERGAMO

Convento dei Frati Francescani
(Franciscan Monastery &
School), 1972
Gambirasio, Zenoni, Barbero,
& Ciagà
Ext.: DEW 229

Palazzo Nuovo (Municipal
Library), 16th c.

Scamozzi, Vincenzo
Ext.: MER 55

Piazza
Ext.: ENA-5 72

S. Maria Maggiore: Capella
 Colleoni (Colleoni Chapel),
 1470-1473
Amadeo, Giovanni Antonio
Ext.: BEA 149, DEQ 166,
 FLE 806, HEW pl. 102,
 MUR 124
Plan: DEQ 166

Società Cattolica di
 Assicurazione, 1967-1971
Gambirasio, Zenoni, Barbero,
 & Ciagà
Ext.: DEW 229

Villa Pizzigoni, 1925-1927
Pizzigoni, Pino
Ext.: DOO fig. 18, ETL 207
Int.: ETL 207

BIBIONE

Market, S. Michele al
 Tagliamento, 1980
Polesello, Gianugo;
 Panzarin, Francesco
Plan: TAF fig. 144
Elev.: TAF fig. 144
Sect.: TAF fig. 144

BIELLA

Cathedral, ca. 1825
Marandono, B. C.
Ext.: MEE fig. 106

BOCA

Santuario, 1830 & later
Antonelli, Alessandro
Ext.: MEE fig. 101

BOLOGNA

Arco del Meloncello
Dotti, Carlo Francesco
Ext.: VAR 255

City Planning, 1917
Piacentini, Marcello

Plan: ETL 126

E. M. P. A. S. Office Building,
 1952-1957
Muratori, Saverio
Ext.: TAF fig. 54

Government Tobacco
 Warehouse, 1952
Nervi, Pier Luigi
Ext.: SMI 244
Sect.: SMI 244

I. A. C. P. Quarter, Via della
 Barca, 1957-1962
Chiarini, Umberto; others
Site Plan: TAF fig. 38

Madonna di S. Luca
Dotti, Carlo Francesco
Ext.: VAR 255
Int.: VAR 257
Plan: VAR 256

Mercato Ortofrutticolo, 1984
Scannavini, Roberto
Ext.: TAF fig. 127-drg.

Palazzo Aldrovandi-Montanari
Angellini, Francesco Maria
Int.: VAR 258-259

Palazzo Davia-Bargellini
Provaglia, Bartolomeo
Ext.: VAR 196

Palazzo della Cassa di
 Risparmio, 1868-1876
Mengoni, Giuseppe
Ext.: MEE fig. 181

Palazzo Fantuzzi
Plan: BUR 140

Palazzo Pizzardi
Plan: BUR 140

Railroad Station, 1866-1868
Ceppi, Carlo;
 Mazzuchetti, Alessandro
Ext.: MEE fig. 162

Sacro Cuore, 1912 & later
Collamarini, Edoardo
Ext.: MEE fig. 138

S. Francesco, 1236-1250
Int.: WHI pl. 2

S. Petronio, begun 1390
Ext.: BUR 21-drg.
Int.: WHI pl. 162
Plan: BUR 21

S. Salvatore
Mazenta, Giovanni Ambrogio
Ext.: VAR 195
Int.: VAR 194, WIT 46
Plan: VAR 193, WIT 46

BOLSENA (VOLSINII)

Poggio Casetta Temple,
ea. 6th c. B. C.
Plan: BOE 36
Sect.: BOE 37

BOMARZO

Villa Orsini: Sacro Bosco,
1550-1570
Ext.: ARC 52, DEF 80,
HEW pls. 358, 359
Plan: ARC 26

BORGO D'ALE

Parish Church (S. Michele),
1770 & later
Vittone, Bernardo Antonio
Ext.: EWA-2 pl. 141,
MAE-4 346, NOR 194
Int.: NOR 195

BOSCOREALE

Roman Country House,
1st c. B. C.
Plan: ROB 311

BRA

S. Chiara, 1742
Vittone, Bernardo Antonio
Ext.: MIL pl. 7, MIM 434,
NOR 179, VAR 241
Int.: MIL pl. 9, MIM 435,
NOR 179, VAR 240 (dome),
WIA pl. 164, WIT 217
Plan: MIL pl. 8, MIM 434,
NOR 179, VAR 239,
WIA pl. 162

BRESCIA

Armi Museum, Castle, 1976
Rovetta, Francesco
Ext.: DAL 166-col.
Int.: DAL 166-col.

Capitolium & Forum, 1st c.
Ext.: BRO pl. 39, WAP 201,
WAR fig. 106-model
Plan: WAP 198

Cemetery, 1815-1849
Vantini, Rodolfo
Ext.: MEE fig. 96

Palazzo Comunale: Loggia,
ca. 1490-1510
Ext.: HEW pl. 111

Post Office, Piazza della
Vittoria, 1927-1932
Piacenti, Marcello
Ext.: ETL 419

S. Maria dei Miracoli, 1488
Jacopo, Mastro
Ext.: FLE 806
Plan: BUR 86
Sect.: BUR 86

BRINDISI

Colonne Steps
Ext.: MER 158-col.

Montesud: Administration
Buildings, 1964
Sgrelli, Ezio
Ext.: GRE fig. 62

BUSTO ARSIZIO

Istituto Tecnico Industriale,
1968
Castiglioni, Enrico
Ext.: DEW 231

Scuola, 1964
Castiglioni, Enrico
Ext.: DEW 232

CADENZA

Villa, 1970-1971
Botta, Mario
Ext.: KLO 271

CADONEGHE

City Hall
 Samonà, Giuseppe
 Ext.: DAL 171-col.

CAERE. *See* **CERVETERI**

CAGLIARI

University of Cagliari: Project,
 1972
 Samonà, Giuseppe; Ajroldi,
 Cesare; Bedoni, Cristiana;
 Chiorino, Mario Alberto;
 Di Falco, Mariella; Doglio,
 Carlo; Fartaglio, Giovanna;
 Samonà, Alberto; Frattini,
 Francesco; Lucci, Rejana;
 Toccafondi, Livia;
 Trincanato, Egle Renata
 Ext.: TAF fig. 108

CAMPOFATTORE

Hut Urn, ea. Iron Age
 Ext.: BOE 25

CAPRIATE D' ADDA

Villa Crespi, ca. 1890
 Pirovano, Ernesto
 Ext.: MEE fig. 139

CANGNANO

S. Giovanni Battiste, 1757-1764
 Alfieri, Benedetto
 Plan: NOR 306

CANINO

Thermal Bath Building, 1981
 Portoghesi, Paolo
 Ext.: DAL 143-col.

CAPRAROLA

City Planning, ca. 1550
 Plan: EWA-17 pl. 116

S. Teresa, 1620
 Rainaldi, Girolamo
 Plan: NOB 154

Villa Farnese (Palazzo
 Farnese), 1547-1549
 Vignola, Giacomo Barozzi da
 Ext.: DEF 211-213, FLE 832,
 HEW pl. 278, LOW pl. 110,
 MAE-4 316, MUR 228
 Int.: HEW pls. 279, 281,
 MUR 229-231
 Plan: BUR 180, FLE 832,
 HEW 271
 Sect.: BUT 180

Villa Farnese: Gardens
 Plan: ARC 30-31, 45

Villa Farnese: Garden Pavilion,
 1547-1549
 Vignola, Giacomo Barozzi da
 Ext.: FLE 830

CAPRI

Villa Jovis, 14-37
 Ext.: WAR fig. 120
 Plan: WAR fig. 121
 Sect.: WAR fig. 121

**CAPUA (SANTA MARIA
 CAPUA VETERE)**

La Conocchia (Mausoleum),
 1st c.
 Ext.: CHA 180, MAC pl.
 136, VAR 64, WAR fig. 100
 Plan: CHA 180
 Sect.: CHA 180

Mausoleum (Carceri Vecchie),
 ca. 125
 Ext.: WAP 245,
 WAR fig. 98

CASAL MARITTIMO

Tholos Tomb, ca. 600 B. C.
 Int.: BOE fig. 95

CASERTA

Houses with Prefabricated
 Elements, 1962
 Mangiarotti, Angelo
 Ext.: GRE fig. 56

Royal Palace (Palazzo Reale,

Regia), 1752-1774
Vanvitelli, Luigi
Ext.: BAL 93, BAR 92, BET
 704, MAE-4 289, MIM 433,
 NOR 309, PEV 465, VAR
 275, WIA pl. 151
Int.: BAL 278, BAR 91, MIM
 432, NOR 310, VAR 276
 (staircase), WIA pl. 153
Plan: MIM 433, NOR 308,
 WIA 262

Royal Palace: Gardens,
 1752-1774
Vanvitelli, Luigi
Ext.: ARC 327-drg.,
 329-col., MER 150-151-col.
Plan: ARC 328

CASTEL DEL MONTE

Castel del Monte, ca. 1240
Ext.: HOF 156, TRA 271,
 MIM 255, PEV 187, 188
Plan: MIM 255, PEV 189

CASTEL GANDOLFO

S. Tommaso di Villanova,
 1658-1661
Bernini, Gianlorenzo
Ext.: VAR 95
Int.: VAR 94, WIA pl. 61
Plan: BEA 597, WIA 116

CATANIA

Palazzo del Municipio
Vaccarini, G. B.
Ext.: MER 169, VAR 289

S. Agata (Cathedral),
 1735-1767
Vaccarini, Giovanni Battista
Ext.: MAE-4 248, NOR 311,
 VAR 288

Teatro Bellini, 1870-1890
Scala, Andrea; Sada, Carlo
Ext.: MEE fig. 229

CEFALU

Cathedral, 1131-1240
Ext.: CON 274, FLE 484

Plan: CON 275, FLE 483

CERCIVENTO

City Hall, 1979-1980
Burelli, Augusto Romano
Ext.: DAL 46-col.

CERVETERI

Banditaccia Cemetery,
 7th c. B. C.
Ext.: BOE 49, 71
Int.: BOE 51, 52, 86-88
Plan: BOE 89

Regolini Galassi Tomb,
 ca. 650 B. C.
Int.: BOE 95

Tomb of the Doric Columns,
 6th c. B. C.
Int.: BOE fig. 40

Tomb of the Frame,
 5th c. B. C.
Int.: FLE 265

Tomb of the Stucco Reliefs,
 4th c. B. C.
Int.: FLE 264, MIM 88

Tomb of the Thatched Roof,
 ea. 7th c. B. C.
Int.: BOE 78

Tomba dei Capitelli,
 6th c. B. C.
Int.: BOE fig. 82

Tomba dei Vasi Greci,
 5th c. B. C.
Plan: BOE fig. 87

Tomba della Cornice,
 5th c. B. C.
Int.: BOE fig. 83

Tumulus Tomb, ca. 500 B. C.
Ext.: FLE 264

CERINIA

Rifugio Pirovano, 1949-1951
Albini, Franco;
 Colombini, Luigi
Ext.: TAF fig. 11

COLLODI

Osteria del Gambero Rosso
(Tavern 'Red Lobster'),
1961-1963
Michelucci, Giovanni
Ext.: DAL 105-col., TAF 25
Int.: DAL 105-col.

Villa Garzoni (Villa Gardi):
Garden, 1690s
Ext.: ARC 183-col
Plan: ARC 113, 181

COMAZZO

Villa Pertusati: Cascade
Ext.: ARC 154-eng.

COMO

Albergo Metropole Suisse, 1927
Terragni, Giuseppe
Ext.: ETL 222

Broletto, ea. 13th c. & later
Ext.: MER 53-col.

Casa del Fascio (Casa del
Popolo), 1936
Terragni, Giuseppe
Ext.: COP 17, COT-1 803,
COT-2 897, DEW 230, DOO
fig. 88-91, ETL 440, FLE
1262, FRM 384, GRE fig. 13,
JOE 21, MAE-4 195, PEV
669, RAE 264-col., SHA 139,
SMI 119
Int.: ETL 443, 457, 560,
FRM 385
Plan: ETL 442, FRM 385
Sect.: FRM 384
Elev.: ETL 356

City Planning, 1858
Plan: BET 224

City Planning, 1927
Terragni, Giuseppe
Plan: ETL 123

Novocomum Apartment House,
1929
Terragni, Giuseppe
Ext.: DEW 230, DOO fig. 28,
GRE fig. 6

Palazzo del Broletto (Town
Hall), 1215
Ext.: KOS 361, PEH 2.2

S. Abbondio, ca. 1063-1095
Ext.: CON 300, HAT pl. 32

S. Fedele, 11th-12th c.
Plan: PEV 124

Sant'Elia Kindergarten,
1936-1937
Terragni, Giuseppe
Ext.: GRE fig. 14

Silk Trade Fair: Exposition
Installation, 1927
Baldessari, Luciano
Int.: DOO fig. 39

Società de Commessi:
Headquarters Project,
ca. 1916
Sant'Elia, Antonio
Ext.: RUS pl. 8.33-drg.

Villa for Diaz de Quijano,
1883-1885
Gaudi, Antoni
Ext.: RUS pl. 2.16

Vitrum Store, 1930
Terragni, Giuseppe
Int.: DOO fig. 74

War Memorial, 1933
Prampolini, Enrico;
Terragni, Giuseppe
Ext.: DOO fig. 65

CONEGLIANO

Accademia Musicale, 1860s
Scala, Andrea
Plan: MEE fig. 228
Elev.: MEE fig. 227

CORI

Temple of Hercules,
la. 2nd c. B. C.
Ext.: BOE 160, BRO pl. 13,
WAP 26

CORLANZONE

Villa Rosa, ca. 1910

Melani, Alfredo
Ext.: ETL 51

CORNETO. *See* **TARQUINIA**

CORTERANZO

S. Luigi Gonzaga, ca. 1740
Vittone, Bernardo Antonio
Ext.: NOR 173
Int.: NOR 174, 175
Plan: NOR 174

CORTONA

Palazzo Pretorio (Museo dell'
Accademia Etrusca), 13th c.
Ext.: MER 120-col.

S. Maria del Calcinaio,
1484-1490
Martini, Francesco di Giorgio
Ext.: DEQ 119, HEW pl. 133,
MUR 91
Int.: DEQ 120, DEQ 122
(dome), HEW pl.134, LOW
pl. 51, MAE-2 109, MUR
90, 92, 93
Plan: DEQ 121, HEW 131,
LOW pl. 52, MUR 90

S. Maria Nuova, ca. 1562
Vasari, Giorgio
Ext.: MUR 240

COSA

Atrium Publicum, 3rd c. B. C.
Plan: BRO pl. 9

Basilica, 2nd c. B. C.
Ext.: BRO pol. 27
Sect.: BRO pl. 28

Capitolium Reconstruction,
ca. 150 B. C.
Ext.: BOE 54, 131, WAP 15
Plan: BOE 131

City Gate, 273 B. C.
Ext.: BOE 116

City Planning, 3rd c. B. C.
Plan: BRO pl. 12

Comitium & Curia, 3rd c. B. C.

Ext.: BOE 145
Plan: BOE 145, WAP 16
Sect.: BRO pl. 8

Forum, 250-125 B. C.
Ext.: BOE 145, WAP 98
Plan: BOE 145, WAP 16

Temples, ca. 100 B. C.
Ext.: BOE 132, BRO pl. 5
Plan: BOE 132

Villa, 2nd c. B. C.
Ext.: BOE 192

CREMA

Cathedral Square Gateway,
17th c.
Ext.: MER 54

S. Maria della Croce, 1493
Battagio, Giovanni
Ext.: BUR 55-drg.,
HEW pl. 108

CREMONA

Baptistery, 1167
Ext.: FLE 472, MER 61-col.

Cathedral, 12th, 15th, 16th c.
Ext.: MER 60-61-col.

Loggia dei Militi, 1292
Ext.: WHI pl. 13

Palazzo Dati, 1769
Arrighi, Antonio
Int.: WIA pl. 152
Plan: EWA-2 fig. 303, WIA
257

Palazzo Raimondi, 1496-1499
Raimondi, Elviso
Ext.: HEW pl. 109

Palazzo Stanga, ea. 18th c.
Ext.: EWA-8 pl. 195,
WIA pl. 147

S. Trinità
Nono, Andrea
Ext.: VAR 249

Torrazzo (Bell-Tower)
Ext.: MER 60-col.

Piazza Trento e Trieste
 Ext.: MER 72

S. Cristoforo, 1498
 Rossetti, Biagio
 Int.: HEW pl. 116

S. Francesco, 1494
 Rossetti, Biagio
 Ext.: DEQ 130, HEW pl. 115

Via Mortara, 1490s
 Rossetti, Biagio; D'Este, Ercole
 Ext.: KOH 256

FIESOLE (FAESULA)

Badia Fiesolana, 1461
 Int.: HEW pl. 29, MUR 43

Temple, 750-100 B. C.
 Plan: BOE 43

FIRENZE. *See* FLORENCE

FIUMICINO, near ROME

Leonardo da Vinci Airport,
 1961-1962
 Morandi, Riccardo
 Ext.: EWA-13 pl. 266
 Int.: COT-1 558
 Plan: EWA-13 fig. 609

Leonardo da Vinci Airport:
 Boeing Hangar, 1970
 Morandi, Riccardo
 Ext.: DAL 117-col., SAR 131

FLORENCE (FIRENZE)

Apartment Building, Via della
 Piagentina, 1964
 Savioli, Leonardo;
 Santi, Danilo
 Ext.: TAF fig. 78

Apartments, Piazza delle Mulina,
 1880
 Poggi, Giuseppe;
 Frosale, Narciso
 Ext.: MEE fig. 211

Arno Bridge,
 Autostrada del Sole, 1963
 Zorzi, Silvano

Ext.: GRE fig. 59

Badia: Chiostro degli Aranci,
 1436-1437
 Rossellino, Bernardo; others
 Int.: HEW pl. 34

Baptistery of S. Giovanni,
 5th c.; 11th & 12th c.,
 1403-1452
 Ext.: BUR 19-drg., CON
 287, EWA-1 pl. 302, KUB
 238, MUR 22, TRA pl.
 26-col.
 Int.: BUR 19-drg., CON 288,
 KUB 239, TRA 207

Bargello, ca. 1255
 Ext.: WHI pl. 14

Berta (Giovanni Berta) Stadium,
 1930-1932
 Nervi, Pier Luigi
 Ext.: COP 130, FRM 356-357,
 JOE 21, PEV 691
 Plan: FRM 357

Biblioteca Nazionale Centrale,
 1911
 Bazzani, Cesare
 Ext.: MEE fig. 264-drg.

Bigallo, 1352-1358
 Ext.: FLE 745

Boboli Gardens,
 ca. 1550 & later
 Buontalenti, Bernardo;
 Vasari, Giorgio; others
 Ext.: ARC 43, EWA-8 pl.
 429, 430, FLE 790, HEW
 pls. 356, 357, MAE-1 336
 Botanical Garden (Giardino
 Botanico), 1550s
 Plan: ARC 82-eng.

Campanile, 1334-1359
 Giotto di Bondone
 Ext.: MAE-2 213, MIM 285,
 KOS 319

Cathedral, 1867-1887
 De Fabris, Emilio
 Ext.: MEE fig. 114-115

Central Railway Station, 1936
 Michelucci, Giovanni

Ext.: PEH 14.28, PEV 672
Int.: PEV 673

Church of the Ogrissanti
Nigetti, Matteo
Ext.: VAR 199

City Planning, ca. 59 B. C.
Plan: BET 437

City Planning, ca. 1200-1250
Plan: BET 440

City Planning, ca. 1250-1300
Arnolfo de Cambio (?).
Plan: BET 444, 446, TRA 274

City Planning, 1427 (Catasto)
Plan: KOH 51

City Planning, 1471-1482
Plan: BET 466, 467

City Planning, 20th c.
Ext.: BET 475
Plan: BET 447, 474

E. N. P. A. S. Headquarters,
1958-1960
Portoghesi, Paolo
Ext.: DAL 141

Fortezza da Basso: Project,
1983
Portoghesi, Paolo
Ext.: TAF fig. 165-drg.

Hotel Savoy, 1890s
Michele, Vincenzo
Ext.: MEE fig. 206
Plan: MEE fig. 206

House, Via Borgognissanti,
1896-1915
Michelazzi, Giovanni
Elev.: RUS pl. 8.32

Houses, 14th, 15th, 18th c.
Ext.: BET 470, 471

Housing, ca. 1888
Corinti, Corinto
Ext.: MEE fig. 207
Plan: MEE fig. 207

Loggia dei Lanzi, 1376-1382
Benci di Cione;
Talenti, Simone
Ext.: FLE 749, MIG 175,

TRA 277

Orsanmichele, founded 1337
Int.: WHI pl 73

Ospedale degli Innocenti
(Foundling Hospital),
1421-1445
Brunelleschi, Filippo
Ext.: BUR 163-drg., EWA-2
pl. 366, DEQ 32, HEW pl. 2,
LOW pl. 1, MAE-1 303,
MIM 301, MUR 15, PEV 291
Int.: BEA 54, HEW 7,
MUR 15
Plan: BEA 54

Palazzo Antinori, 1470s
Ext.: TRA 292

Palazzo Davanzati, 14th c.
Ext.: BAK 164, KOS 377,
TRA 290
Int.: BAK 165, EWA-8 pl.
100, KOS 377

Palazzo "Der Villa", ca. 1850
Ext.: MEE fig.108

Palazzo di Parte Guelfa,
ca. 1420
Brunelleschi, Filippo
Ext.: HEW 17, LOW pl. 13,
MUR 44

Palazzo Fenzi
Silvani, Gherardo
Ext.: VAR 201

Palazzo Gerini-Neroni, 1460
Ext.: HEW pl. 30

Palazzo Gondi, 1490
Sangallo, Giuliano da;
Cronaca, Il
Ext.: EWA-12 pl. 388,
MUR 109
Int.: HEW pl. 143

Palazzo Guadagni, 1490-1506
Pollaiuolo, Simone
Ext.: EWA-12 pl. 54,
FLE 799

Palazzo Medici-Riccardi,
1444-1460
Michelozzo di Bartolomeo

others
Ext.: DEW 238, DOO fig.
 58-59, ETL 309, PEH 14.28,
 PEV 672
Int.: GRE 21, PEV 673

S. Maria Novella Railroad
 Station: Powerhouse,
 1932-1934
Mazzoni, Angiolo
Ext.: DOO fig. 60

S. Miniato al Monte, 1018-1062;
 1062-1090 & later
Ext.: BUR 18, CON 289,
 EWA-12 pl. 221, FLE 472,
 PEV 130, SAA pl. 72,
 TRA 206
Int.: CON 290, FLE 472,
 HAT pl. 32, PEV 131,
 RAE 100-col., SAA pl. 71,
 TRA 206
Plan: CON 291, SAA pl. 73

S. Miniato al Monte: Chapel of
 the Cardinal of Portugal,
 1461-1466
Rossellino, Bernardo
Int.: EWA-12 pl. 16,
 HEW pl. 37

S. Niccolò, 1865 & later
Poggi, Giuseppe
Ext.: MEE fig. 168

S. Pancrazio: Chapel of the
 Holy Sepulchre (Rucellai
 Chapel), ca. 1455-1460
Alberti, Leon Battista
Ext.: HEW pl. 25, MAE-1 55
Int.: HEW pl. 23
Plan: HEW pl. 25

S. Salvatore al Monte, ca. 1480
Il Cronaca
Ext.: EWA-8 pl. 191
Plan: HEW 141

S. Spirito, 1445-1482
Brunelleschi, Filippo
Ext.: EWA-1 pl. 386
Int.: DEQ 8 (dome), DEQ
 44-45, FLE 796, HEW pl. 5,
 LOW pls. 8, 9, MIM 306,
 MUR 28-31, PEV 293, RAE

132-col., TRA 286
Plan: DEQ 40, FLE 796, HEW
 9, LOW pl. 11, MIM 306,
 MUR 28, PEV 292, TRA 286
Sect.: DEQ 40, FLE 796
Elev.: DEQ 40

S. Trinità, 1594
Buontalenti, Bernardo
Ext.: MUR 244

Sorgane Quarter Building,
 1963-1966
Ricci, Leonardo
Ext.: TAF fig. 77

State Archives of Florence:
 Project, 1972
G. R. A. U. (Anselmi,
 Alessandro; Eroli, Pierluigi;
 Pierluisi, Franco).
Ext.: TAF fig. 98-drg
Site Plan: TAF fig. 99

Synagogue, 1874-1882
Falcini, Mariano; Treves,
 Marco; Michele, Vincenzo
Ext.: MEE fig. 144

Triumphal Arch, 1739-1745
Jadot, Jean-Nicolas
Ext.: MEE fig. 41

Uffizi (Palazzo degli Uffizi),
 1560-1580
Vasari, Giorgio
Ext.: DEF 194-195, ENA-3
 504, EWA-9 pl. 312, HEW
 pls. 350, 351, MAE-4 293,
 MUR 242, 243, PEH 2.1,
 PEV 364, 365
Int.: LOW pl. 108, MUR 241
Plan: HEW 322, MUR 242

Viale G. Matteotti, 1868 & later
Poggi, Giuseppe
Ext.: MEE fig. 168

Villino Broggi-Caraceni, 1911
Michelazzi, Giovanni
Ext.: RUS pl. 8.30
Plan: RUS pl. 8.29

Villino Favard, 1857
Poggi, Giuseppe
Ext.: MEE fig. 209-210

Villa Medici di Castello: Gardens
Ext.: ARC 66-col.

Villa Poggio Imperiale,
1804 & later
Cacialli, Giuseppe;
Poccianti, Pasquale
Ext.: MEE fig. 65
Int.: MEE fig. 18

Villa Poggio Imperiale: Chapel,
ca. 1812
Cacialli, Giuseppe;
Poccianti, Pasquale
Plan: MEE fig. 66

FORLI

Teatro Comunale: Project, 1978
Sacripanti, Maurizio
Ext.: TAF fig. 95-drg.

FOSSANOVA

Abbey Church, ca. 1208
Ext.: MIM 251
Int.: GRO pl. 93, MIM 252
Plan: GRO pl. 91, MIM 252

FRASCATI

Villa Aldobrandini:
Water Theater
Maderno, Carlo
Ext.: ARC 57-eng., VAR 41

Villa de Pratolino: Garden
Plan: ARC 27, 34

FRATTE

Temple, 4th c. B. C.
Ext.: BOE 61

GABII

Theater-Temple, 2nd c. B. C.
Ext.: BOE 165
Plan: BOE 166

GALLARATE

Cemetery, 1865
Boito, Camillo
Ext.: MEE fig. 119

Hospital, 1871 & later
Boito, Camillo
Ext.: MEE fig. 120

GALIPOLLI

Fort
Ext.: MER 159-col.

GARGANO

Hotel Manacore, 1962
D'Olivo, Marcello;
Simonitti, Vincenzo
Ext.: GRE fig. 76

GENAZZANO

Nympaeum (Ninfeo)
Bramante, Donato
Ext.: DEF 144
Plan: DEF 145

GENOA (GENOVA)

Apartments, Via Maragliano,
1907
Coppedè, Gino
Ext.: MEE fig. 258

Castello Mackenzie, 1890s
Coppedè, Gino
Ext.: MEE fig. 140

Chiesa dell' Immacolata,
1856-1873
Cervetto, Domenico; others
Ext.: MEE fig. 219

Chiesa della Sacra Famiglia,
1956 & later
Quaroni, Ludovico; De Carlo,
Adolfo; Mor, Andrea;
Sibilla, Angelo
Ext.: TAF fig. 37

Chiesa della Santissima
Annunziata, 1830
Barabino, Carlo
Ext.: MEE fig. 77

Cinema Elio, 1951
Daneri, Luigi Carlo
Ext.: SMI 129

City Planning, 1573

Plan: BET 610

Forte-Quezzi Housing Project,
1956-1958
Daneri, Carlo
Ext.: DAL 64-col.

Galleria Mazzini, 1871
Int.: MEE fig. 157

Hotel Punta S. Martino, 1958
Gardella, Ignazio; Zanuso,
Marco; Venezioani, Guido
Ext.: GRE fig. 47

I. N. A. Casa Residential Unit,
Villa Bernabo Brea, 1953
Daneri, Luigi Carlo;
Bianchi, L. Grossi;
Zappa, Giulio
Plan: GRE fig. 53

Palazzo Andrea Doria, Piazza
S. Matteo Reconstruction,
ca. 1486
Ext.: HEW pl. 125

Palazzo Bianco: Communal
Galleries, 1950-1951.
Albini, Franco.
Int.: TAF fig. 41

Palazzo della Meridiana
(Palazzo Grimaldi),
mid. 16th c.
Ext.: BEA 424

Palazzo del'Universita,
1634-1636
Bianco, Bartolomeo
Ext.: FLE 818, HAT pl. 56,
NOB 244, 245, WIA pl. 37
Int.: CHA pls. 37, 38, 40
Plan: CHA 46, WIA 80
Sect.: WIA 80

Palazzo Doria, Vico d'Oria,
ca. 1450
Int.: HEW pl. 124

Palazzo Ducale, 1771
Catoni, Simone
Ext.: MEE fig. 1

Palazzo Durazzo-Pallavicini,
1619 & later
Bianco, Bartolomeo

Ext.: BEA 424, FLE 806

Palazzo Lamba-Doria, ca. 1298
Ext.: WHI pl. 14

Palazzo Municipale (Palazzo
Tursi, Palazzo Comunale),
1564-1566
Lurago, Rocco
Ext.: BEA 425, FLE 808,
MAE-3 40, NOB 243
Plan: FLE 808
Sect.: FLE 808

Palazzo Rosso Museum,
1953-1960
Albini, Franco
Int.: DAL 27-col.

Palazzo Sauli, ca. 1555
Alessi, Galeazzo
Ext.: FLE 805

Porta Pia, 1633
Bianco, Bartolomeo
Ext.: FLE 811

Residential Quarter, Forte di
Quezzi, 1956 & later
Daneri, Luigi Carlo; Fuselli,
Eugenio; Andreani, Claudio
Della Rocca, Robadlo
Morozzo; Pateri, Mario;
Pulitzer, Gustavo;
Sibilla, Angelo
Ext.: TAF fig. 40

S. Agostino Museum, 1977-1986
Albini, Franco
Int.: DAL 28-29-col.
Site Plan: DAL 28-col.

S. Annunziata, 1587;
facade, ca. 1830
Della Porta, Giacomo;
Barabino, Carlo
Ext.: FLE 818

S. Lorenzo Treasury Museum
(Tesoro di S. Lorenzo),
1952-1956
Albini, Franco; Helg, Franca
Int.: GRE fig. 49, TAF fig. 42
Site Plan: TAF fig. 43

S. Maria Assunta de Carignano,
1549

Int.: NOR 192, 193
Plan: NOR 190
Sect.: NOR 190

GROSSETO

City Planning
Plan: MER 13

GUBBIO

Palazzo dei Consoli, ca. 1350
Ext.: KOH 67-col., MER
130-col., WHI pl. 76

S. Francesco, begun 1259
Ext.: WHI pl. 4

HERCULANEUM

House of Neptune &
Amphitrite, 1st c. B. C.
Int.: EWA-10 pl. 173, MIM
110, RAE 76-col.

House of the Mosaic Atrium,
ca. 1st c. B. C.
Ext.: WAP 62, WAR fig.
110, 111-drg
Plan: WAP 62, WAR fig. 112

House of the Stags, 1st c. B. C.
Ext.: WAP 62, WAR fig.
110, 111-drg
Plan: WAP 62

INVERIGO

Villa Cagnola d'Adda,
1813-1833
Cagnola, Luigi
Ext.: MEE fig. 71-71a

IMOLA

City Planning, ca. 1503
Leonardo da Vinci
Plan: KOH 130-drg.

ISOLA BELLA

Garden of Isola Bella,
Lake Maggiore
Ext.: ARC 150-col.

IVREA

Cathedral of L'Assunta, 10th c.
Int.: KUB 99

Olivetti Complex, 1954-1957
Figini, Luigi; Pollini, Gino
Ext.: SMI 242, TAF fig.
32-33, GRE fig. 64,
SHA 215
Site Plan: DEW 232,
TAF fig. 31

Olivetti Complex: Refectory,
1955-1959
Gardella, Ignazio
Int.: TAF fig. 46

Olivetti Complex: Residential
Center, 1969-1970
Gabetti, Roberto;
Isola, Aimaro;
Re, Luciano
Ext.: TAF fig. 123

JESI

Palazzo Comunale: Courtyard,
ca. 1490-1500
Martini, Francesco di Giorgio
Int.: HEW pl. 72

LACCO AMENO D' ISCHIA

Terme Regina Isabella,
1950-1953
Gardella, Ignazio
Ext.: TAF fig. 22

LAKE NERO

Sled-Lift Station, Val di Susa,
1946 & later
Mollino, Carlo
Ext.: TAF fig. 16

LANUVIUM

Temple of Juno Sospita,
5th c. B. C.
Ext.: FLE 262

LATINO (LITTORIA)

Post Office, 1932
Mazzoni, Angiolo

Ext.: ETL 318

LECCE

Church of the Rosary
Zimbalo, Giuseppe
Ext.: VAR 282

I. N. A. Casa Residential
Complex, Galatina, 1958
Pellegrin, Luigi; Antonelli,
Franco; Cecchini, Angelo;
Cocconcelli, Ciro; Roggero,
Mario
Ext.: TAF fig. 39

Park
G. R. A. U. (Gruppo Romano
Architetti Urbanisti)
Ext.: KLO 401-drg.,
KLO-drg., 403-drg.

Piazza del Duomo
Ext.: VAR 283

S. Croce, 16th-17th c.
Ext.: MER 157-col.

S. Matteo
Carducci, Achille
Ext.: VAR 280

Il Sedile
Riccardi, Giuseppe
Ext.: VAR 279

Seminary Palace
Cino, Giuseppe
Ext.: VAR 284

LEGHORN

Il Cisternone, 1829-1842
Poccianti, Pasquale
Ext.: MEE fig. 57
Sect.: MEE fig. 58

LEGNANO

Palazzo Municipale: Project,
1974
De Feo, Vittorio; Ascione,
Errico; Aggarbati,
Fabrizio; Saggioro, Carla
Ext.: TAF fig. 96-drg.

Sun Therapy Colony, 1939

B. B. P. R
Ext.: GRE fig. 22, SMI 164
Int.: SMI 164
Plan: SMI 164
Sect.: SMI 164

LIGNANO PINETA

Villa Spezzotti, 1958
D'Olivo, Marcello
Ext.: TAF fig. 79

LIGORNO

House, 1975-1976
Botta, Mario
Ext.: KLO 276-col.

LISSONE

Cemetery Project, 1981
Battisti, Emilio
Ext.: DAL 38

LODI

Garage Barnabone, 1920s
Muzio, Giovanni
Ext.: ETL 373

Piazza della Vittoria
Ext.: MER 50-51-col.

LOMELLO

S. Maria Maggiore, c. 1040
Int.: TRA 204

LONEDO

Villa Godi, ca. 1540
Palladio, Andrea
Ext.: DEF 150, MUR 303

LONIGO

Cathedral, 1877-1895
Franco, Giacomo
Plan: MEE fig. 135
Elev.: MEE fig. 135

LORETO

Basilica, ca. 1470-1495
Giuliano da Maiano

Ext.: HEW pl. 40

S. Casa, 1509
Bramante, Donato
Int.: HEW pl. 166

LUCCA

E. N. P. A. S. Headquarters,
1958-1961
Portoghesi, Paolo
Ext.: DAL 141-col.

Palazzo del Pretorio (Palazzo
della Signoria, Palazzo de
Governo), 1550
Ammanati, Bartolomeo
Ext.: BUR 154, MUR 240

Palazzo Micheletti, ca. 1550
Ammanati, Bartolomeo
Ext.: FLE 806

Piazza del Mercato
Ext.: MER 104-col.

S. Michele, 1143
Ext.: EWA-8 pl. 178, RAE 33

LUGO

City Planning (Aerial View),
20th c.
Ext.: KOH 131

Villa Piovene
Palladio, Andrea
Ext.: DEF 151

LUNI

Acropolis Reconstruction,
ea. 4th c. B. C.
Sect.: BOE 68

Apennine Hut Reconstruction,
Bronze Age
Ext.: BOE 12
Plan: BOE 12
Sect.: BOE 12

Tomb of the Caryatids,
600s B. C.
Ext.: BOE 101
Int.: BOE 83

Walls, ea. 4th c.

Ext.: BOE 68

LUVIGLIANO

Villa dei Vescovi, ca. 1530
Falconetto, Giovanni
Ext.: HEW pl. 220,
LOW pl. 89, MUR 278

MACERATA

Loggia dei Mercanti, 15th c.
Ext.: MER 129-col.

Piazza della Libertà
Ext.: MER 129-col.

MANTUA (MANTOVA)

Cartiere Burgo (Burgo Paper
Factory), 1960-1962
Nervi, Pier Luigi
Ext.: DEW 236, DAL 127,
Elev.: ENA-3 559

Casa de Gioanni Boniforte da
Concorezzo, 1455
Ext.: HEW pl. 74

Casa de Mantegna (Mantegna
[Andrea Mantegna] House),
la. 15th c.
Mantegna, Andrea
Ext.: HEW pl. 77

Casa via Frattini 5,
ca. 1460-1470
Ext.: HEW pl. 75

Cathedral, ca. 1540-1545
Giulio Romano
Int.: HEW pl. 236, MUR 192,
PEV 363
Plan: HEW 232

Domus Nova, ca. 1480
Fancelli, Luca
Ext.: HEW pl. 76

Giulio Romano House, ca. 1540
Giulio Romano
Ext.: FLE 830, HEW pl. 238,
MAE-2 217, MUR 193, PEV
349

Palazzo del Te, 1525-1535
Giulio Romano

Ext.: BAK 236, DEF 97-99,
EWA-12 pl. 53, FLE 829,
HEW pl. 230, LOW pl. 90,
MUR 183, 184, 186, PEV
347, 348
Int.: BEA 204, BUR
177-drg., EWA-8 pl. 428,
HEW pls. 231, 232, LOW pl.
92, MUR 187-190
Plan: EWA-9 fig. 463, HEW
229, LOW pl. 94, MUR 183

Palazzo del Te: Giardino
Segreto, 1525-1535
Giulio Romano
Ext.: ARC 88

S. Andrea, 1472-1494
Alberti, Leone Battista
Ext.: BEA 122, 123, DEQ 96,
ENA-1 305, EWA-1 pl. 27,
HEW pl. 27, LOW pls. 31, 33,
MAE-1 158, MIM 313, MUR
64, PEV 317
Int.: BEA 122, DEQ 97-99,
HEW pl. 26, LOW pl. 30,
MAE-1 157, MIM 314,
MUR 66, PEV 318, VAR 20
Plan: BEA 122, ENA-1 153,
HAT 341, LOW pl. 32, MIM
315, MUR 3, PEV 318

S. Benedetto al Polirone, 1540
Giulio Romano
Ext.: HEW pl. 237

S. Sebastiano, 1460
Alberti, Leon Battista
Ext.: DEQ 92, EWA-1 pl. 56,
HEW pls. 24, 25, LOW pl. 24,
MAE-1 56, MUR 62,
PEV 316
Int.: DEQ 91, LOW pl. 25
Plan: DEQ 90, EWA-1 figs.
196, 200, 643, HEW pl. 25,
LOW pl. 26, MUR 63, PEV
316

MANZIANA

Ponte del Diavolo, ca. 100 B. C.
Ext.: BOE 124
Plan: BOE 124

MARINO

S. Maria del Rosario
Sardi, Giuseppe
Int.: VAR 160

MARLIA

Villa Orsetti: Gardens
Ext.: ARC 13-eng
Plan: ARC 13, 112

MASER

Chapel, 1560s
Palladio, Andrea
Ext.: MEE fig. 82

Villa Barbaro, 1560-1568
Ammanati, Bartolomeo;
Palladio, Andrea
Ext.: DEF 113, KOS 481,
WOR 281
Int.: DEF 113, RAE 30, 31

Villa Barbaro: Nymphaeum,
1560-1568
Ammanati, Bartolomeo;
Palladio, Andrea
Ext.: ARC 54

MASSA MARITTIMA

Duomo, begun 1287
Int.: WHI pl. 5

MATERA

La Martella Village,
1951 & later
Quaroni, Ludovico; Agati,
Luigi; Gorio, Federcio;
Lugli, Piero Maria; Valori,
Michele
Ext.: TAF fig. 17
Site plan: TAF fig. 18

S. Giovanni Battista, ca. 1200
Int.: KUB 347

Sassi (Old Dwellings)
Int: MER 155-col.

University of Calabria Project,
1973
Gregotti, Vittorio

Plan: MID pls. 643, 644

MELEDO

Villa Grissino
Palladio, Andrea
Plan: DEF 157

MERANO

Cathedral
Ext.: MER 24-col.

MERATE

Villa Villani-Novati (Villa
Belgioioso): Garden
Ext.: ARC 152
Plan: ARC 156-eng., ARC 116

MESSINA

M. P. S. Offices, 1958
Samona, Giuseppe
Ext.: GRE fig. 54

S. Francesco, founded 1254
Int.: WHI pl. 5

S. Maria della Scala, ca. 1450
Ext.: HEW pl. 127

Somaschi Church, 1660-1662
Guarino Guarini
Plan: NOB 219
Sect.: NOB 219

MESTRE

Garage Marcon, 1907
Torres, Giuseppe
Ext.: ETL 46

Hospital, 1984
Aymonino, Carlo; Calcagni,
Luigi; Mar, Giampaolo;
Tamaro, Gigetta
Ext.: TAF fig. 159-drg.

METAPONTUM

Temple of Hera (Tavoline
Paladine), 6th-5th c. B. C.
Ext.: LLO 259

MILAN (MILANO)

Alfa-Romeo Works: Storage,
1937
Baroni, Giorgio
Ext.: JOE 21

Alfa-Romeo Works: Technical
Offices, Arese, 1968-1972
Gardella, Ignazio; Castelli,
Anna; Gardella, Jacopo
Ext.: TAF fig. 85

Apartment Building, 1931-1932
Muzio, Giovanni
Ext.: ETL 347

Apartment Building,
Via Foppa, 1933-1934
Portaluppi, Piero
Ext.: ETL 370

Apartment Building,
Via Longhi, 1933-1934
Minali, Alessandro
Ext.: ETL 365

Apartment House, 1952
Valori, Michele; Sgrelli, Egio;
Donatelli, R.
Ext.: GRE fig. 57

Apartment House, Piazza
Piemonte, 1927-1928
Borgato, Mario
Ext.: ETL 331

Apartment House, Via Moscova,
1923
Muzio, Giovanni
Ext.: GRE fig. 2

Apartment House,
Via Serbelloni, 1924-1930
Andreani, Aldo
Ext.: DOO fig. 22

Apartments, Via Gioberti,
ca. 1906
Stacchini, Ulisse
Ext.: MEE fig. 256

Arco del Sempione, 1806-1838
Cagnola, Luigi
Ext.: MEE fig. 42

Arena: Triumphal Gate,
1806-1813

Amadeo, Giovanni Antonio;
Dolcebuono, Giovanni
Giacomo; Francesco del
Giorgio
Ext.: HEW pl. 96

Cathedral, 1806-1813
Amati, Carlo;
Zanoia, Giuseppe
Ext.: MEE fig. 38

Cathedral, 1886
Beltrami, Luca
Ext.: MEE fig. 117

Cathedral, 1887
Marcucci, Emilio
Ext.: MEE fig. 118

Cathedral, 1888
Brentano, Giuseppe
Ext.: MEE fig. 116

Catholic University of the
Sacred Heart, 1929
Muzio, Giovanni
Ext.: DOO fig. 20

Catholic University of the
Sacred Heart: Men's
Dormitory, 1934
Muzio, Giovanni
Ext.: DOO fig. 81-82

Central Station, 1912,
1925-1931
Stacchino, Ulisse
Ext.: MEE fig. 262-drg.,
PEH 14.21

Chase Manhattan Bank
Building, 1969
B. B. P. R. Architectural
Studio
Ext.: COT-1 78, COT-2 81,
KLO 87-col., KLO 88

Chiesa della Madonna dei
Poveri, 1952-1954
Figini, Luigi; Pollini, Gino
Int.: COT-1 249, TAF fig. 61

Chiesa di S. Enrico, Metanopoli,
1963-1966
Gardella, Ignazio
Int.: TAF fig. 84

Chiesa Mater Misericordiae,
1956-1958
Mangiarotti & Morassutti
Int.: DEW 228

Cimitero Monumentale,
1863-1866
Maciachini, Carlo
Ext.: MEE fig. 126

Cimitero Monumentale:
Chapel, 1863-1866
Maciachini, Carlo
Ext.: MEE fig. 125

City Planning, 1934
Plan: BET 779

City Planning (Master Plan),
1945
Italian CIAM Group; Albini,
Franco; Bottoni, Piero;
Cerutti, Ezio; Gardella,
Ignazio; Mucchi, Gabriele;
Palanti, Giancarlo; Pucci,
Mario; Putelli, Aldo
Plan: TAF fig. 3

Civic Center, Pieve Emanuele,
1968-1982
Canella, Guido; Achilli,
Michele; Brigidini,
Daniele; Fiorese, Giorgio
Ext.: TAF fig. 126

Clinica Colombo, 1909
Sommaruga, Giuseppe
Ext.: DEW 226

Collini House, Via Statuto, 1919
Greppi, Giovanni
Ext.: GRE fig. 4

Corso Venezia Building,
1926-1930
Portaluppi, Piero
Ext.: DOO fig. 17

Diano Marina Exhibition Building
Muzio, Giovanni
Ext.: ETL 182

Domus Carola, Via de Togni,
1933
Ponti, Gio; Lancia, Emilio
Ext.: ETL 353

Ext.: TAF fig. 127

I. N. A. Casa Quarter, Cesate,
1950 & later
Albini, Franco; Albricci,
Gianni; B. P. R.;
Gardella, Ignazio
Ext.: TAF fig. 27

Immobiliare Cagisa Office
Building, 1958-1969
B. P. R
Ext.: TAF fig. 87

Istituto Marchiondi (Boarding
School), 1953-1959
Viganò, Vittoriano
Ext.: DEW 227

Italian Aeronautics Exhibition:
Sala delle Medaglie d'Oro,
1934
Nizzoli, Marcello;
Persico, Edoardo
Int.: COT 625, DOO fig. 77,
GRE fig. 11

L'Abeille Society Building,
Via Leopardi, 1959-1960
Magistretti, Ludovico;
Veneziani, Guido
Ext.: TAF fig. 57

Magazzino Contratti, 1903
Broggi, Luigi
Ext.: MEE fig. 241

Marchiondi Spogliardi
Institute, 1952-1957
Viganò, Vittoriano
Ext.: TAF fig. 58, JOE 132
Int.: GRE fig. 68

Milan Fair: Breda Pavilion,
1953-1954
Baldessari, Luciano;
Grisotti, Marcello
Ext.: SMI 200, TAF fig. 35-36

Mixed-Use Building, 1926
Portaluppi, Piero
Ext.: ETL 209

Montecatini Office Building,
1939
Fornaroli, Antonio;
Ponti, Gio; Soncine, Eugenio

Ext.: GRE fig. 24

Monument to the Victims of
Concentration Camps
(Cimitero Monumentale),
1946
B. P. R.
Ext.: DAL 39, TAF fig. 2,
GRE fig. 29

Museo Civico di Storia
Naturale, 1892 & later
Ceruti, Giovanni
Ext.: MEE fig. 141

Office & Residential Building,
Corso Monforte, 1965
Caccia-Dominioni, Luigi
Ext.: TAF fig. 62

Office & Residential Complex,
Corso Italia, 1952-1956
Moretti, Luigi
Ext.: TAF fig. 19

Office Building, Meda Square
B. B. P. R.
Ext.: DAL 42-col.

Office Building, Via Manzoni,
1919
Carminati, Antonio
Ext.: ETL 331

Office Tower Building, 1952
Castiglione, Achille
Ext.: DAL 55

Orphanage & Convent, 1955
Caccia-Dominioni, Luigi
Ext.: GRE fig. 41

Ospedale Maggiore (Albergo de
Poveri), ca. 1460 & later
Filarete, Antonio
Ext.: BUR 199-drg., DEQ
164, EWA-12 pl. 3, FLE
819, HEW 99, MUR 120-
drg., PEH 9.11, WOR
264-col.
Plan: EWA-12 fig. 14, FLE
819, HEW 99, MUR 120-
drg.

Ospedale Maggiore: Cortile,
ca. 1460 & later
Filarete, Antonio

Ext.: DEQ 165

Palazzino Comi, 1906
Sommaruga, Giuseppe
Ext.: MEE fig. 252

Palazzo Arcivescovile:
Canonica, 1564
Tibaldi, Pellegrino
Int.: HEW pl. 322

Palazzo Berri-Meregalli,
1911-1914
Arata, Giulio Ulisse
Ext.: DOO fig. 15, ETL 42-43

Palazzo Besana in Piazza
Belgioioso, ca. 1815
Piuri, Giovanni Battista
Ext.: MEE fig. 60

Palazzo Castiglioni, 1901-1903
Sommaruga, Giuseppe
Ext.: ETL 42, MAE-4 103,
MEE fig. 249, RUS pl. 8.19
Plan: MEE fig. 250

Palazzo del Arte, 1932-1933
Muzio, Giovanni
Ext.: ETL 338-339
Plan: ETL 342
Sect.: ETL 342
Site Plan: ETL 339

Palazzo del Senato (Collegio
Elvetico), 1608-1627
Mangone, Fabio;
Ricchino, Francesco Maria
Ext.: NOB 246,
WIA pls. 37, 38

Palazzo Fidia, 1924-1930
Andreani, Aldo
Ext.: DEW 224, DOO fig. 23,
ETL 199, 200, GRE fig. 8

Palazzo Litta
Bolli, Bartolomeo
Ext.: VAR 248

Palazzo Marino (Municipale),
1558-1560
Alessi, Galeazzo
Ext.: BUR 161, DEF 200,
EWA-12 pl. 91, FLE 844,
HEW pl. 310, MUR 247
Plan: HEW 290

Palazzo Marino, 1890
Beltrami, Luca
Ext.: MEE fig. 180

Palazzo Reale, 1769-1778
Piermarini, Giuseppe
Ext.: MEE fig. 3-4

Palazzo Reale, 1772-1775
Albertolli, Giocondo
Int.: MEE fig. 19

Palazzo Rocca Saporiti, 1812
Perego, Giovanni
Ext.: MEE fig. 59

Palazzo Servelloni, 1794
Cantoni, Simone
Ext.: MEE fig. 20

Palazzo SIVEM, 1933-1934
Lancia, Emilio; Poni, Gio
Ext.: ETL 356-357

Piazza Duse Office Building,
1933-1935
Zanini, Gigiotti
Ext.: DOO fig. 21

Piazza Fontana, 1944-1946
De Finetti, Gisueppe
Ext.: TAF fig. 5-drg
Site Plan: TAF fig. 5

Pirelli Building (Torre Pirelli),
1955-1960
Nervi, Pier Luigi; Ponti, Gio;
Fornaroli, Antonio; Rosselli,
Alberto; Danusso, Arturo
Ext.: COP 191, COT 635, DAL
138-139-col., DEW 226,
TAF fig. 65, EWA-13 pl.
258, FLE 1270, GRE fig. 67,
PEH 13.34, RAE 292, SHA
227
Plan: SHA 227

Porta Comasina (Porta
Garibaldi), 1826
Moraglia, Giacomo
Ext.: MEE fig. 36

Porta Nuova, 1810-1813
Zanoia, Giuseppe
Ext.: MEE fig. 34

Porta Ticinese, 1801-1814

MODENA

Cathedral, 1099 & later
 Ext.: CON 312, EWA-1 pl.
 395, EWA-12 pl. 219
 Int.: CON 313, EWA-1 pl. 388
 Plan: CON 314

Cemetery: Project, 1971
 Rossi, Aldo; Brahieri, Gianni
 Ext.: TAF fig. 129

MODICA

S. Giorgio, 1750s
 Gagliari, Rosario;
 Sinatra, Vincenzo
 Ext.: MER 172-col., NOR 315

MOLFETTA

Cathedral, 1162 & later
 Ext.: CON 269, MER 127-128

MONDOVI

Boarding School of Bishop,
 1966-1969
 Gabetti, Roberto; Isola, Aimaro
 Ext.: DAL 81-col.

Santuario di Vicoforte,
 1728-1733
 Plantery, Gian Giacomo
 Int.: NOR 304

MONREALE

S. Maria La Nuova (Cathedral),
 1174-1182
 Ext.: CON 276, FLE 477, 481,
 MER 177-col.
 Int.: CON 277, 278, FLE 481,
 HAT pl. 30

MONTAGNANA

Towers, 12th c.
 Ext.: MER 94-col.

Villa Pisani
 Palladio, Andrea
 Ext.: DEF 154

Walls, 12th c.
 Ext.: MER 94-col., WHI pl. 81

MONTECCHIO

Ville Cerato
 Palladio, Andrea
 Ext.: DEF 152

MONTEFIASCONE

Fortress, ca. 1363
 Int.: EWA-13 pl. 227

MONTENARS

Church of Empress S. Elena,
 1983-1986
 Burelli, Augusto Romano
 Ext.: DAL 47-col.

MONTEPULCIANO

Palazzo Pubblico, la. 14th c.
 Ext.: FLE 745

Palazzo Tarugi, ca. 1530
 Sangallo, Antonio da,
 the Elder
 Ext.: EWA-12 pl. 390,
 LOW pl. 86

S. Agostino, ca. 1430
 Michelozzo
 Ext.: DEQ 18, MUR 52

S. Biagio, 1518-1529
 Sangallo, Antonio da,
 the Elder
 Ext.: DEF 118-119, EWA-3
 pl. 390, FLE 830, MUR 155
 Int.: HAT pl. 43, HEW pl.
 188, MUR 156
 Plan: HEW 184, MUR 154

MONTERIGGIONI

Fortified Walls, 12th c.
 Ext.: BET 496, 497, OUR pls.
 116, 117

MONZA

Cemetery Project, 1912
 Sant' Elia, Antonio;
 Peternostro, Italo
 Ext.: ETL 60, MEE fig.
 260-drg., RUS pl. 8.26

International Exposition of
Decorative Arts (Biennale),
3rd: Dopolavoro, 1927
Gruppo 7
(Figini, Luigi; Pollini, Gino)
Ext.: DOO fig. 25-drg.

International Exposition of
Decorative Arts, 3rd:
Garage, 1927
Gruppo 7
(Figini, Luigi; Pollini, Gino)
Ext.: DOO fig. 26-drg.,
ETL 230-model

International Exposition of
Decorative Arts, 3rd:
Gas Works, 1927
Gruppo 7 (Terragni,
Giuseppe)
Ext.: DOO fig. 26-drg.,
ETL 231-model

International Exposition of
Decorative Arts, 3rd:
Office Building Project,
1927
Gruppo 7 (Larco, Sebastiano;
Rava, Carlo Enrico)
Ext.: DOO fig. 24-drg.

International Exposition of
Decorative Arts, 3rd:
Sion Theater
Project, 1927
Sartoris, Alberto
Ext.: DOO fig. 29-drg.

International Exposition of
Decorative Arts, 4th:
Atrium, 1930
Pizzigoni, Giuseppe
Int.: ETL 215

International Exposition of
Decorative Arts, 4th:
Casa Elettrica, 1930
Figini, Luigi; Pollini, Gino;
Frette, Guido; Libera,
Adalberto; Bottoni, Piero
Ext.: DOO fig. 32, ETL 221
Int.: DOO fig. 33
Plan: DOO fig. 34

International Exposition of

Decorative Arts, 4th:
Exposition Installation, 1930
Baldessari, Luciano
Ext.: DOO fig. 42-drg.

International Exposition of
Decorative Arts, 4th:
Gallery of Graphic Arts,
1930
Muzio, Giovanni
Int.: ETL 219

International Exposition of
Decorative Arts, 4th:
Hall of Italian Marble, 1930
Muzio, Giovanni
Int.: ETL 217

International Exposition of
Decorative Arts, 4th:
Vatican House, 1930
Lanza, Emilio; Ponti, Gio
Int.: ETL 216

Villa Reale, 1777-1780
Piermarini, Giuseppe
Ext.: MEE fig. 13

NAPLES

Albergo dei Poveri, 1751 & later
Fuga, Ferdinando
Ext.: PEH 9.27

Banca d'Italia, 1949 & later
Foschini, Arnaldo
Ext.: TAF fig. 15

Bourse, 1893 & later
Guerra, Alfonso;
Ferrar, Luigi
Ext.: MEE fig. 182

Castel Nuovo
Ext.: DEQ 195-199
Plan: DEQ 194

Cathedral, 1877-1905
Alvino, Enrico
Ext.: MEE fig. 124

Certosa di S. Martino:
Cloister, ca. 1630
Fanzago, Cosimo
Int.: VAR 263, WIA pl. 112

Church of the Spirito Santo

Int.: MEE fig. 95

S. Gennaro: Cappella del
Soccorso (Cathedral), 1497
Malvita da Como, Tommaso
Int.: HEW pl. 132

S. Giorgio Maggiore, ca. 400
Int.: KRA 160

S. Giovanni a Carbonara: Capella
Carraciolo (Carraciolo
Chapel), ca. 1515
Int.: EWA-13 pl. 139,
HEW pl. 192

S. Maria degli Angeli alle Croce
Fanzago, Cosimo
Ext.: VAR 264

S. Maria Donna Regina,
1307-1320
Int: WHI pl. 87

S. Maria Egiziaca, 1651-1717
Fanzago, Cosimo
Plan: WIA 198

S. Pietro a Maiella, ea.14th c.
Int.: WHI pl. 87

S. Restituta, ca. 360-400
Int.: KRA 161

Teatro San Carlo, 1737
Medrano, G. A.;
Caresale, Angelo
Plan: PEH 6.28

Teatro San Carlo, 1810-1844
Niccolini, Antonio
Ext.: MEE fig. 51

University of Naples: Faculty
of Technology Building,
1957
Cosenza, Luigi
Ext.: DAL 62-col.

NEMI

Temple Roof Terracotta Model,
750-100 B. C.
Ext.: BOE 55
Sect.: BOE 55

NERVESA

Follina Residence, 1978
Follina, Toni
Ext.: DAL 79-col.

NERVIANO

Factory, 1953
B. B. P. R
Ext.: SMI 164

NICHELINO

Ippica Torinese Society Center
Gabetti, Roberto; Isola, Aimaro
Ext.: DAL 81-col.

NIZZA

S. Gaetono, ca. 1745
Vittone, Bernardo Antonio
Int.: NOR 181
Plan: NOR 180

NOCERI INFERIORE

Library & Culture Center,
1969-1970
Ext.: DAL 69-col.,
69-axon. drg.

Maiorino Museum, 1981
Pagliari, Nicola
Int.: DAL 131-col.

NONANTOLA

Abbey of S. Silvestro,
ca. 1121-13th c.
Ext.: EWA-17 pl. 95

NORBA (NORMA)

Walls & Gate, 4th c. B. C.
Ext.: BOE 116, BRO pl. 11

NOTO

Monastery of Santissimo
Salvatore
Ext.: MER 173-col.

S. Chiara
Gagliardi, Rosario
Ext.: VAR 188

S. Francesco
 Ext.: MER 173-col.

S. Gaudenzio
 Tibaldi, Pellegrino
 Int.: DEF 205

NOVARA

Cathedral, 1854-1869
 Antonelli, Alessandro
 Ext.: MEE fig. 103

Office Building, 1959-1960
 Gregotti, Vittorio;
 Meneghetti, Ludovico;
 Stoppino, Giotto
 Ext.: TAF fig. 50

S. Gaudenzio, 1841-1888
 Antonelli, Alessandro
 Ext.: MEE fig. 102

ORBETELLO

Hangar, 1939-1940
 Nervi, Pier Luigi
 Ext.: ENA-3 557-drg., EWA-1
 pl.415, FLE 1269, PEV 692,
 RAE 255
 Int.: GRE 37

ORVIETO

Belvedere Temple, 5th c. B. C.
 Plan: BOE 45, EWA-5 fig. 129

Cathedral, ca. 1310 & later
 Maitani, Lorenzo;
 Arnolfo di Cambio
 Ext.: MIM 286, WHI pl. 8
 Int.: FLE 733, 750, WHI pl. 8

Crocefisso del Tufo, 6th c. B. C.
 Ext.: BOE 70

Palazzo del Capitano, ca. 1250
 Ext.: WHI pl. 11

S. Domenico: Petrucci Chapel,
 ca. 1516
 Sannicheli, Michele
 Plan: HEW 223

OSOPPO

Fantoni Office Building,

1972-1978
 Valle, Gino
 Ext.: DAL 190-191-col.

OSTIA

Apartment Blocks,
 2nd-3rd c. B. C.
 Ext.: BRO pls. 78-80,
 WOR 167-model
 Plan: BRO pl. 77

Bath Buildings, ca. 1st-2nd c.
 Ext.: WAP 185, 192
 Plan: WAR fig. 80

City Planning, 4th c. B. C.
 Plan: BOE 127, MAC pl. 44,
 WAP pls. 198, 205,
 WAR fig. 72-73

City Planning, ca. 125
 Plan: MAA 254

Fire Brigade Headquarters
 (Barracks of the Vigiles),
 117-138
 Plan: WAP 179, WAR fig. 77

Fountain
 Ext.: MAC pl. 98

Fortress, 1483-1486
 Pontelli, Baccio
 Ext.: MAE-3 447

Granaries (Horrea of
 Hortensius), ca. 30-40
 Plan: WAR fig. 75

Harbor, 1st-2nd c.
 Plan: MIM 120

House of Cupid & Psyche,
 ca. 300
 Ext.: WAP 177
 Plan: WAP 177, WAR fig. 128

House of Diana, 2nd c.
 Ext.: HAT pl. 15, MIM 112,
 RAE 72-col., ROB 308, SAR
 22-drg. (courtyard), WAP
 182, 183, 191, WAR fig. 76
 Plan: WAR fig. 128

House of the Charioteers,
 ca. 1st-2nd c.
 Ext.: WAP 184, 186-189,

WAR fig. 82

House of the Fortuna
 Annonaria, la. 2nd c.
 Ext.: WAP 178
 Plan: WAP 179, WAR fig. 128

House of the Lararium, ca. 125
 Ext.: WAR fig. 83
 Plan: MAC pl. 150

House of the Triple Windows,
 ca. 175
 Ext.: WAR fig. 85

Houses, ca. 1st-2nd c.
 Ext.: SAR 22

Insula of the Muses, ca. 130
 Ext.: MAC 209

Piazzale of the Corporations,
 ca. 12 B. C.
 Plan: WAR fig. 74

Porta Marina Area, 1st c.
 Plan: MAC 264

Public Lavatory, Via della Forica
 Ext.: TRA 119

Theater, ca. 10
 Ext.: FLE 304
 Plan: WAR fig. 74.

Via della Fontana
 Ext.: MAC pl. 28

OSTIA LIDO

Apartment Buildings,
 1933-1934
 Libera, Adalberto
 Ext.: ETL 298

PADUA (PADOVA)

Banca d'Italia Headquarters,
 1968-1974
 Samonà, Giuseppe;
 Samonà, Alberto
 Ext.: COT-1 706, DAL
 170-col., TAF fig. 107
 Int.: DAL 170-col.

Botanical Garden (Giardino
 Botanico), 1550s
 Plan: ARC 81

Caffé Pedrocchi, 1816-1831
 Jappelli, Giuseppe
 Ext.: MAE-2 478,
 MEE fig. 52-54

Cimitero Monumentale,
 1890-1896
 Holzner, Enrico;
 Britto, Giovanni
 Ext.: MEE fig. 127

Cinema Altino, 1951
 De Giorgio, Quirino
 Ext.: SMI 129

Cinema Arlecchino, 1948
 Menghi, Roberto
 Ext.: SMI 129

Loggia Cornaro, 1524
 Falconetto, Giovanni Maria
 Ext.: HEW pls., 212, 219,
 MUR 258
 Plan: HEW 212, MUR 258

Meat Market, 1821
 Japelli, Giuseppe
 Ext.: MEE fig. 75

Municipal Museum, 1879
 Boito, Camillo
 Ext.: MEE fig. 122

Palazzo delle Debite, 1872
 Boito, Camillo
 Ext.: MEE fig. 121

Palazzo delle Ragione, ca. 1306
 Ext.: WHI pl. 86

Porta S. Giovanni, 1528
 Falconetto, Giovanni Maria
 Ext.: HEW 221

S. Antonio, ca. 1232-1307
 Ext.: CON 298, EWA-8 pl.
 174, FLE 740, WHI pl. 6
 Int.: CON 299, FLE 740

S. Giustina, 1532
 Moroni, Andrea;
 Valle, Andrea della
 Ext.: LOW pl. 65
 Int.: EWA-12 pl. 50,
 HEW pl. 344
 Plan: BUR 115, HEW 317

Warehouse, 1958

Carnelivari, Matteo
Int.: DEQ 212-214, 218

Teatro Massimo, 1875-1897
Basile, Giovanni Battista
Ext.: MEE fig. 230
Plan: MEE fig. 231

University of Palermo: New
Science Department
Building, 1969-1985
Gregotti, Vittorio
Ext.: DAL 95-col.
Int.: DAL 95-col.

Villa Belmonte, 1801 & later
Marvuglia, Giuseppe
Venanzio
Ext.: MEE fig. 31

Villa della Favorita: Fountain
of Hercules, ca. 1814
Marvuglia, Giuseppe Venanzio
Ext.: MEE fig. 30

Villa della Favorita:
Palazzina Cinese, 1799-1802
Patricola, Giuseppe
Ext.: MEE fig. 29

Villa Giulia: Gardens, 1790s
Dufourney, Léon
Ext.: ARC 349-col
Plan: ARC 348-eng.

Villa Igiea, 1901
Basile, Ernesto
Int.: MEE fig. 254

Villino Basile, 1903
Basile, Ernesto
Ext.: ETL 45

Villino Florio, 1899-1903
Basile, Ernesto
Ext.: RUS pl. 8.27
Plan: RUS pl. 8.28

Zen Quarter: Project, 1969
Gregotti, Vittorio; Amoroso,
Francesco; Bisogni,
Salvatore; Matsui,
Hiromichi; Purini, Franco
Site Plan: TAF fig. 120

PALMANOVA

City Planning (Aerial View)
1593-1623
Ext.: KOH 19-col.

PALESTRINA (PRAENESTE)

Basilica, ca. 80 B. C.
Ext.: BOE 171, 172

Sanctuary of Fortuna Primigenia:
Temple, ca. 2nd c. B. C.
Ext.: BRO pls. 18, 19,
EWA-7 pl.199, MAA pl. 7,
8-model, TRA 135,
WAP 44-47

Sanctuary of Fortuna Primigenia:
Temple, ca. 80 B. C.
Ext.: BOE 169, BRO pl. 20
Plan: BOE 168
Sect.: BOE 172

PARABITA

Cemetery, 1967-1982
Anselmi, Alessandro
Ext.: DAL 30-col.
Site Plan: DAL 30-col.

PARMA

Baptistery, 1196-1270
Antelami, Benedetto
Ext.: FLE 478, MAE-1 83
Int.: FLE 478

I. N. A. Office Building,
1950-1953
Albini, Franco
Ext.: GRE fig. 42, TAF fig. 23

Madonna della Steccata, 1521
Zaccagni, G. F
Ext.: HEW pl. 215
Int.: HEW pl. 216
Plan: HEW 207

S. Croce, 1887
Iorio da Erba
Ext.: MEE fig. 133

S. Croce, 1887
Bartoli, Enrico
Ext.: MEE fig. 134

Teatro Farnese (Farnese
Theater), 1618-1628
Alcotti, Giovanni Battista
Int.: BEA 678, FLE 811,
PEH 6.12
Plan: BEA 678

PAULLO

Laboratory Project, 1969
Grassi, Giorgio
Ext.: 265-col. drg.

PAVIA

Castello Visconteo,
ca. 1360-1365
Ext.: WHI pl. 157

Cathedral, 1488
Bramante, Donato
Ext.: BEA 252
Int.: HEW pl. 106, MUR 128
Plan: BEA 252, BUR 114,
HEW 107

Cathedral Model, 1490
Rocchi, Cristoforo
Ext.: HEW pl. 105, MUR 129

Certosa di Pavia, 1429-1473
Solari, Govanni;
Solari, Guiniforte;
Amadeo, Giovanni
Ext.: DEF 140-141, FLE 751,
805, HAT pl. 42, HEW pl.
98, MUR 126, RAE 144-col.,
TRA pl. 40-col
Int.: FLE 751, HEW pl. 97,
MUR 126, 127
Plan: FLE 751, HEW 98

Collegio Borromeo, 1564
Tibaldi, Pellegrino
Ext.: MUR 250
Int.: HEW pl. 323, MUR 250

Ponte Coperto, 14th c.
Ext.: MER 48-col.

S. Maria del Carmine, ca. 1370
Ext.: WHI pl. 161
Int.: WHI pl. 161

S. Michele, ca. 1100-1160
Ext.: CON 307, FLE 475

Int.: FLE 475
Plan: FLE 475
Sect.: FLE 475

University of Pavia:
Great Hall, ca. 1845-1850
Marchese, Giuseppe
Ext.: MEE fig. 100

University of Pavia: Laboratories
& Scientific Department
Building, 1974-1976
De Carlo, Giancarlo
Ext.: DAL 67

PERUGIA

Palazzo dei Priori, 1293-1297
Giacomo di Servadio;
Giovanello di Benvenuto
Ext.: WHI pl. 15

Porta Augusta, 2nd c. B. C.
Ext.: MIM 87

Porta Marzia, ca. 4th c. B. C.
Ext.: WAP 31

Porta Romana, ca. 4th c. B. C.
Ext.: WAP 31

S. Bernardino, 1461-1466
Duccio, Agostino di
Ext.: HEW pl. 38

Tomb of the Volumnii,
2nd c. B. C.
Int.: BOE 92, EWA-4 pl. 454
Plan: BOE 80
Sect.: BOE 80

PESARO

Marconi School of Science,
1970
Aymonino, Carlo
Ext.: COT 54

Palazzo Ducale, ca. 1472
Genga, Girolamo;
Genga, Bartolomeo
Ext.: MUR 89

Villa Imperiale
Genga, Girolamo
Ext.: DEF 148
Plan: BUR 178

Sect.: BUR 179
Elev.: BUR 179

Villa Ruggeri, 1902-1907
Brega, Giuseppe
Ext.: RUS 202, pl. 8.31

PESCIA

Covered Market, 1951
Brizzi, Gori, Gori, Ricci,
& Savioli
Ext.: SMI 218

S. Francesco: Capella Cardini,
1451
Int.: HEW pl. 28

PETRAIA

Villa Medicea
Buontalenti, Bernardo
Ext.: DEF 193

PIACENZA

Madonna di Campagna, 1522
Tramello, Alessio
Ext.: HEW pl. 217
Int.: HEW pl. 218
Plan: HEW 210

Palazzo Comunale, begun 1280
Ext.: WHI pl. 13

PIAZZA ARMERINA

Villa of Maximian, ea. 4th c.
Ext.: MAC 276-model,
WAR 312-axon.
Plan: BAK 144, FLE 336,
MAC 275

PIENZA

Cathedral, ca. 1460
Rossellino, Bernardo
Ext.: DEQ 101, LOW pl. 29,
MER 117-col., MUR 74, 75
Int.: HEW pl. 36,
MUR 76, 77
Plan: BUR 135

City Planning, 15th c.
Ext.: BET 537, 539
Plan: BET 537, 538, BUR 171

Palazzo Comunale, 1460s
Rossellino, Bernardo
Ext.: DEQ 104

Palazzo Piccolomini, ca. 1461
Rossellino, Bernardo
Ext.: DEQ 106-107, FLE 807,
MUR 70, 71
Int.: MUR 72
Plan: MUR 70

Palazzo Piccolomini: Cortile,
ca. 1461
Rossellino, Bernardo
Ext.: DEQ 107

Palazzo Vescovile, ca. 1460s
Rossellino, Bernardo
Ext.: DEQ 103

Piazza Pio II, 1460-1462
Rossellino, Bernardo
Ext.: HEW pl. 35,
MER 117-col.
Plan: DEQ 100, MIM 311

PIEVE EMANUELE

Civic Center, 1971-1979
Canella, Guido
Ext.: DAL 49-col.

PIOMBINO DESE

Villa Cornaro
Palladio, Andrea
Ext.: DEF 153

PISA

Baptistery, 1153-1265
Salvi, Diotisalvi
Ext.: FLE 470, RAE 96-col.,
WOR 205-col
Plan: CON 296A, FLE 470
Sect.: CON 296A, FLE 470

Campanile, 1174-1271
Ext.: FLE 470
Plan: FLE 470
Sect.: FLE 470

Camposanto, begun 1277
Ext.: WHI pl. 10

Cathedral & Campanile,

1063-1118, 1261-1272
Ext.: BUR 16, CON 292, 294,
 ENA-1 301, FLE 469, MIM
 207, RAE 96-col, TRA pl.
 25-col., WOR 205-col.
Int.: CON 293, FLE 469,
 MIM 206
Plan: CON 295, FLE 469,
 MIM 207
Sect.: FLE 469

S. Giovanni al Gatano, 1947
Muratori, Saverio
Ext.: DAL 121

S. Maria della Spina, ca. 1323
Ext.: WHI pl. 75

PISTOIA

Cassa di Risparmio, 1964-1966
Michelucci, Giovanni
Ext.: TAF fig. 26

Ospedale del Ceppo
Ext.: BUR 163

Park at Celle
Ext.: ARC 503-505-col.

Puccini Gardens, Scornio:
 Temple of Pythagoras,
 1821-1827
Digny, Luigi de Cambray
Ext.: ARC 365-col.

S. Maria delle Grazie, ca. 1452
Michelozzo di Bartolomeo
Int.: HEW pl. 12

POGGIO A CAIANO

Villa Medicea, ca. 1480-1485
Sangallo, Giuliano da
Ext.: BAK 235, HEW pl. 138,
 LOW pl. 57, MIM 316, MUR
 108, RAE 141-col
Int.: HEW pl. 139, LOW pl. 60
Plan: BAK 235, HEW 134,
 LOW pl. 59, MIM 316, MUR
 108

Villa Medicea: Gardens
Plan: ARC 32-33

Villa Medicea: Orangery,
 ca. 1825

Poccianti, Pasquale
Plan: MEE fig. 68
Elev.: MEE fig. 68

POIANA MAGGIORE

Villa Poiana
Palladio, Andrea
Ext.: DEF 153

POMPEII

Amphitheater, ca. 80 B. C.
Ext.: BOE 204, TRA 124,
 WAP 22, 23
Int.: EWA-13 pl. 256, WAP 23

Arch, Via del Foro
Ext.: MAC pl. 74

Basilica, ca. 120 B. C.
Ext.: BOE 152, RAE 72-col.
Plan: EWA-7 fig. 396,
 PEV 26, ROB 268

Baths, 63-79
Ext: WAR fig. 92
Plan: WAR fig. 93

City Planning: North, East
 Quarters, 520-450 B. C.
Plan: BOE 73, EWA-1 fig.
 708

Forum, ca. 80
Ext.: BET 183, WAP 24, 25
Plan: BET 182, WAP 25,
 WAR fig. 88

Forum Baths, ca. 80 B. C.
Ext.: BOE 142, EWA-8 pl. 96
Int.: BRO pl. 33, WAP 122
Plan: BOE 196

House of Lucretius Fronto,
 ca. 2nd-1st c. B. C.
Int.: WAP 48, 49

House of Menander, 2nd c. B. C.
Ext.: BRO pl. 21
Int.: BET 188, BRO pl. 22,
 WAP 58
Plan: BRO pl. 21

House of Sallust, 2nd c. B. C.
Plan: HAT 154, WAP 60

House of the Faun,

ca. 2nd c. B. C.
Int.: BAK 105, EWA-7 pl. 200
Plan: BOE 91, EWA-7 fig.
402, ROB 306, WAP 59

House of the Pansa, 2nd c. B. C.
Plan: BAK 105, FLE 332
Sect.: FLE 332

House of the Silver Wedding,
2nd c. B. C.
Int.: BRO pl. 24, EWA-13
pl. 247, HAT pl. 13
Plan: BET 186

House of the Surgeon,
4th-3rd c. B. C.
Ext.: BOE 184
Int.: BRO pl. 7
Plan: BAK 104, BET 186,
BOE 88, ROB 303, WAP 59

House of the Vettii, ca. 50
Ext.: BRO pl. 23, FLE 332,
HAT pl. 13, WAP 57, 61
Int.: MIM 110
Plan: BET 186, FLE 332

Stabian Baths, 1st c. B. C.
Ext.: WAP 122, 123
Plan: BRO pl. 32, WAP 121
Sect.: BRO pl. 32

Strada dei Teatri,
ca. 750-100 B. C.
Ext.: BOE 107

Temple of Apollo, 1st c. B. C.
Ext.: BRO pl. 15,
EWA-13 pl. 240
Plan: ROB 206

Tetrakionion Tomb, before 79
Ext.: MAC pl. 89

Theater (Large Theater),
2nd c. B. C.
Plan: BOE 199, ENA-3 55,
WAP 22

Theater (Small Theater),
1st c. B. C.
Plan: EWA-13 fig. 591, ROB
273, WAP 22

Triangular Forum, 79
Ext.: BET 181

Plan: BET 180

Villa of the Mysteries (Villa
Item), 2nd c. B. C.
Ext.: BOE 191, BRO pl. 26,
WAP 61
Plan: BRO pl. 25, WAP 60

POMPOSA

S. Maria, 1063
Ext.: CON 301

PONTECASALE

Villa Garzone, mid. 16th c.
Sansovino, Jacopo
Ext.: DEF 114-115,
MUR 278, 279
Plan: MUR 278

POPOLI

U. N. R. R. A.-Casas
Development, 1950
Ridofli, Mario;
Frankl, Wolfgang
Plan: TAF fig. 7
Elev.: TAF fig. 7

PORDENONE

Primary School, 1984
Raffin, Giorgio; Beltrame, Piero
Ext.: DAL 153

Zanussi Factory Offices,
1959-1961
Valle, Gino
Ext.: COT-1 836, DAL
188-col., TAF fig. 63,
SHA 246
Sect.: DAL 188, SHA 246

PORTA AGUILA

Castello Buon Consiglio, 1921
Wenter-Marini, Giorgio
Ext.: ELT 118-drg.

PORTONOVO

S. Maria, 12th c.
Int.: OUR pls. 112-115
Plan: OUR 101, 102

Sect.: OUR 101, 102

POSSAGNO

Possagno Plaster-Cast Gallery,
1955-1959
Scarpa, Carlo
Int.: DAL 174-col.

Tempio Canova, 1819-1833
Selva, Giovanni Antonio
Ext.: MEE fig. 97

POZZUOLI (PUTEOLI)

Amphitheater, 1st c.
Int.: MAA pl. 135,
WAP 232, 233
Plan: BRO pl. 47

Market, 2nd c.
Plan: WAR fig. 96

Olivetti Plant, 1951 & later
Cosenza, Luigi
Ext.: GRE fig. 63, TAF fig. 34

Tomb, Via Celle, 2nd c.
Ext.: WAR fig. 99-axon.

PRATO

Goti Factory
Ricci, Leonardo
Ext.: DAL 154

S. Maria delle Carceri,
1485-1492
Sangallo, Giuliano da
Ext.: BEA 226, DEQ 66,
EWA-12 pl. 388, FLE 794,
LOW pl. 54, MAE-3 644,
MIM 317, MUR 114, 115
Int.: DEQ 67, HEW pl. 140,
LOW pl. 55, MIM 318,
MUR 116
Plan: BEA 226, MIM 318,
MUR 114

PROVAGLIO D' ISEO

Residential Complex, 1984
Puglielli, Emilio
Ext.: DAL 145-col.

PUNTA SAN VIGILIO

Villa Brenzone: Rotunda of the
Ancients
Ext.: ARC 108

PUTEOLI. *See* POZZUOLI

PUTIGNANO

Junior High School, 1983
Carmassi, Massimo
Ext.: DAL 54-col.

RACCONIGI

Palazzo Reale, 1834-1839
Palagi, Pelagio
Ext.: MEE fig. 105

RAGUSA IBLA

S. Giorgio, 1746-1766
Gagliardi, Rosario
Ext.: NOR 313, VAR 291

RANDAZZO

S. Maria: Portale
Ext.: DEQ 160

RAVENNA

Baptistery of the Orthodox,
400-450
Ext.: KRA 141, MAN fig.
140, MIM 133, WAP 152
Int.: KRA 142, MAD 35,
MAN fig. 141, MIM 132,
PEV 31, TRA 166
Plan: MAD 36, MIM 132

Mausoleum of Galla Placidia,
ca. 425
Ext.: CON 61, EWA-2 pl. 425,
FLE 365, 368, KRA 145,
MAD 34, MAN fig. 139, MIM
129, PEV 33, TRA pl. 14-col
Int.: FLE 368, KRA 146
Plan: FLE 368
Sect.: FLE 368

Mausoleum of Theodoric,
ca. 526
Ext.: EWA-4 pl. 457, KRA

234, TRA 167, WAP 99
Plan: EWA-13 fig. 619,
 FLE 368

Palace of the Exarchs,
 ca. 712-752
 Ext.: CON 63

S. Apollinare in Classe,
 ca. 543-539
 Ext.: EWA-2 pl. 430, FLE
 348, 356, KRA 240, MAD
 65, MIM 130
 Int.: BAK pl. 7-col., FLE 348,
 356, KRA 239, MAN fig. 148,
 MIM 131, PEV 25, TRA 166
 Plan: BET 232, EWA-9 fig.
 87, FLE 356, MIM 131
 Sect.: FLE 356

S. Apollinare Nuovo, 493-520
 Int.: ENA-1 229, ENA-3 61,
 KRA 149, MAN fig. 142,
 MIM 130, PEV 23
 Plan: PEV 22

S. Croce, ca. 425
 Ext.: KRA 145

S. Francesco, 560
 Int.: FLE 363

S. Giovanni Evangelista, 424-434
 Ext.: KRA 147
 Int.: KRA 148
 Plan: EWA-9 fig. 86

S. Vitale, 526-547
 Ext.: CON 62, ENA-3 631,
 EWA-1 pl. 384, KRA 192,
 MAD 40, 41, MAN fig. 144,
 MIM 62, PEV 34, TRA 176
 Int.: BRO pl. 99, HAT pl. 25,
 KRA 187-191, MAD 42, 43,
 MAN fig. 145-147, MER
 75-col., MIM 134, PEV 35,
 36, RAE 85-col., TRA 176,
 WAP 323
 Plan: BRO pl. 98, FLE 382,
 MAD 39, MAN fig. 143,
 MIM 135, PEV 34, TRA
 176, WAP 322
 Sect.: FLE 382, MIM 135

Savings Bank Tax Collection
 Office, 1962-1965

Quaroni, Ludovico
 Ext.: DAL 151-col.
 Int.: DAL 151-col.

REGGIO EMILIA

Parmesan Cheese Cooperative
 Headquarters, 1983
 Canali, Guido
 Ext.: DAL 48

Town Hall, 18th c.
 Ext.: MER 68-col.

RIMINI (ARIMINUM)

Arch of Augustus, 27 B. C.
 Ext.: MAC pl. 80,
 WAP 216, 217

Bridge of Augustus, 14-20
 Ext.: FLE 342, WAR fig. 107

S. Francesco (Tempio
 Malatestiano, Malatesta
 Temple), ca. 1446
 Alberti, Leone Battista
 Ext.: BEA 108, DEQ 72,89,
 EWA-1 pls. 51, 52, FLE
 807, HAT pl. 43, HEW pl.
 19, LOW pl. 27, MAE-1 52,
 MIM 310, MUR 59-61, PEV
 301-303
 Int.: DEQ 86,
 Plan: BEA 108, ENA-1 151,
 EWA-1 fig. 94, EWA-12 fig.
 11, HEW 31

RIVA SAN VITALE

Baptistery, ca. 500
 Ext.: KRA 140
 Plan: KRA 139
 Sect.: KRA 139

House, 1972-1973
 Botta, Mario
 Ext.: KLO 272-drg.

**RIVAROLA CANAVESE
(RIVAROLO)**

S. Michele, 1759
 Vittone, Bernardo Antonio
 Ext.: MIL pl. 46

Int.: WIT 216 (dome)
Plan: MIL pl. 47A

RIVEO

Villa Sartori, 1975-1977
Reichlin, Bruno;
Reinhart, Fabio
Ext.: KLO 284

RIVOLTA D' ADDA

S. Sigismondo, 1099
Int.: CON 306

ROCCA DI MONDAVIO

Rocca di Mondavio,
1479 & later
Ext.: DEQ 70, 83-84

ROCCA DI SAN LEO

Rocca di S. Leo, 1479 & later
Ext.: DEQ 70, 83-84,
HEW pl. 73

ROCCA DI SASSOCORVARO

Rocca di Sassocorvaro,
1479 & later
Ext.: DEQ 70, 83-84

ROME (ROMA)

A. G. I. P. Motel: Project, 1968
Ridolfi, Mario;
Frankl, Wolfgang;
Malagricci, Domenico
Ext.: TAF fig. 88-89-drg.

Acqua Claudia, 38
Ext.: FLE 340, WAP pl. 117

Acqua Paola, 1610-1614
Ponzio, Flaminio;
Fontana, Giovanni
Ext.: EWA-8 pl. pl. 207,
NOB 28, WIA pl. 6

Aerhotel, 1978
Studio Passarelli
Ext.: DAL 132-col.

All Saints, 1880-1937
Street, George Edmund

Ext.: MEE fig. 152-154

Apartment Blocks, 2nd-3rd c.
Plan: BRO pl. 76

Apartment Building, 1926-1929
Capponi, Giuseppe
Ext.: ETL 274

Apartment Building,
Via Villa Massima, 1934
Ridolfi, Mario;
Frankl, Wolfgang
Ext.: DOO fig. 80

Apartment House,
Via Liegi, 1922
Piacentini, Marcello
Ext.: ETL 137-drg.

Apartment House,
Via S. Valentino, 1936-1937
Ridolfi, Mario
Ext.: GRE fig. 16

Apartments, Via Po, 1921
Coppedè, Gino
Ext.: MEE fig. 259

Aqueduct, 1st c.
Ext.: BRO pl. 57, WAP 101

Aqueducts,
2nd c. B. C.-2nd c. A. D
Plan: SAR 31

Ara Pacis, 13-9 B. C.
Ext.: EWA-3 pl. 385,
EWA-7 pl. 261, SAR 43,
WAP 76-79
Plan: SAR 44, WAP 76

Arch of Constantine, ca. 315
Ext.: BAK 109, EWA-7 pl.
265, FLE 322, MIM 109,
SAR 43, WAP 298, WAR 291

Arch of Janus, ca. 315
Ext.: EWA-9 pl. 35,
FLE 319, SAR 43

Arch of Septimius Severus,
Forum Romanum, 203
Ext.: EWA-7 pl. 264, FLE
321, SAR 42, WAP 29, 295,
299, WOR 161-col.

Arch of the Goldsmiths, 204

Biblioteca Nazionale: Project,
1957
Caniggia, Gianfranco; Marconi,
Paolo; Portoghesi, Paolo
Ext.: TAF fig. 51-drg.

Braccio Nuovo, 1806-1823
Stern, Raffaello
Int.: PEH 8.13

Bridge over the Tiber
at Magliana, 1967
Morandi, Riccardo
Ext.: SAR 131

Caffè Greco, 1850s
Int.: SAR 125

Campus Martius
Plan: KOH 13

Capitolium, 6th-1st c. B. C.
Plan: BRO pl. 3

Carceri Nuove, Via Giulia, 1650s
Del Grande, Antonio; others
Ext.: ELL pl. 16

Casa Baldi, 1959-1962
Portoghesi, Paolo
Ext.: KLO 209-col
Plan: KLO 209

Casa de Salvi, 1930
Aschieri, Pietro
Ext.: DOO fig. 53

Casa del Cannocchiale
(Binoculars House), 1936
Bianchini, Giovanni
Ext.: ETL 277

Casa del Girasole (Sunflower
House), Viale Buozzi,
1947-1950
Moretti, Luigi
Ext.: Dew 220, TAF fig. 20

Casa del Sole, 1929-1930
Sabbatini, Innocenzo
Ext.: ETL 273

Casa Nebbiosi, 1929-1930
Capponi, Giuseppe
Ext.: DOO fig. 49
Plan: DOO fig. 50

Casa Papanice, 1969-1970

Portoghesi, Paolo;
Gigliotti, Vittorio
Ext.: JEA 112-col.,
JEL 16, JEN 50-col
Int.: JEL 15, JEN 53-col
Plan: JEL 17, JEN 51

Casino Valadier, Piazza
del Popolo, 1816-1824
Valadier, Giuseppe
Ext.: EWA-10 fig. 520, MEE
fig. 69, SAR 125

Castel Sant'Angelo (Hadrian's
Mausoleum), ca. 135
Ext.: CHA 179, FLE 317,
SAR 49, 49-reconstruction
drg., WAP 43
Plan: FLE 317, SAR 49
Sect.: SAR 49

Castrum Praetorium, 21-23
Ext.: WAP 102
Sect.: EWA-13 fig. 441

Catacomb of S. Callisto:
Chapel of the Popes, ca. 250
Int.: KRA 4

Catacomb of S. Panfilo,
ca. 200-350
Int.: KRA 2

Cavalcavia Viaduct over the
Via Olimpica, 1960
Morandi, Riccardo
Ext.: SAR 131

Central Station, 1867 & later
Bianchi, Salvatore
Ext.: MEE fig. 164

Chamber of Deputies Office
Building: Project, 1967
Quaroni, Ludovico; Esposito,
Gabriella; Lonzi, Marta;
Quistelli, Antonio
Ext.: TAF fig. 92-drg.

Chamber of Deputies Office
Building: Project, 1967
Samonà, Alberto;
Samonà, Giuseppe
Ext.: TAF fig. 93-drg.

Chapel of the Sacrament
(Capella del Sacramento, S.

KOH 231, MIM 96, PEV 12,
RAE 69-col., ROB pl. 16B,
SAR 52, TRA 125, WAP
90-92, WAR fig. 32
Int.: FLE 306, MER 140-col,
SAR 52, WAP 92, 93
Plan: BET 164, CHA 56, FLE
308, MIM 97, ROB 284, SAR
52, TRA 125, WAR fig. 31
Sect.: SAR 53, WAR fig. 31

Colosseum Model, 1939
Ext.: BET 165

Column of Marcus Aurelius, 174
Ext.: EWA-7 pl. 264, FLE
326, SAR 44
Plan: FLE 326

Column of Trajan, Forum of
Trajan, 113
Apollodorus
Ext.: FLE 326, WAP 94, 95,
120
Plan: FLE 326

Convent of Buon Pastore, 1930
Brasini, Armando
Ext.: MAE-1 283

Convent of the Servites
Ext: ELL pl. 61

Corso Cinema Theater,
1915-1918
Piacentini, Marcello;
Wenter-Marini, Giorgio
Ext.: ETL 241
Int.: ETL 242
Sect.: ETL 242

Curia (Senate), Forum
Romanum, 6-1 B. C.
Plan: MAC pl. 130,
WAP 51, 304, 308

Danteum Project, 1938
Terragni, Giuseppe;
Lineri, Piero
Ext.: ETL 516-model
Int.: ETL 526
Plan: ETL 548
Sect.: ETL 527, 558-560

Domus Augustana (Flavian
Palace, Palace of Domitian,
Palatium), ca. 92
Rabirius
Ext.: BRO pls. 81, 83-85,
MAA pl. 55-71, SAR 38,
WAP 109-117, 148, WAR
fig. 37-axon.
Int.: WAP 110, 150
Plan: BRO pl. 82, MAA 58,
ROB 244, SAR 39, WAP 71,
108, 116, WAR fig. 36, WOR
166

Domus Aurea (Golden House of
Nero), after 64
Severus; Celer
Ext.: CHA 114
Int.: CHA 122, 123, MAA pl.
26-29, MAE-4 43, SAR 41,
WAP 105-107, WAR fig. 44
Plan: BET 145, CHA 114,
EWA-12 fig. 522, MAA pl.
24, 30, MAE-4 43, SAR 41,
TRA 151, WAR fig. 45-46
Sect.: WAR fig. 45-46.

Domus Flavia, 1st c. A. D
Ext.: MAA-1 pl. 45-49, 45-drg.
Plan: MAA pl. 44
Sect.: MAA pl. 44

Domus Flavia: Fountains, 1st c.
Ext.: SAR 40
Plan: WAR fig. 36

E. U. R. Building, 1938-1942
Ext.: GRE 36, RAE 266

Esposizione Universale:
Palazzo dei Ricevimente e
Congressi, 1942
Libera, Adalberto
Ext.: ETL 493

Esposizione Universale:
Palazzo della Civiltà, 1942
La Padula, Ernesto B.
Ext.: ETL 496

Exposition of the Fascist
Revolution: Martyr's Shrine,
1932
Libera, Adalberto;
Valente, Antonio
Ext.: ETL 414

Flaminio Stadium, 1960
 Nervi, Pier Luigi
 Ext.: SAR 130

Fontana Felice,
 Piazza S. Bernardino, 1585
 Fontana, Domenico
 Ext.: SAR 133

Fontana Paola, 1610
 Ext.: SAR 134

Forum Augustum, 10-2 B. C.
 Ext.: BRO pl. 38, WAP 75
 Int.: BRO pl. 37
 Plan: BRO pl. 37, CHA 9,
 EWA-12 fig. 511, SAR 36,
 WAP 69

Forum Holitorium
 Ext.: BOE 155, WAP 34
 Plan: BOE 156, 157

Forum Julium (Forum of
 Caesar), 1st c. B. C.
 Ext.: BRO pl. 36
 Plan: BRO pl. 35, EWA-7
 fig. 402, WAP 69

Forum of Trajan (Forum
 Traianus), ca. 113-117
 Apollodorus
 Ext.: BRO pl. 61, HAT pl.
 14, MIM 92, SAR 38,
 WAP 94-96
 Int.: BRO pl. 62
 Plan: CHA 8, MAA pl. 74,
 MAE-1 91, MIM 92, SAR
 36, WAP 69
 Sect.: RAE 71

Forum Romanum,
 ca. 6th-1st c. B. C.
 Ext.: BRO pl. 2, EWA-12 pl.
 304, SAR 34-drg., TRA pl.
 12-col., 143, WAP 28, 29, 83
 Plan: WAP 71

Forum Transitorium
 (Forum of Nerva), 1st c.
 Ext.: WAP 85
 Plan: WAP 69.

Forums, dates vary
 Ext.: SAR 10
 Plan: SAR 36, WAP 69,

WAR fig. 6, WOR 161

Forums Model, 1939
 reconstruction
 Ext.: BET 157

Fountain, Piazza del Quirinale,
 1588
 Ext.: SAR 133

Fountain, Piazza della Rotonda,
 1711
 Ext.: SAR 132

Fountain of the Four Rivers,
 1648-1651
 Bernini, Gian Lorenzo
 Ext.: EWA-2 pl. 271, NOB
 40, 41, SAR 135

Fountain of the Tortoises
 (Fontana delle Tartarughe),
 Piazza Mattei, 1584
 Landini, Taddeo
 Ext.: SAR 132

Fountain of Trevi (Fontana di
 Trevi), 1732-1736
 Salvi, Nicola
 Ext.: BAK 339, BAR 61, ELL
 pl. 136-137, EWA-2 pl. 137,
 FLE 850, MIM 422, NOR 26,
 27, SAR 136, VAR 179

Gatti Wool Factory, 1953
 Nervi, Pier Luigi
 Int.: GRE fig. 61, SMI 246

Galleria Colonna, ca. 1675
 Grande, Antonio del
 Int.: PEH 8.6

Galleria Nazionale d' Arte
 Moderna, 1911
 Bazzani, Cesare
 Ext.: MEE fig. 265

Garbatella Housing Block, 1927
 Sabbatini, Innocenzo
 Ext.: DOO fig. 36

Gesù e Maria
 Rainaldi, Carlo
 Ext.: VAR 147

Giardino del Pincio: Loggiato,
 1806-1814
 Valadier, Giuseppe

Magazzini Boccioni, ca. 1895
Giulio de Angelis
Ext.: MEE fig. 166

Manifattura dei Tabacchi,
1859-1863
Sarti, Antonio
Ext.: MEE fig. 99

Markets of Trajan,
Trajan's Forum, 2nd c.
Apollodorus
Ext.: CHA 37-40, 42, 54,
126-128, 130, 131, EWA-1
pl. 323, MAA pl. 75-
isometric drg., 82-91, MAC
267, MAE-1 92, SAR 38,
TRA 146, WAP 304, WAR fig.
39-axon., 42-43, 81
Int.: CHA 41, 43, 44, SAR 38,
MAA pl. 78, 92, 95, WAR
fig. 40
Plan: SAL-1 38, WAP pl. 142
Sect.: MAA pl. 76

Mausoleum of Augustus,
ca. 25 B. C.
Ext.: FLE 317, SAR 48,
WAP 143
Plan: EWA-13 fig. 620, SAR 48
Sect.: EWA-13 fig. 620
Elev.: SAR 48-drg.

Mausoleum of Helena
(Tor Pignattara), ca. 1st c.
Ext.: WAP 151

Mausoleum of Tor de' Schiavi,
ca. 300
Ext.: WAR fig. 287-288 drg
Plan: WAR fig. 288

Ministero dell' Educazione,
1913-1928
Razzani, Cesare
Ext.: MEE fig. 266

Ministero delle Finanze,
1870-1877
Canevari, Raffaele;
Martinozzi, Martinori
Ext.: MEE fig. 183

Minnucci House, 1926
Minnucci, Gaetano

Ext.: DOO fig. 37

Monte di Pietà, ca. 1740
Salvi, Nicola
Ext.: ELL pl. 77

Monument of the Fosse
Ardeatine, 1944-1947
Fiorentino, Mario; Apirle,
Nello; Calcaprina, Cino;
Cardelli, Aldo; Perugini,
Giuseppe
Ext.: SMI 174-175, TAF fig. 1,
GRE fig. 32, SAR 129

Monument to Victor
Emmanuel II: Project, 1882
Nénot, Paul-Henri
Ext.: MEE fig. 188

Monument to Victor
Emmanuel II: Project, 1882
Piacentini, Marcello
Ext.: MEE fig. 189

Monument to Victor
Emmanuel II: Project, 1884
Corinti, Corinto
Ext.: MEE fig. 190

Monument to Victor
Emmanuel II: Project, 1884
Manfredi, Manfredo
Ext.: MEE fig. 191

Monument to Victor
Emmanuel II: Project, 1884
Sacconi, Giuseppe
Ext.: MEE fig. 187

Monument to Victor
Emmanuel II: Project,
1885-1911
Sacconi, Giuseppe
Ext.: EWA-10 pl. 157, FLE
1215, LOY 187, MEE fig.
192, PEH 1.36

Mosque & Islamic Center
Model, 1976
Portoghesi, Paolo
Ext.: COT 640

Museo Capitolino (Palazzo
Nuovo)
Ext.: DAF 187

138, 139, NOR 313, SAR
120, WIA pl. 146
Plan: NOR 213

Palazzo dello Sport, 1956-1957
Nervi, Pier Luigi; others
Ext.: DAL 126, SHA 243
Sect.: SHA 243
Plan: SHA 213

Palazzo di Firenze, 1550
Ammannati, Bartolomeo
Int.: HEW pl. 347

Palazzo di Giustizia, 1886-1910
Calderini, Guglielmo
Ext.: MEE fig. 263, PEH 5.20

Palazzo di Giustizia: Project,
1885
Rivas, F. P.
Ext.: MEE fig. 194

Palazzo di Giustizia: Project,
1886
Carimini, Luca
Ext.: MEE fig. 193

Palazzo di Giustizia: Project,
1888-1910
Calderini, Guglielmo
Ext.: MEE fig. 196-199

Palazzo di Giustizia: Project,
1890
Magni, Giulio
Ext.: MEE fig. 200

Palazzo di Montecitorio
(Chamber of Deputies,
Palace of Justice),
1650-1694
Bernini, Gian Lorenzo
Ext.: EWA-2 pls. 269, 271,
NOB 248, SAR 103,
WIA pl. 67

Palazzo Doria-Pamphili,
1730-1735
Valvassori, Gabriele
Ext.: BET 598, EWA-13 pl.
238, FLE 430, MAE-4 255,
NOR 212, SAR 120, VAR
162, WIA pl. 144
Int.: FLE 431

Palazzo Doria-Pamphili:

Gardens & Park
Plan: ARC 35

Palazzo Falconieri, 1646-1649
Borromini, Francesco
Ext.: EWA-2 pl. 310,
WIA pl. 77

Palazzo Farnese (Farnese
Palace), ca. 1515
Sangallo, Antonio da, the
Younger; Michelangelo;
others
Ext.: BAK 232, BEA 311,
DEF 169, ENA-1 305, FLE
826, HEW pl. 212, LOW pl.
99, MIM 333, MUR 178,
179, NOB 20, PEV 341-345,
RAE 138, SAR 85, VAR 26
Int.: BAK 252, HEW pl. 209,
211, 252, LOW pl. 100, MIM
335, MUR 179, 180
Plan: BEA 311, DEF 169,
FLE 826, HEW 201, 208,
MIM 334, PEV 342
Sect.: FLE 826, MIM 334

Palazzo Farnese: Gardens,
ca. 1560
Vignola, Giacomo Barozzi da
Ext.: LOW pl. 116

Palazzo Gaetoni Project, 1581
Volterra, Francesco Capriani
da
Ext.: HEW pl. 298
Plan: HEW pl. 297

Palazzo Gentili, Via Arcione
(Palazzo del Drago), 18th c.
Ext.: ELL pl. 108

Palazzo Lezzani, 1832
Valadier, Giuseppe
Ext.: MAE-4 252

Palazzo Margherita (U. S.
Embassy), 1886-1900
Koch, Gaetano
Ext.: MEE fig. 216
Plan: MEE fig. 217

Palazzo Massimo alle Colonne,
1532-1536
Peruzzi, Baldassare
Ext.: DEF 94, EWA-11 pl.

46, TRA 136, VAR 97, WAP
135, WAR fig. 52-drg., 53,
54-axon.
Int.: BAK pl. 5, BRO pls. 68,
69, CHA 91-94, EWA-16 pl.
17-col., FLE 289, HAT pl.
17, MAA pl. 104, 107, MIM
101, RAE 74, ROB 250, SAR
47, TRA 136, WAR fig.
55-painting, 56
Plan: FLE 288, MAA 98, 101,
MIM 104, SAR 47, TRA
136, WAP pl. 152
Sect.: BET 168, FLE 288,
MAA 101, 105, SAR 47,
TRA 136, WAR fig. 54

Piazza Benedetto Brin,
Garbatella, 1920-1922
Sabbatini, Innocenzo
Ext.: ETL 148

Piazza del Campidoglio, ca. 1592
Michelangelo
Ext.: ENA-1 306, MAE-3 173
Plan: SAR 87

Piazza del Campidoglio
(Capitoline Hill): Palazzo
dei Conservatori, ca. 1592
Michelangelo
Ext.: DEF 186, EWA-9 pl. 5,
LOW pl. 107, MAE-3 173,
MIM 338
Plan: EWA-9 fig. 907

Piazza del Campidoglio
(Capitoline Hill): Palazzo
dei Senatori, ca. 1592
Michelangelo
Ext.: DEF 186, MAE-3 173,
MUR 212

Piazza del Popolo, 1662-1679
Rainaldi, Carlo;
Bernini, Gian Lorenzo
Ext.: EWA-2 pl. 344,
EWA-4 pl. 188, NOB 32, 33,
SAR 116, A pl. 107
Plan: EWA-10 fig. 519, SAR
115, WIA 185

Piazza Dempione, 1921-1923
Sabbatini, Innocenzo
Ext.: ETL 150

Piazza di S. Ignazio, 1727-1728
Raguzzini, Filippo
Ext.: ELL pl. 134, MIL pl. 40,
MIM 429, NOR 25, VAR 165
Plan: MIL pl. 39, MIM 429,
NOR 25, SAR 119, WIA 249

Piazza di S. Maria del Priorata,
1765
Piranesi, Giovanni Battista
Ext.: MEE fig. 12

Piazza di Spagna (Scala di
Spagna, Spanish Steps,
Spanish Staircase),
1723-1725
Specchi, Alessandro;
Sanctis, Francesco de
Ext.: CHA 175-eng., FLE 850,
KOH 229, MAE-1 566, MER
142-col., MIL pl. 38, MIM
428, NOR 24, RAE 199, SAR
118, VAR 171, WIA 251,
pl. 445
Plan: SAR 118, VAR 170
Isometric view: VAR 164

Piazza di Spagna: Project, 1660s
Benedetti, Elpidio
Ext.: WIT 99-drg.

Piazza Navona:
Fountain of Neptune
Ext.: MER 141-col.

Piazza Vittorio Emanuele II,
1870 & later
Koch, Gaetano
Ext.: MEE fig. 176

Polyfunctional Building, 1964
Studio Passarelli
Ext.: DAL 132-col.

Pons Aelius, ca. 1st c. B. C.
Ext.: WAP 43

Pons Fabricius (Ponte dei
Quattro Capi)
Ext.: ELL pl. 9

Ponte dei Fiorentini
Ext.: MEE fig. 175

Ponte del Risorgimento, 1910
Hennebique, Francois
Ext.: SAR 127

Ponte di Nona, Via Praenestina,
ca. 80 B. C.
Ext.: WAP 42

Ponte Fabrico (Pons Fabricius),
62 B. C.
Ext.: ROB 14A, SAR 30
Sect.: SAR 29-eng.

Ponte Milvio (Ponte Molle, Pons
Milvius), 109 B. C.
Ext.: SAR 30, TRA 121

Ponte Milvio, 1805
Valadier, Giuseppe
Ext.: MEE fig. 39

Ponte Rotto (Ponte Emilio),
179 B. C.
Ext.: MEE fig. 174, SAR 31

Ponte Sisto, 1474
Pontelli, Baccio, attributed
Ext.: SAR 75

Porta Appia (Porta
S. Sebastiano), 275;
remodeled 400
Ext.: SAR 25, WAP 311,
WAR fig. 279-drg., 280
Sect.: WAP 399

Porta Asinara
Ext.: SAR 27

Porta del Popolo, 1561-1564
Bigio, Nanni di Baccio
Ext.: MAE-1 207

Porta di Ripetta, 1703
Specchi, Alessandro
Ext.: MIL pl. 37-eng.,
MIM pl. 423-eng.

Porta Latina
Ext.: SAR 27

Porta Maggiore (Porta
Prenestina)
Ext.: SAR 27, WAP 88, 89,
WAR fig. 21

Porta Ostiensis (Porta Ostiense),
3rd c.
Ext.: SAR 27, WAP 312

Porta Pia, 1561-1564
Michelangelo

Ext.: BUR 166, HEW pl. 262,
MUR 213, SAR 27

Porta Pia, 1852
Vespignani, Virgilio
Ext.: MEE fig. 50

Porta Portese in Trastevere,
1643
De Rossi, Marcantonio
Ext.: MAE-1 561

Porta Tiburtina, 5 B. C.
Ext.: WAP fig. 2

Portico of Aemilia (Porticos
Aemilia), 193 B. C.
Ext.: BOE 144, BRO pl. 30,
WAP 62, WAR fig. 12
Plan: BOE 129, WAP 100
Sect.: BRO pl. 31

Portico of Metellus, 2nd c. B. C.
Plan: BRO pl. 14

Post Office, Piazza Bologna, 1933
Ridolfi, Mario
Int.: ETL 278, GRE fig. 15

Pozzo Tomb, ca. 800 B. C.
Sect.: BOE 19

Prison, Ospizio di S. Michele
Ext.: ELL pl. 79

Prison, Via Giulia
Ext.: ELL pl. 80

Pyramid of Caius Cestius,
ca. 18-12 B. C.
Ext.: ELL pl. 205, ETL 293,
EWA-5 pl.195, SAR 50,
WAP 18

Residential Building,
Via Campania, 1963-1965
Passarelli, Vincenzo; Cercato,
Paolo; Costantini, Maurizio;
Falorni, Enrcio; Passarelli,
Fausto; Passarelli, Lucio;
Tonca, Edgardo
Ext.: TAF fig. 80

Residential Unit, Tuscolano
Quarter, 1950-1951
Libera, Adalberto
Ext.: TAF fig. 30

Ext.: MAE-2 124

S. Basilio Quarter, 1956
Fiorentino, Mario
Ext.: GRE fig. 39

S. Biagio in Campitelli (S. Rita de
Cascia), 1653 & later
Ext.: ELL pl. 24

S. Bibiana, 1624-1626
Bernini, Gian Lorenzo
Ext.: SAR 101, TRA 339,
VAR 76, WIA pl. 60

S. Carlo ai Catinari, 1612-1620
Rosati, Rosato
Ext.: NOB 142
Int.: NOB 143
Plan: NOB 142

S. Carlo al Corso (S. Ambrogio
e Carlo al Corso), ca. 1672
Longhi, Onorio;
Longhi, Pietro; Longhi,
Martino, the Younger
Ext.: VAR 122 (dome).
Plan: EWA-2 fig. 269

S. Carlo alle Quattro Fontane,
1638-1667
Borromini, Francesco
Ext.: BAK 325, EWA-1 pl.
397, FLE 848, MAA 233
(lantern), MAE-1 250, MIM
381, NOB 164-169, PEV
396, 397, SAR 106, TRA
346, VAR 53, 51 (cupola), 46
(courtyard), WIA pl. 76,
WIT 166
Int.: BAK 327, BEA 629,
MAE-1 251, MIL pls. 23,
24, MIM 380, NOB 170-173,
PEV 398, 399, RAE 167,
SAR 107, TRA 346, VAR
59, 50-eng., WIA pls. 69,
70, WIT 162 (dome), WIT
163
Plan: BAK 326, BEA 597,
CHA 96, FLE 848, MIL pls.
22, 23, MIM 380, NOB 162,
PEV 395, SAR 107, TRA
346, VAR 47, WIA 132

S. Caterina a Magnapoli
Soria, Giovanni Battista
Ext.: VAR 126

S. Caterina della Ruota,
la. 16th c.
Mascarino, Ottavio
Ext.: ELL pl. 42

S. Caterina a Magnapoli
Soria, Giovanni Battista
Ext.: VAR 126

S. Cecilia in Trastevere,
ea. 18th c.
Ext.: ELL pl. 55

S. Claduio dei Borgognoni,
1728-1731
Dérizet, Antoine
Ext.: ELL pl. 45

S. Clemente, 1099-1108
Ext.: FLE 350.
Int.: CON 285-drg., SAR 66,
WAP pl. 78
Plan: FLE 349
Sect.: FLE 349, KRA 132

S. Costanza (Mausoleum of
Constantina),
ca. 325-350 B. C.
Ext.: EWA-9 pl. 38, FLE 368,
MAD 15
Int.: BAK 140, FLE 368,
KRA 28, MAD 16, MIM 122,
SAR 57, WAR fig. 293
Plan: MAD 14, SAR 57
Sect.: FLE 368, MAD 14,
MIM 122

S. Croce dei Lucchesi, ca. 1670
Rossi, Mattia de
Ext.: ELL pl. 27

S. Croce in Gerusalemme
Reconstruction, as in ca. 329
Sect.: KRA 16

S. Croce in Gerusalemme
(Basilica Sessoriana),
1741-1743
Gregorini, Domenico;
Passalacqua, Pietro
Ext.: ELL pl. 54, MIL pl. 42,
MIM 428, SAR 122,

S. Girolamo della Carita:
Capella Spada, 1662
Borromini, Francesco
Int.: EWA-2 pl. 310,
NOB 315, 316

S. Gregorio Magno, 1629-1633
Soria, Giovanni Battista;
others
Ext.: MAE-4 106, WIA pl. 5

S. Gregorio Magno:
Capella Salviata, 1600
Volterra, Francesco Capriani
da; Maderno, Carlo
Int.: NOB 117

S. Ignazio di Loyola, 1626-1650
Algardi, attributed
Ext.: SAR 119
Plan: EWA-8 fig. 436

S. Ivo della Sapienza, 1642-1650
Borromini, Francesco
Ext.: EWA-1 pl. 420, FLE
847, MAE-1 253, MIM 383,
NOB 192, 194, 195, SAR
108, TRA 348, VAR 55, 56,
WIT 155 cupola)
Int.: BAR pl. 2, CHA pls.
25-28, JEL 18, MAE-1
254, NOB 196-201, TRA
348, VAR 58, WIA pls. 69,
70
Plan: BEA 597, 633, 634,
BUR 128, MIL pls. 25-27,
MIM 382, SAR 108, TRA
348, VAR 56, WIA 136, 137

S. Ivo della Sapienza: Cupola,
1642-1650
Borromini, Francesco
Ext.: KOH 293, SAR 108,
VAR 56
Int.: SAR 109, VAR 58.
Plan: SAR 108

S. Lorenzo fuori le Mura,
579-590; 1220
Int.: FLE 355, KRA 232

S. Lorenzo in Damaso, 380;
rebuilt; ca. 1500
Bramante, Donato
Plan: EWA-12 fig. 31

S. Lorenzo in Lucina: Baptistery,
1721
Sardi, Giuseppe
Int.: NOR 300

S. Luca e Martina, 1635-1650
Cortona, Pietro B. da
Ext.: MAE-1 459, SAR 104,
TRA 352

S. Luigi dei Francesci,
ca. 1580-1585
Della Porta, Giacomo
Ext.: EWA-12 pl. 90, MUR 216

S. Marcellino e Pietro,
1731-1732
Teodoli, Girolamo
Ext.: MAE-4 193

S. Marcello al Corso, 1519;
1682-1683
Sansovino, Jacopo;
Fontana, Carlo
Ext.: ELL pl. 25, EWA-8 pl.
223, MAE-2 93, NOB 320,
SAR 116, TRA 354, VAR
153, WIA pl. 144

S. Marco, Palazzo Venezia,
ca. 1460-1465
Ext.: HEW pl. 47, SAR 73
Plan: EWA-8 fig. 413

S. Maria Aventina, 1764-1766
Piranesi, Giovanni Battista
Ext.: MAE-3 429

S. Maria d'Aracoeli, 1200s
Ext.: SAR 70
Int.: EWA-13 pl. 227

S. Maria degli Angeli,
1561-1564
Michelangelo
Int.: HEW pl. 266, SAR 55,
WAP pl. 380
Plan: SAR 55

S. Maria dei Miracoli,
1662-1679
Bernini, Gian Lorenzo;
Fontana, Carlo;
Rainaldi, Carlo
Ext.: FLE 849, KOH 243-col.,
VAR 144

Int.: BRO pl. 97, FLE 357,
KRA 135, 136, MAD 32,
SAR 61, TRA 164

S. Salvatore in Campo, ca. 1639
Ext.: ELL pl. 77

S. Salvatore in Lauro
Mascarino, Ottaviano
Int.: VAR 29

S. Sebastiano, ca. 400-450;
rebuilt, 1609-1613
Ponzio, Flaminio;
Vasenzio, Giovanni
Ext.: FLE 847, KRA 20-model,
WIA pl. 5
Int.: WIA pl. 3

S. Silverstro in Capite: Tower
Ext.: SAR 65

S. Sisto Vecchio
Ext.: ELL pl. 38-39

S. Spirito in Sassia, 1538-1544
Sangallo, Antonio da, the
Younger
Ext.: MUR 219

S. Stefano Rotonda, 468-483
Ext.: EWA-9 pl. 39, FLE 366
Int.: FLE 355, KRA 48, 49,
MIM 124, PEV 29, RAE 34,
SAR 58, 58-drg., TRA 165
Plan: FLE 366, MIM 124,
PEV 29
Sect.: FLE 366

S. Susanna, 795; rebuilt, 1475;
1597-1603
Maderno, Carlo; others
Ext.: BAK 319, EWA-2 pl.
137, FLE 817, MAE-3 71,
MIL pl. 13, MIM 373, NOB
304, PEV 402, RAE 164-
col., SAR 97, TRA 337,
VAR 33, WIA pl. 35

S. Teodoro, 18th c.
Fontana, Carlo; others
Ext.: ELL pl. 29

S. Tommaso in Parione, 1650s
Ext.: ELL pl. 19

S. Trinità de' Pellegrini

Maggi, Paolo
Ext.: ELL pl. 35
Int.: WIT 42

S. Trinità dei Monti, ca. 1580
Porta, Giacomo della
Ext.: MUR 238

S. Vincenzo e S. Anastasio,
1646-1650
Longhi, Martino, the Younger
Ext.: NOB 306, 307, PEH
403, SAR 113, VAR 129,
WIA pl. 106

S. Vitale Reconstruction,
401-417
Int.: KRA 134

School for the Quartiere
Trionfale, 1921
Frezzotti, Oriole
Ext.: ETL 145-drg.

Servian Wall, begun 378 B. C.;
rebuilt, 87 B. C.
Ext.: BOE 180,
EWA-13 pl. 220

Small Palace, Arbia Street,
1960-1961
Aymonino, Carlo
Ext.: DAL 32-col.

Stazione Termini (Railway
Station Terminal),
1947-1951
Montuori, Eugenio;
Calini, Leo; others
Ext.: COP 26, DEW 221, FLE
1269, PEH 14.29, PEV 707,
SAR 129
Int.: PEV 706

Stazione Termini: Project,
1947
Cardelli, Aldo; Carè, Arrigo;
Ceradini, Giulio; Fiorentino,
Mario; Quaroni, Ludovico;
Ridolfi, Mario
Ext.: TAF fig. 6-drg.

Strada Pia, 1559-1565
Michelangelo
Ext.: KOH 264-drg.

Synagogue, 1889

Plan: CHA 106, EWA-12 fig.
526, FLE 279, WAR fig. 59.

Temple of Venus Genetrix,
Forum Julium, ca. 46 B. C.
Ext.: WAP 75
Plan: WAP 69

Temple of Vesta, Forum
Boarium (Round Temple),
ca. 50 B. C.
Ext.: BOE 138, EWA-12 pl.
132, FLE 284, SAR 45, WAP
20, 21

Tenth Anniversary of the
Fascist Revolution
Exhibition: March on Rome
Room, 1932
Terragni, Giuseppe
Int.: DOO fig. 84

Tenth Anniversary of the
Fascist Revolution
Exhibition: Sacrario, 1932
Libera, Adalberto;
Valente, Antonio
Int.: DOO fig. 83

Theater of Marcellus,
ca. 46-10 B. C.
Ext.: BRO pl. 43, FLE 304,
305, MIM 95, SAR 52, TRA
123, WAP 64, 65
Int.: BRO pl. 42
Plan: BRO pl. 41, FLE 305,
MIM 95, SAR 52
Sect.: TRA 122

Theater of Pompey, ca. 205-208
Plan: WAP 50, WOR 159

Tomb of Annia Regilla, ca. 143
Ext.: FLE 315, MAC pl.
133-model, WAP 133,
WAR fig. 70-71

Tomb of C. Poplicius Bibulus,
ca. 60 B. C.
Ext.: BOE 212

Tomb of Caecilia Metella,
ca. 20 B. C.
Ext.: FLE 317, SAR 50, 50
(frieze detail)

Tomb of Eurysaces, ca. 30 B. C.
Ext.: MAC pl. 131

Tomb of S. Supicius Galba,
ca. 100 B. C.
Ext.: BOE 210

Tomb of the Caetennii, ca. 150
Ext.: WAR fig. 69-axon
Int.: WAR fig. 68

Tower Building, Ethiopia
Street, 1957-1962
Fiorentino, Mario
Ext.: DAL 77

Trinità dei Monti: Obelisk,
1786-1789
Antinori, Giovanni
Ext.: KOH 229, MAE-1 88

Triton Fountain, Piazza
Barberini, 1641
Bernini, Gianlorenzo
Ext.: SAR 134

Tumuli, Via Appia, ca. 100 B. C.
Ext.: BOE 213

Underground Basilica, ca. 50
Int.: WAP pl. 55

University of Rome, 1933
Piacenti, Marcello; others
Ext.: COT-1 626,
ETL 423-424, 425-model
Plan: DOO fig. 54

University of Rome:
Administration Building,
1932-1935
Piacentini, Marcello
Ext.: DOO fig. 55

University of Rome: Botany
Building, 1932-1935
Capponi, Giuseppe
Ext.: DOO fig. 57

University of Rome: Faculty of
Engineering, 1982-1986
De Feo, Vittorio
Ext.: DAL 70-col.
Plan: DAL 70

University of Rome: Physics
Building, 1932-1935

Pagano, Giuseppe
Ext.: DOO fig. 56

Via Appia
Ext.: BET 206

Via Aurelia Antica
Ext.: ELL pl. 4
Via dei Pianarelli
Ext.: ELL pl. 172

Via dell' Impero (Via dei Fori
Imperiali), 1932
Ext.: KOH 231

Via della Pilotta
Ext.: ELL pl. 92

Via Flaminia (Via del Corso),
ca. 50 A. D
Ext.: BRO pl. 58, SAR 28

Via Giulia
Ext.: BET 569

Via Sacra & Clivus Palatinus,
ca. 380 B. C.
Ext.: BOE 109

Vicolo della Scalone
Ext.: ELL pl. 6-7

Villa Albani, ca. 1761
Marchionni, Carlo
Ext.: EWA-10 pl. 211, MEE
fig. 6-8, SAR 123, 123-eng.
Plans: PEH 8.9

Villa Albani: Gardens, ca. 1760
Marchionni, Carlo
Ext.: EWA-8 pls. 442, 445
Plan: EWA-8 fig. 1097

Villa Borghese, 1613-1615
Vasanzio, Giorgio
Ext.: MAE-4 291

Villa Borghese, ca. 1787
Asprucci, Antonio;
Asprucci, Mario
Ext.: MEE fig. 23

Villa Borghese:
Egyptian Propylea, 1820s
Canini, Luigi
Ext.: MEE fig. 44

Villa Borghese: Fountain of
Esculapius, 1818-1829

Canini, Luigi
Ext.: MEE fig. 47

Villa Borghese: Gardens,
ca. 1787
Asprucci, Antonio;
Asprucci, Mario
Plan: MEE fig. 22

Villa Borghese: Piazzale
Flaminio Gates, 1825-1828
Canini, Luigi
Ext.: MEE fig. 46

Villa Borghese: Temple of
Esculapius, 1785-1792
Asprucci, Antonio;
Asprucci, Mario;
Unterberger, Christoph
Ext.: MEE fig. 45

Villa Borghese: Temple of
Faustina & Antoninus,
1785-1792
Ext.: ELL pl. 209

Villa Borghese: Triumphal
Arch, 1818-1828
Canini, Luigi
Ext.: MEE fig. 48

Villa Carpegna
Ext.: ELL pl. 190-193

Villa del Pigneto, ca. 1630
Cortona, Pietro da
Ext.: WIA pl. 80-eng.
Plan: EWA-11 fig. 360,
WIA pl. 80

Villa Doria Pamphili: Chapel,
1896-1902
Collamarini, Edoardo
Ext.: MEE fig. 137

Villa Farnesina, 1509-1511
Peruzzi, Baldassare
Ext.: EWA-11 pl. 120, FLE
831, HEW pl. 194, MUR
174, 175, SAR 83, TRA 306
Plan: HEW 189, MUR 174,
SAR 83

Villa Farnesina: Loggia di
Psiche, 1509-1511
Peruzzi, Baldassare
Int.: BUR 255-drg., HEW pl.

Olimpico), 1588-1590
Scamozzi, Vincenzo
Int.: HEW pl. 345,
MER 62-col., MUR 316
Plan: EWA-12 fig. 100,
EWA-17 pl. 116

SACRO MONTE

Chiesa dell' Assunta, 1891-1896
Ceruti, Giovanni
Ext.: MEE fig. 226

SALERNO

Chiesa della Sacra Famiglia,
1969-1973
Portoghesi, Paolo; Gigliotti,
Vittorio; Palma, Giuseppe;
Alamanni, Mario; Ago,
Fabrizio
Int.: DAL 142-col., TAF fig. 52

Solimene Ceramics Factory,
1953
Soleri, Paolo; Mills, Mark
Ext.: COP 229, SHA 195
Int.: COP 229

SALSOMAGGIORE

Luigi Zoja Baths, 1967-1970
Albini, Franco; Albini, Marco
Ext.: TAF fig. 83

Shops, 1950
Vigano, Vittoriano
Ext.: SMI 131

SAN GIMIGNANO

Towers, 12th-13th c.
Ext.: CON 297, MER
116-col., TRA pl. 37-col.

SAN GIOVENALE

Etruscan Houses, ca. 600 B. C.
Ext.: BOE 76, 77

Etruscan Tombs Model,
ca. 600 B. C.
Ext.: BOE 84, 98

Etruscan Wall, ea. 4th c.
Ext.: BOE 68

House K, ca. 600 B. C.
Ext.: BOE fig. 68

Porzarago Cemetery,
ca. 600 B. C.
Plan: BOE 78
Sect.: BOE 78
Tomb Facades, ca. 400 B. C.
Ext.: BOE 100

SAN GIULIANO

Tomb of Princess Margrethe
of Denmark, 6th c. B. C.
Int.: BOE 52

Tomba della Regina, 6th c. B. C.
Ext.: BOE 101

SAN MARINO

Cathedral, 1826-1836
Serra, Antonio
Ext.: MEE fig. 78

Palace of Government
Azzuri, Francesco
Ext.: MEE fig. 143

SAN VITO D' ALTIVOLE,
near TREVISO

Brion Family Tomb, 1970-1972
Scarpa, Carlo
Ext.: DAL 178-179-col.,
TAF fig. 105
Int.: TAF fig. 104

SANTA SOFIA DI PEDEMONTE

Villa Sarego
Palladio, Andrea
Ext.: DEF 112
Int.: DEF 112

SAONARA

Villa dei Conti Cittadella
Vigodarsere: Chapel,
ca. 1817
Japelli, Giuseppe
Ext.: MEE fig. 70

SARONNO

Santuario della Madonna
 dei Miracoli, 1596-1612
Tibaldi, Pellegrino
Ext.: Murray 254

SAVONA

Cathedral, 1880
 Mazzanti, Riccardo
Ext.: MEE fig. 224

Cathedral, 1888
Ext.: MEE fig. 223

Cathedral, 1880-1886
 Calderini, Guglielmo
Ext.: MEE fig. 222

Palazzo Rovere, ca. 1490
Ext.: HEW 140

SCHIO

Cathedral, 1805-1820
 Diedo, Antonio
Ext.: MEE fig. 74

SCIACCA

Palazzo Steripinto
Ext.: DEQ 160

Teatro Popolare: Project, 1974
 Samonà, Giuseppe;
 Samonà, Alberto
Ext.: TAF fig. 109-drg.

SEBENICO

Cathedral, 1477
Ext.: EWA-13 pl. 76,
 HEW pl. 94

SEGESTA

Temple, la. 5th c.
Ext.: LAW pls. 83, 85, LLO figs.
 441, 462, 463, RAE 43
Int.: LLO fig. 369

SEGGIANO DI PIOLTELLO

City Hall, 1976-1981
 Canella, Guido

Ext.: DAL 50-col.

SEGRATE

City Hall (Civic Center),
 1963-1966
Achilli, Michele; Brigidini,
 Daniele; Canella, Guido;
 Lazzari, Laura
Ext.: GRE fig. 88, TAF fig. 125

SEGUSIO. *See* SUSA

SELINUS, SICILY

Megaron Temple, ca. 600 B. C.
Plan: EWA-13 fig. 569,
 LAW 98

Temple C, ca. 550 B. C.
Ext.: LAW pl. 30, LLO fig. 344
Plan: LAW fig. 67, LLO fig. 343

Temple D, ca. 536 B. C.
Plan: EWA-1 fig. 643,
 LAW 122, SCR pl.34

Temple E (Temple of Hera),
 6th-5th c. B. C.
Ext.: LLO 256-258
Plan: EWA-7 fig. 121

Temple F, ca. 525 B. C.
Ext.: LAW 122, ROB 74
Plan: LAW 122, SCR pl.34

Temple G, ca. 520-450 B. C.
Ext.: LAW 102, ROB 87
Plan: EWA-13 fig. 517, LAW
 122, ROB 86, SCR pl.34

SETTIGNANO

Villa Gamberaia, ca. 1550 & later
Ext.: FLE 790

SFORZINDA

City Planning (Ideal City),
 ca. 1460-1464
Filarete
Plan: KOH 186

SIENA

Casa Pollini, ca. 1527

Ext.: ARC 149-col.

STUPINIGI

Villa Reale di Stupinigi (Royal
Hunting Lodge), 1729-1733
Juvarra, Filippo
Ext.: BAL 95, BAR 43-col.,
BET 698, 699, EWA-1 pl.
389, MAE-2 528, MIM 425,
NOR 223, 224, PEV 465,
TRA 356, WIA pl. 159
Int.: BAL 95, BAR 34-col.,
BET 699, MILB pl. 45, MIM
424, NOR 226, TRA 356,
WIA pl. 161
Plan: BAL 95, BAR 73, BET
699, NOR 223, WIA 277
Sect.: BET 699

**SU NURAXI DI BARUMINI,
SARDINIA**

Nuraghe, ca. 1500 B. C.
Ext.: BOE 17

SUBIACO

Monastero di Santa Scolastica:
Chapel, 1777
Quarenghi, Giacomo
Int.: MEE fig. 21

SULMONA

Aqueduct, Piazza Garibaldi,
2nd c.
Ext.: MER 145-col.

SUSA (SEGUSIO)

Arch of Augustus, ca. 8 B. C.
Ext.: BRO pl. 55, EWA-8 pl.
230, MIM 109, WAP 87,
pl. 100, WAR fig. 101

Ribat of Sussa, la. 8th c.
Ext.: HOA pls. 64, 65, 67
Int.: HOA pl. 66
Plan: HOA pl. 63

SYRACUSE

Cathedral, 1728

Palma, Andrea
Ext.: BAR 96, VAR 287

Palazzo Beneventano dal Bosco,
17th c.
Ext.: MER 170-col.

Temple of Apollo (Temple of
Artemis), ca. 600 B. C.
Ext.: LAW 121, LLO 251, 252
Plan: EWA-7 fig. 121, LAW
121, LLO 251, SCR pl.34A

TAORMINA

Badia Vecchia
Ext.: DEQ 156

Palazzo Corvaia
Ext.: DEQ 158

Palazzo S. Stefano, 1330
Ext.: DEQ 157, FLE 759

Theater, 1st c.
Ext.: ENA-1 55

TARANTO

Castle
Ext.: MER 156-col.

TARCHUNA. *See* **TARQUINIA**

TARENUM. *See* **TRANI**

TARQUINIA

Asquini Residence, 1968
Portoghesi, Paolo
Ext.: DAl 141

Ara della Regina Temple,
750-100 B. C.
Plan: BOE 40,
EWA-5 fig. 135

Enel Workers Housing, 1981
Portoghesi, Paolo
Ext.: DAL 143-col.

Tomb of the Cardinal,
ca. 300 B. C.
Int.: BOE 81

Tomb of the Giglioli, 2nd c. B. C.

Int.: BOE 93

Tomb of the Marcareccia,
2nd c. B. C.
Int.: BOE 90
Plan: EWA-13 fig. 619

Tombs, ca. 5th c. B. C.
Ext.: MER 135-col.

TAVOLIERE

Settlement, Neolithic Age
Plan: BOE 11

TERAMO

Palazzo di Giustizia, 1968-1981
Caniggia, Gianfranco; Greco,
Romano; Imperato, Gaetano;
others
Ext.: TAF fig. 160-model

TERNI

Lina House, Marmore, 1966
Ridolfi, Mario
Ext.: TAF 90
Plan: TAF 90
Elev.: TAF 90
Sect.: TAF 90

Matteotti Quarter, 1969-1975
De Carlo, Giancarlo
Ext.: TAF fig. 111

Technical Institute for
Geometry, 1968-1969
De Feo, Vittorio
Ext.: DAL 68-col., 68-model

TERRACINA

Insula, Via dei Sanniti,
1st c. B. C.
Ext.: BOE fig. 133

Temple of Jupiter Anxur,
ca. 80 B. C.
Ext.: BOE 175, MAA pl. 6,
WAP 35, 36
Int.: WAP 37

Temple Platform, 2nd c. B. C.
Ext.: BRO pl. 16

Via dei Sanniti, 1st c. B. C.

Ext.: BOE 141

THIENE

Estel Office Building, 1972-1986
Stella, Franco
Ext.: DAL 186-187-col.

TIBUR. *See* **TIVOLI**

TIVOLI (TIBUR)

Hadrian's Villa, ca. 124-135
Ext.: BET 175, FLE 337,
SAR 22, MAC 282-model,
TRA 152-model, WAR fig.
123-model
Plan: BET 174, EWA-12 fig.
531, FLE 334, 336, MAC
281, AR fig. 124

Hadrian's Villa: Canopis
(Canal of Canopo),
ca. 124-135
Ext.: SAR 22, TRA 152,
WAP pls. 172-174

Hadrian's Villa: Circular
Casino, ca. 123-135
Ext.: MIM 114
Plan: MIM 114, TRA 152

Hadrian's Villa: Great Baths,
ca. 124-135
Ext.: MAC 212-restoration
drg.
Int.: EWA-12 pl. 291, WAP
pl. 190

Hadrian's Villa: Greek Library,
ca. 120-125
Plan: MAC 227

Hadrian's Villa: Piazza d'Oro,
125-135
Ext.: SAR 22-drg.,
WAP pls. 194-196
Int.: WAP pl. 186
Plan: MIM 113, WAP pls.
181, 183, 184, 186

Hadrian's Villa: Teatro
Marittimo, 118-125
Ext.: WAP pls. 176-180
Plan: WAP pl. 175

Temple of Hercules Victor
(Sanctuary of Hercules),
ca. 50 B. C.
Ext.: BOE 154, 167, MAA pl.
5, WAP 48, 44
Plan: EWA-7 fig. 401

Temple of Vesta (Temple of the
Sibyl, Round Temple),
ca. 80 B. C.
Ext.: BOE 158, 163, BRO pl.
17, EWA-7 pl. 201, FLE
284, MIM 94, ROB 9A, WAP
55, 56
Plan: FLE 284, MIM 94

Tetrastyle Temple, 2nd c. B. C.
Ext.: BOE 160

Villa d'Este, ca. 1565-1572
Ligorio, Pirro
Ext.: HEW pl. 272, FLE 835,
LOW pl. 117

Villa d'Este: Fountains, ca. 1550
Ext.: EWA-9 pl. 313, FLE
811, SAR 137

Villa d'Este: Gardens,
ca. 1565-1572
Ligorio, Pirro
Ext.: ARC 26, EWA-8 pl.
432, MAE-3 11

TODI

Palazzo del Capitano, 1290s
Ext.: WHI pl. 11

S. Fortunado, begun 1292
Int.: WHI pl. 4

S. Maria della Consolazione,
1508-1604
Cola da Caprarola; others
Ext.: BEA 229, EWA-8 pl.
206, FLE 825, MILB pl. 1,
MIM 328, MUR 159
Int.: HEW pl. 187, MIM 329,
MUR 160, 161
Plan: BEA 229, EWA-8 fig.
419, FLE 825, MIL pl. 3,
MIM 330, MUR 159

TOLLI

Secondary School, 1975
Grassi, Giorgio;
Monestiroli, Antonio
Ext.: TAF fig. 132-drg.

TONINI

Casa Tonini, 1972-1974
Reichlink, Bruno;
Reinhart, Fabio
Ext.: KLO 279-284

TORCELLO

S. Fosca, ca. 1000
Ext.: EWA-8 pl. 174, FLE 359,
394, KRA 366, SAV fig. 2
Int.: FLE 359
Plan: EWA-8 fig. 424

TORTONA

Government Salt Warehouse,
1950
Nervi, Pier Luigi
Ext.: SMI 238

TRANI (TARENUM)

Cathedral, begun 1098
Ext.: CON 267, EWA-8 pl.
172, TRA pl. 27-col.
Plan: EWA-12 fig. 357

TRAPANI

Palazzo della Giudecca: Tower
Ext.: DEQ 160

S. Pietro, 1848-1850
Selvatico, Pietro
Ext.: MEE fig. 107

TRENTO

Banca Cooperativa, 1925
Gilberti, Ettore
Int.: ETL 467
Plan: ETL 467

Colonia Ridente, 1920
Wenter-Marini, Giorgio
Ext.: ETL 143-drg.

Plan: ETL 143

Elementary School Project,
 1931-1932
Libera, Adalberto
Ext.: ETL 284-287-drg.

Trentino-Alto Adige Regional
 Hall, 1954-1962
Libera, Adalberto
Ext.: DAL 98-col.

TREVISO

S. Nicolò, begun ca. 1303
Ext.: WHi pl. 85

TRIESTE

Bourse, 1802-1806
Mollari, Antonio
Ext.: MEE fig. 72

City Planning, 1969
Semerani, Luciano;
 Tamaro, Gigetta; others
Plan: TAF fig. 97

I. A. C. P. Residential Complex,
 1970-1983
Studio Celli & Tognon
Ext.: DAL 60

Nuovo Ospedale, Cattinara,
 1965-1983
Semerani, Luciano;
 Tamaro, Gigetta
Ext.: TAF fig. 145

Palazzo Comunale, 1869-1871
Bruno, Niccolò
Ext.: MEE fig. 179

Regional Administration
 Building Project, 1974
Rossi, Aldo
Ext.: KLO 251, 252, 253-drg.

S. Antonio, 1826-1849
Nobile, Pietro
Ext.: MEE fig. 85
Int.: MEE

State Hospital of
 Cattenara, 1965 & later
Semerani, Luciano
Ext.: DAL 183-col.

Synagogue
Berlam, Ruggiero
Ext.: MEE fig. 146

TRISSINO

Villa Trissino da Porto (Villa
 Marzotto): Gardens
Muttoni, Francesco
Ext.: ARC 153
Plan: ARC 153

TROIA

Cathedral, begun 1093
Ext.: CON 270,
 EWA-12 pl. 223

TURIN (TORINO, ancient AUGUSTA TAURINORUM)

Apartment Block, Via Palmieri,
 1912
Gussoni, Gottardo
Ext.: RUS pl. 8.12

Automobile Exhibit Pavilion,
 1960
Morandi, Riccardi
Int.: TAF fig. 67

Bottega d'Erasmo, 1953 & later
Gabetti, Roberto; Isola, Aimaro
Ext.: TAF fig. 48

Casa delle Imprese Bellia,
 1894-1898
Ceppi, Carlo
Ext.: MEE fig. 237

Chiesa del Carmine, 1732-1735
Juvarra, Filippo
Int.: MIL pl. 43, MIM 426,
 NOR 80-82, VAR 237, WIA
 pl. 161
Sect.: WIA 278

Chiesa della Gran Madre
 di Dio, 1818-1831
Bonsignore, Ferdinando
Ext.: MEE fig. 90, MIM 488

Chiesa delle Sacramentine,
 1846-1850
Dupuy, Alfonso
Ext.: MEE fig. 93

House, Via Bezzecca, 1904
Velati-Bellini, Giuseppe
Ext.: RUS pl. 8.18

Italia '61 Exhibition: Palace of
Labor (Palazzo del Lavoro),
1961
Nervi, Pier Luigi; Ponti, Gio
Ext.: SHA 244

Malfei Apartment Building, 1904
Vandone, Antonio
Ext.: RUS pl. 8.13

Mole Antonelliana, 1863-1888
Antonelli, Alessandro
Ext.: ETL 16-drg.,
MEE fig. 104

New Urban Development
Project, 1923
Sartoris, Alberto
Ext.: DOO fig. 38-drg.

Noviziato delle Suore de Carita,
1965
Raineri, Giorgio
Ext.: GRE fig. 87

Nursery School, 1980-1982
Derossi, Pietro
Ext.: DAL 71-col.

Palace of Labor, 1960-1961
Nervi, Pier Luigi
Int.: ENA-3 558-drg.

Palazzo Asinari, 1686 & later
Garove, Michelangelo
Int.: NOR 216, 217

Palazzo Barolo, 1692
Baroncelli, Gian Francesco
Int.: NOR 215

Palazzo Beggiono di S. Albano
(Palazzo Lascaris), 1665
Castellamonte, Amedeo di
Ext.: MAE-1 390

Palazzo Carignano, 1679-1692
Guarini, Guarino
Ext.: EWA-7 pl. 104, FLE
812, HAT pl. 57, MIB pl.
31, MIM 391, NOB 260, PEV
415, VAR 224
Int.: MIM 392, NOB 262

Plan: MIL pl. 32, MIM 391,
NOB 260, VAR 226

Palazzo Carignano, 1863-1871
Ferri, Gaetano
Ext.: MEE fig. 178

Palazzo Cavour, 1729
Plantery, Gian Giacomo
Int.: NOR 220, 221

Palazzo Ceriani-Peyron,
1878-1879
Ceppi, Carlo
Ext.: MEE fig. 208

Palazzo del Lavoro, 1960
Luigi, Pier; Nervi, Antonio
Int.: TAF fig. 66

Palazzo Gualino, 1929
Pagano, Giuseppe;
Levi-Montalcini, Gino
Ext.: DOO fig. 31

Palazzo Madama, 1718-1721
Juvarra, Filippo
Ext.: EWA-8 pl. 226, NOR
75, VAR 234, WIA pl. 159
Int.: HAT pl. 57, NOR 78,
79, VAR 236 (staircase)

Palazzo Martini de Cigala,
1716-1719
Juvarra, Filippo
Ext.: NOR 222
Int.: NOR 222

Palazzo Saluzzo-Paesana,
1715-1722
Plantery, Gian Giacomo
Ext.: NOR 218, 219
Int.: NOR 220

Piazza Castello, 1584 & later
Vitozzi, Ascanio
Ext.: BET 696, NOB 72

Piazza della Repubblica:
Project, 1982
Cellini, Francesco;
Cosentino, Nicoletta
Ext.: TAF fig. 166-drg.

Piazza dello Statuto, 1864
Bollati, Guseppe
Ext.: MEE fig. 167

Piazza S. Carlo (Piazza Reale),
 1621 & later
Castellamonte, Carlodi
Ext.: KOH 261,
 NOB 74, 76, 77

Piazza Vittorio Veneto,
 1818 & later
Grizzi, Giuseppe; Promis, Carlo
Ext.: MIM 488, NOB 80
Plan: MIM 488

Porta Nuova Station, 1866-1868
Bianchi, Salvatore
Ext.: MEE fig. 163

Porta Palatina, ea. 1st c.
Ext.: MAC pl. 78,
 WAR fig. 103-drg.

Quartieri Militari, 1716-1728
Juvarra, Filippo
Ext.: NOR 36, 37

Railroad Station, 1871
Ratti
Ext.: MEE fig. 161

Regio Theater, 1964 & later
Mollino, Carlo
Ext.: DAL 113-col.

Residential Building,
 Via S. Agostino, 1980-1983
Gabeti, Roberto; Isola, Aimaro;
 Drocco, Guido
Ext.: TAF fig. 148

S. Chiara, ca. 1745
Vittone, Bernardo Antonio
Int.: NOR 183, 184
Plan: NOR 182
Sect.: NOR 182

S. Chiara: Dome, ca. 1745
Vittone, Barnardo Antonio
Int.: WIT 216

S. Cristina, 1715
Juvarra, Filippo
Ext.: MAE-2 524

S. Filippo, 1730s-1890s
Juvarra, Filippo
Ext.: MEE fig. 73

S. Filippo Neri, 1679
Guarini, Guarino

Plan: EWA-7 fig. 197,
 NOB 225
Sect.: NOB 225

S. Giovanni Battista
 (Cathedral), 1491-1498
Meo del Caprino
Ext.: EWA-12 pl. 3,
 HEW pl. 122
Int.: HEW pl. 123
Plan: HEW 123

S. Giovanni Battista: Chapel of
 S. Sindone (Chapel of the
 Holy Shroud), 1667-1694
Guarini, Guarino
Ext.: FLE 811, MIM 390,
 NOB 228, WIA pl. 155
Int.: EWA-1 pl. 421, MIM
 390, NOB 226, RAE 168-col,
 VAR 219, WIA pl. 156
Plan: FLE 814, NOB 225,
 VAR 217, WIA 270
Sect.: FLE 814, NOB 225,
 VAR 221, WIA pl. 155

S. Giovanni Battista: Chapel of
 S. Sindone: Dome,
 1667-1694
Guarini, Guarino
Int.: VAR 220, WIT 179

S. Lorenzo, 1668-1687
Guarino Guarini
Ext.: CHA pl. 41, EWA-2 pl.
 142, EWA-7 pl. 103, NOB
 230, 231
Int.: BAK 329, BAR 65, BEA
 913, CHA pls. 42-44, MIL
 pl. 29, MIL pl. 30, MIM
 389, NOB 232, 234, PEV
 416, 417, VAR 212, WIA
 pls. 157, 158, WIT 183
Plan: BAR 65, BEA 912, BET
 696, CHA 46, FLE 813, MIL
 pl. 28, MIM 389, NOB 229

S. Lorenzo: Dome, 1668-1687
Guarino Guarini
Ext.: VAR 215
Int.: VAR 213, WIT 183

S. Maria al Monte dei
 Cappuccini, 1585-1596

Laurana, Luciano
Ext.: BET 545, DEQ 108-110,
 FLE 794, HEW pl. 65, LOW
 pl. 39, 47, MAE-2 622,
 MER 125-126-col., MUR
 80-83, PEV 305, 310, RAE
 139, WOR 273-col. drg.
Int.: DEQ 111, EWA-9 pl.
 97, HEW pl. 66, 67, LOW pl.
 41, MUR 84, 86, 87
Plan: BET 545, BUR 138,
 DEQ 108, HEW 74, MUR 80

Palazzo Ducale: Capella del
 Perdono (Perdono Chapel),
 ca. 1444-1482
Bramante, Donato
Int.: EWA-2 pl. 337,
 HEW pl. 69

Palazzo Ducale: Courtyard,
 ca. 1450
Laurana, Luciano
Ext.: BUR 138,
 EWA-9 pl. 99, 100

Palazzo Ducale: Federico's
 Study, 15th c.
Int.: BET 550, 551, EWA-8
 pl. 100, EWA-9 pl. 97
Plan: BET 551

Palazzo Ducale: Sala del
 Trono, ca. 1444-1482
Laurana, Luciano
Int.: HEW pl. 68

Piazza Maggiore, 1470s
Ext.: DEQ 112

S. Bernardino degli Zoccolanti,
 1482-1490
Francesco di Giorgio Martino
Ext.: DEQ 114, 116, EWA-1
 pl. 397, MUR 94
Int.: DEQ 116-117, HEW pl.
 70, LOW pl. 48, MUR 94, 95
Plan: DEQ 114, LOW pl. 49

University of Urbino, 1963-1966
De Carlo, Giancarlo
Ext.: TAF fig. 110

University of Urbino: Dormitory
 Complex, 1962-1966
De Carlo, Giancarlo

Ext.: DAL 66

University of Urbino: Facolà di
 Magistero, 1968-1976
De Carlo, Giancarlo
Ext.: TAF fig. 112

University of Urbino: Faculty
 of Education, 1976
De Carlo, Giancarlo
Ext.: COT-1 193, COT-2 216

VALLINOTTO

Pilgrimage Church of the
 Visitation (Santuario della
 Visitzione di Maria),
 1738-1739
Vittone, Bernardo Antonio
Ext.: NOR 172, WIA pl. 163,
 WIT 213
Int.: NOR 172, WIA pl. 163,
 WIT 211 (dome).
Plan: NOR 172, WIA pl. 162
Sect.: NOR 172, WIA pl. 162

Pilgrimage Church of the
 Visitation: Dome,
 1738-1739
Vittone, Bernardo Antonio.
Int.: WIT 211

VALSANZIBIO

Villa Barbarigo: Aviary,
 ea. 18th c.
Ext.: ARC 186-col.

Villa Barbarigo:
 Diana Pavilion, ea. 18th c.
Ext.: ARC 186-col.

Villa Barbarigo: Garden,
 ea. 18th c.
Plan: ARC 120, 185

VARANO

Delizia Pavilion, 1983-1986
Zermani, Paolo
Ext.: DAL 198-199-col.
Int.: DAL 198

VARESE

Aletti Tomb, 1898

Elev.: FLE 841

S. Peter's: Baldacchino,
 ca. 1655-1657
Bernini, Gian Lorenzo
Ext.: BAR 33-col., BEA 606,
 SAR 100, VAR 78

S. Peter's: Dome, 1546-1551;
 1588-1591
Michelangelo;
 Della Porta, Giacomo
Ext.: HEW pl. 259, LOW pl. 81
Int.: BEA 601
Plan: FLE 842
Sect.: FLE 841

S. Peter's: Dome Model,
 1558-1561
Michelangelo
Ext.: HEW pls. 258, 259,
 MUR 208, 209

S. Peter's: Project, ca. 1450
Alberti, Leone Battista (?);
 Rossellino, Bernardo
Plan: HEW 30

S. Peter's: Project, 1506
Bramante, Donato
Ext.: HEW 159, LOW 79
Plan: FLE 841, HEW 158a,
 159, pls. 160, 161, LOW pl.
 80, SAR 88

S. Peter's: Project, ca. 1514
Bramante, Donato
Ext.: MUR 150
Plan: HEW pl. 162,
 MUR 146, 148, 150

S. Peter's: Project, ca. 1520
Peruzzi, Baldassare
Plan: HEW pls. 167,
 168, 158B

S. Peter's: Project, 1539 & later
Sangallo, Antonio da,
 the Younger
Ext.: DEF 186-model,
 HEW pl. 205-model
Plan: HEW 158-col., MUR 202

S. Peter's: Project, 1547
Michelangelo
Plan: SAR 88

S. Peter's Square (Piazza San
 Pietro), 1655-1657
Bernini, Gian Lorenzo
Ext.: BET 585, 589, FLE 838,
 843-drg., MAE-1 196,
 MILB pl. 15, SAR 99,
 99-drg., VAR 82
Plan: BET 584, CHA 50

Vatican Museum New Wing,
 1970
Studio Passarelli
Ext.: DAL 312-col.

VEII

City Planning, 750-100 B. C.
Plan: BOE 65

City Wall, ca. 400 B. C.
Ext.: BOE 66
Sect.: BOE 66

House, ca. 600 B. C.
Ext.: BOE 76

Portonaccio Temple,
 750-100 B. C.
Ext.: BOE 62, WAP 12
Plan: BOE 40
Elev.: TRA 113

Temple of Minerva, 5th c. B. C.
Ext.: BRO pl. 4

VELLEIA

Basilica-Forum-Temple Complex
Ext.: WAP 206
Plan: WAP 200, WAR fig. 105

VELLETRI

Temple Model, 6th c. B. C.
Ext.: BOE 43

Vigna d'Anrea, ea. Iron Age
Sect.: BOE 20

VENICE

Accademia Bridge, 1984-1985
Nicolin, Pier Luigi;
 Marinoni, Giuseppe
Ext.: TAF fig. 162-163

Albergo del Salvadego, 13th c.
Ext.: SAV fig. 11

Apartment House, Zattere,
1954-1958
Gardella, Ignazio
Ext.: DAL 88, TAF fig. 47

Arsenal: Archway, 1460
Gambello, A
Ext.: SAV fig. 32, 32-drg.

Bell Tower, S. Giorgio, 1791
Buratti, Benedetto
Ext.: SAV fig. 96

Biblioteca Querini-Stampalia:
Restoration, 1961-1963
Scarpa, Carlo
Int.: TAF fig. 103

Biennale, 24th: Austria Pavilion,
1954
Hoffmann, Josef
Ext.: SAV fig. 100

Biennale, 24th: Canada Pavilion,
1958
B. P. R.
Ext.: SAV fig. 100

Biennale, 24th: Holland
Pavilion, 1954
Rietveld, Gerrit
Ext.: SAV fig. 100

Biennale, 24th: Venezuela
Pavilion, 1956
Scarpa, Carlo
Ext.: GRE fig. 75, SAV fig. 100

Biennale, 27th: Nordic
Pavilion, 1962
Fehn, Sverre
Ext.: COT-1 246, COT-2 281

Bridge of Sighs, 1564-1614
Contino, Antonio
Ext.: SAV fig. 70

Ca' d'Oro, ca. 1430
Ext.: BAK 166, DEQ 132,
EWA-1 pl. 380, EWA-6 pl.
338, FLE 745, HAT pl. 38,
MIM 290, MUR 256,
PEV 300, SAV fig. 26
Plan: SAV fig. 26

Ca' da Mosto, 12th c.
Ext.: SAV fig. 10
Plan: SAV fig. 10

Ca' Farsetti, 12th c.
Ext.: SAV fig. 9

Ca' Loredan, 12th c.
Ext.: SAV fig. 9

Caffè (Società Canottieri
Bucintoro), 1838
Santi, Lorenzo
Ext.: MEE fig. 55

Campo del Ghetto, 16th-17th c.
Ext.: SAV fig. 80

Campo S. Angelo, 15th c.
Ext.: SAV fig. 31, fig. 31-drg.
Plan: SAV fig. 31

Church of Gesuiti, 1715-1728
Rossi, Domenico
Ext.: SAV fig. 81
Int.: SAV fig. 81

Church of the Tolentini, 1591,
1706-1714
Scamozzi, Vincenzo;
Tirali, Andrea
Ext.: SAV fig. 83

Church of the Zitelle,
1582-1586
Palladio, Andrea
Ext.: SAV fig. 68, WIT 150
Plan: SAV fig. 68

City Planning, 1348
Plan: BET 332

City Planning, 1500
Plan: KOH 61-drg.

City Planning (Barene di
S. Giuliano), 1959
Quaroni, Ludovico; others
Plan: COT-1 651-model,
COT-2 724, GRE fig. 71-drg.

Convento della Carita, 1552
Palladio, Andrea
Ext.: SAV fig. 65
Int: SAV fig. 65
Plan: SAV fig. 65

Doge's Palace (Palazzo Ducale),

ca. 1345-1438
Ext.: DEQ 144-145, EWA-6
pl. 340, FLE 730, KOS fig.
15.3, PEV 260, SAV fig. 23,
TRA 318
Plan: FLE 853, SAV fig. 23

Doge's Palace: L'Arco Foscari,
ca. 1345-1438
Rizzo, Antonio;
Bon, Bartolomeo
Ext.: DEQ 145

Doge's Palace: Scala dei
Giganti, 1483
Rizzo, Antonio
Int.: DEQ 147, EWA-8 pl.
198, HEW pl. 90

Dormitory & Cloister of the Bay
Leavers, 1494-1540
Buora, Giovanni
Ext.: SAV fig. 49

Fenice Theater, 1790-1792
Selva, Giannantonio
Ext.: SAV 94
Int.: SAV 94
Plan: SAV 94

Fondaco dei Tedeschi,
after 1505
Ext.: PEV- 15.9
Int.: EWA-6 pl. 189

Fondaco dei Turchi, 12th c.
Ext.: FLE 477, HAT pl. 26
Plan: EWA-13 fig. 615

Forte S. Andrea (Castel
Nuovo), 1543
Sammichele, Michele
Ext.: MUR 283, SAV fig. 62
Plan: SAV fig. 62

Gesuati (S. Maria del Rosario),
1726-1743
Massari, Giorgio
Ext.: VAR 89, WIA pl. 150
Plan: VAR 89

Harbor Buildings, S. Giorgio,
1810-1815
Mezzani, Giuseppe
Ext.: SAV fig. 96

I. N. A. I. L. Center,
S. Simeone, 1950-1956
Samonà, Giuseppe;
Trincanato, Egle Renata
Ext.: TAF fig. 56

Maddalena Church, 1760
Temanza, Tommaso
Ext.: SAV fig. 92

Madonna dell' Orto, 14th c.
Ext.: SAV fig. 17

Palazzetto, Ponte del Paradiso,
13th c.
Ext.: SAV fig. 12
Plan: SAV fig. 12

Palazzo Ariani-Minotto,
ca. 1350-1400
Ext.: SAV fig. 24

Palazzo Barbi, 1582-1590
Vittoria, Alessandro.
Ext.: SAV fig. 71

Palazzo Belloni-Battagia,
1648-1660?
Longhena, Baldassare
Ext.: MAE-3 25

Palazzo Cavalli Franchetti,
1818-1880
Boito, Camillo;
Manetti, Girolamo
Int.: SAV fig. 99

Palazzo Centani (Goldoni's
House), 15th c.
Ext.: SAV fig. 28

Palazzo Centani: Courtyard,
15th c.
Ext.: SAV fig. 28

Palazzo Contarini:
Spiral Staircase, 15th c.
Ext.: SAV fig. 33

Palazzo Cornaro-Mocenigo,
ca. 1540
Sanmichele, Michele
Ext.: DEF 130, MUR 277

Palazzo Corner (Ca' Corner della
Ca' Grande), 1537-1556
Sansovino, Jacopo
Ext.: FLE 855, HEW pl. 242,

Palazzo Vendramin Calergi
(Palazzo Loredan),
ca. 1500-1509
Coducci, Mauro
Ext.: BLU pl. 61A, DEQ 187,
EWA-12 pl. 11, MAE-1
434, SAV fig. 48

Palazzo Zorzi, 1500
Coducci, Mauro
Ext.: SAV fig. 46

Piazza S. Marco, ca. 1600
Ext.: BET 346, ENA-1 300,
EWA-1 pl. 402, KOH 223,
KOS 475, HEW pl. 81, SAV
fig. 61, TRA pl. 43-col
Int.: KUB 222, 223
Plan: DEF 134, EWA-1 fig.
647, HEW 234, KOS 474

Piazza S. Marco: Napoleanic
Wing, 1810-1811
Antolini, Giovanni;
Santi, Lorenzo;
Soli, Giuseppe Maria
Ext.: MEE fig. 38a, 61,
SAV fig. 95

Pietà Church, Riva degli
Schiavoni, 1744-1760
Massari, Giorgio
Ext.: SAV fig. 90
Int.: SAV fig. 90

Prisons, 1563-1614
Da Ponte, Antonio;
Contino, Tommaso;
Rusconi, Giovanni Antonio
Ext.: SAV fig. 70

Procuratie Nuove, 1581-1599
Scamozzi, Vincenzo
Ext.: DEF 133, MAE-3 609

Procuratie Vecchie
& Clock Tower, 1500-1532
Coducci, Mauro
Ext.: DEF 133, SAV fig. 45

Punta della Goana (Dogana da
Mar), 1677
Benoni, Giuseppe
Ext.: SAV fig. 86
Plan: SAV fig. 86

Railway Bridge, 1841-1846
Meduna, Tommaso
Ext.: SAV fig. 97

Il Redentore
Palladio, Andrea
Ext.: DEF 125, EWA-11 pls.
34, 35, FLE 866, HEW pl.
333, KOS 479, LOW pl. 126,
MUR 310, PEV 366, SAV
fig. 67
Int.: HEW pl. 331, LOW pl.
127, MUR 311, SAV fig. 67
Plan: DEF 125, HEW 309,
KOS 478, MUR 311, SAV
fig. 67
Sect.: KOS 478

Rialto Bridge
Ponte, Antonio da
Ext.: BET 355, HEW pl. 341
Plan: EWA-13 fig. 609

S. Alvise, 1388
Ext.: SAV fig. 21

S. Apollonia Cloister, 12th c.
Ext.: SAV fig. 7

S. Donato, Murano, 12th c.
Ext.: SAV fig. 3

S. Elena, ca. 1435
Ext.: SAV fig. 18

S. Fantin Scarpagnino,
Antonio, 1507-1564
Int.: SAV fig. 52
Plan: SAV fig. 52

S. Francesco della Vigna, 1534
Sansovino, Jacopo
Ext.: MUR 306

S. Francesco della Vigna:
Facade, ca. 1570
Palladio, Andrea
Ext.: DEF 124, HEW pl. 332

S. Giorgio dei Greci,
1538 & later
Ext.: FLE 854
Int.: FLE 854
Plan: FLE 854

S. Giorgio Maggiore, 1565
Palladio, Andrea

Coducci, Mauro
Ext.: DEQ 178-179, HEW pl.
84, SAV fig. 41
Int.: DEQ 176-177
Plan: DEQ 176

S. Niccolò dei Mendicoli, 12th c.
Ext.: SAV fig. 6, 6-drg.

S. Niccolò dei Tolentini,
1706-1714
Tirali, Andrea
Ext.: MEE fig. 5

S. Pietro di Castello, 1596-1619
Smeraldi, Francesco;
Grapiglio, A.
Ext.: SAV fig. 69

S. Salvatore, 1507-1534
Spaventi, Giorgio
Int.: SAV fig. 51
Plan: BUR 116, SAV fig. 51

S. Sebastiano, 1508-1548
Scarpagnino, Antonio
Ext.: SAV fig. 74

S. Simeone Piccolo, 1718-1738
Scalfarotto, Giovanni
Ext.: MEE fig. 5,
SAV fig. 91, VAR 252
Int.: VAR 253

S. Stae, 1710-1712
Rossi, Domenico
Ext.: MAE-3 614, VAR 251

S. Stefano Church & Cloister,
1350s-1374
Ext.: SAV fig. 16
Int.: SAV fig. 16

S. Zaccaria, ca. 1488-1500
Coducci, Mauro;
Gambella, Antonio
Ext.: DEQ 183, HEW pl. 82,
MIM 322, SAV fig. 42
Int.: DEQ 181182, SAV fig. 42
Plan: SAV fig. 42

S. Zaccaria: Chancel Chapel,
1463-ca. 1471
Caducci, Mauro;
Gambella, Antonio
Int.: DEQ 182, HEW pl. 83

Salizzada S. Moisè Buildings,
1853
Fuin, G.
Ext.: SAV 98

Schola Spagnola (Synagogue),
1555
Ext.: SAV fig. 80

Schola Tedesca (Synagogue),
1528
Ext.: SAV fig. 80

Scuola dei Carmini
Longhena, Baldassare
Ext.: SAV fig. 78

Scuola di S. Giovanni
Evangelista, 1349-1512
Coducci, Mauro
Ext.: SAV fig. 29
Int.: HEW pl. 89, LOW pl. 67,
SAV fig. 39

Scuola di S. Maria in Val
Verde, 1523-1583
Sansovino, Jacopo
Ext.: SAV fig. 22, SAV fig. 59

Scuola di S. Rocco,
ca. 1515 & later
Castello, Giambattista;
Scarpagnino, Antonio
Ext.: HEW pl. 342
Int.: HEW pl. 343,
SAV fig. 55
Plan: HEW 316, SAV fig. 55

Scuola Grande di San Marco
(Ospedale Civile), 1485-1495
Buora, Giovanni di Antonio;
Lombardo, Pietro;
Coducci, Mauro
Ext.: DEQ 184-185, EWA-8
pl. 198, FLE 856, HEW pl.
88, LOW pl. 68, SAV fig. 40

Scuola Levantina (Eastern
Synagogue), 1538
Ext.: SAV fig. 80

Slaughterhouse, 1841
Salvadori, Giuseppe
Ext.: SAV 97c

Teatro La Fenice, 1790-1792
Selva, Giovanni Antonio

Porta dei Borsari, ca. 79-81
 Ext.: EWA-13 pl. 235, WAP
 86, WAR fig. 108

Porta dei Leoni,
 1st c. B. C.-1st c. A. D
 Ext.: WAP 33
 Plan: WAP 33

Porta Nuova, 1533-1540
 Sanmicheli, Michele
 Ext.: HEW 215, pl. 222,
 MUR 283
 Plan: HEW 215

Porta Palio, 1542-1555
 Sanmicheli, Michele
 Ext.: EWA-12 pl. 393, FLE
 868, HEW pl. 223, MUR 283
 Plan: HEW 216

Porta S. Zeno
 Elev.: BUR 166-drg.

S. Anastasia, 1261 & later
 Ext.: FLE 741

S. Zeno Maggiore,
 ca. 1123 & later
 Ext.: CON 310, EWA-12 pl.
 220, FLE 476, 477
 Int.: CON 311, FLE 476

VETULONIA

City Planning, 750-100 B. C.
 Plan: BOE 65

VICENZA

Basilica Palladiana (Palazzo
 della Ragione), 1549
 Palladio, Andrea
 Ext.: BUR 155, DEF 140,
 EWA-11 pl. 29, FLE 862,
 HAT pl. 45, HEW pl. 334,
 MAE-3 356, MER 100-col.,
 MUR 296-298
 Plan: FLE 862, HEW 311,
 MUR 298
 Sect.: FLE 862

Casa Civena
 Palladio, Andrea
 Ext.: DEF 109-drg.

Casa del Diavolo, 1571

Palladio, Andrea
 Ext.: FLE 865

Loggia del Capitanio, 1571
 Palladio, Andrea
 Ext.: HEW pl. 335,
 MAE-3 359, MUR 299

Palazzo Chiericati (Museo
 Civico), 550-1580
 Palladio, Andrea
 Ext.: BEA 512, BUR 158,
 ENA-1 307, EWA-11 pl. 30,
 KOS 486, LOW pl. 124, MUR
 299, PEV 355
 Plan: BEA 512

Palazzo da Schio, ea. 15th c.
 Ext.: HEW pl. 95

Palazzo Porto Barbaran
 Ext.: BUR 157

Palazzo Thiene-Bonin-Longara
 (Banco di Popolare), ca. 1542
 Palladio, Andrea
 Ext.: BUR 160, HEW pl. 336,
 MUR 295
 Plan: EWA-11 fig. 67,
 MUR 301

Palazzo Valmarana (Palazzo
 Braga), 1566
 Palladio, Andrea
 Ext.: BAL 99, BUR 157,
 EWA-11 pl. 30, FLE 865,
 HEW pl., KOS 481,
 MUR 294, 302
 Plan: MUR 302

S. Felice e Fortunato, 5th c.
 Plan: KRA 138

S. Lorenzo, after 1281/82
 Int.: WHI pl. 6

Teatro Olimpico, 1580-1584
 Palladio, Andrea;
 Scamozzi, Vincenzo
 Int.: BUR fig. 351, FLE 811,
 LOW pl. 128, MAE-3 359,
 MIL 349, PEH 6.8, 6.09
 Plan: BEA 675, HEW 318,
 MUR 312, PEH 6.10

Theater: Project, 1968
 Gardella, Ignazio

Ext.: TAF fig. 86-model

Villa Rotunda (Villa Capra),
1550 & later
Palladio, Andrea
Ext.: BAK 239, DEF 70,
EWA-11 pl. 31, FLE 865,
HAT pl. 45, HEW pl. 339,
KOS 481, LOW pl. 122, MIM
346, MUR 293, PEV 353
Int.: BAK 239
Plan: DEF 68, FLE 865, HEW
314, MIM 346, MUR 292,
PEV 353
Sect.: BUR 183, FLE 865,
MIM 346
Elev.: BUR 183

VICOFORTE DI MONDOVI

S. Maria, 1596
Vitozzi, Ascanio; others
Ext.: HEW pl. 328
Int.: HEW pl. 329
Plan: HEW 302

VIGANELLO

House, 1980
Botta, Mario
Ext.: KLO 278-col.

Tomb, ca. 500 B. C.
Plan: BOE 50
Sect.: BOE 50

VIGEVANO

Piazza Ducale, ca. 1492-1494

Bramante, Donato
Ext.: DEF 30, MER 46-col., 47

VILLANOVA DI MONDOVI

S. Croce
Vittone, Bernardo Antonio
Ext.: WIT 221-drg.

VINCIGLIATA

Castello dei Visdomini, ca. 1855
Fancelli, Giuseppe
Ext.: MEE fig. 109

VITERBO

Palazzo dei Papi, 1266
Ext.: WHI pl. 12

VOLSINII. *See* BOLSENA

VOLTERRA

Castle, 1343
Ext.: FLE 756

Etruscan Gate, 3rd c. B. C.
Ext.: KOS 131

Palazzo dei Priori, 1208-1257
Ext.: EWA-13 pl. 251, FLE 745

VULCI

Etruscan Shrine, 3rd c. B. C.
Ext.: ROB pl. 8B

PART II
Architect Index

ACHILLI, MICHELE, 20th c.

City Hall (Civic Center), 1963-1966, Segrate

Civic Center, Pieve Emanuele, 1968-1982, Milan

Secondary School, Monaca di Cesano Boscone, 1975-1983, Milan

AGATI, LUIGI, 20th c.

La Martella Village, 1951 & later, Matera

AGGARBATI, FABRIZIO, 20th c.

Palazzo Municipale Project, 1974, Legnano

AGO, FABRIZIO, 20th c.

Chiesa della Sacra Famiglia, 1969-1973, Salerno

AJROLDI, CESARE, 20th c.

City Hall, Cadoneghe

ALAMANNI, MARIO, 20th c.

Chiesa della Sacra Famiglia, 1969-1973, Salerno

ALBERTI, LEON BATTISTA, 1404-1472

Palazzo Rucellai, 1446-1451, Florence

Palazzo Rucellai Cortile, 1446-1451, Florence

Palazzo Venezia Courtyard, ca. 1455-1471, Rome

S. Andrea, 1472-1494, Mantua

S. Annunziata, ca. 1450, Florence

S. Francesco (Tempio Malatestiano, Malatesta Temple), ca. 1446, Rimini

S. Maria Novella, 1278-1350; 1456-1470, facade, Florence

S. Pancrazio Chapel of the Holy Sepulchre (Rucellai Chapel), ca. 1455-1460, Florence

S. Peter's Project, ca. 1450, Vatican City

S. Sebastiano, 1460, Mantua

ALBERTOLLI, GIOCONDO, 1742-1839

Palazzo Reale, 1772-1775, Milan

Villa Poggio Imperiale, 1772-1775, Florence

ALBERTOLLI, GRATO, 18th c.

Villa Poggio Imperiale,
1772-1775, Florence

ALBINI, FRANCO, 1905-1977

City Planning (Master Plan),
1945, Milan

I. A. C. P. (Mangiagalli) Quarter,
1950-1951, Milan

I. N. A. Casa Quarter, Cesate,
1950 & later, Milan

I. N. A. Office Building,
1950-1953, Parma

Luigi Zoja Baths, 1967-1970,
Salsomaggiore

Palazzo Bianco Communal
Galleries, 1950-1951, Genoa

Palazzo Rosso Museum,
1953-1960, Genoa

Rifugio Pirovano, 1949-1951,
Cerinia

Rinascente Department Store,
1957-1961, Rome

S. Agostino Museum,
1977-1986, Genoa

S. Lorenzo Treasury Museum
(Tesoro di S. Lorenzo),
1952-1956, Genoa

Subway, 1963, Milan

Triennale, 5th Steel-Framed
Residence, 1933, Milan

ALBINI, MARCO, 20th c.

Luigi Zoja Baths, 1967-1970,
Salsomaggiore

ALBRICCI, GIANNI, 20th c.

I. N. A. Casa Quarter, Cesate,
1950 & later, Milan

**ALCOTTI, GIOVANNI BATTISTA,
17th c.**

Teatro Farnese (Farnese

Theater), 1618-1628, Parma

ALEANDRI, IRENEO, 1795-1885

Railway Viaduct, 1846-1853,
Ariccia

ALESSI, GALEAZZO, 1512-1572

Palazzo Marino (Municipale),
1558-1560, Milan

Palazzo Sauli, ca. 1555, Genoa

S. Maria Assunta de Carignano,
1549, Genoa

S. Maria Presso S. Celso,
1570, Milan

S. Paolo e Barnaba, 1561-1567,
Milan

Villa Cambiaso, 1548, Genoa

Villa Grimaldi, ca. 1555, Genoa

**ALFIERI, BENEDETTO,
1700-1767**

Palazzo Ghilini, 1730-1733,
Allesandria

S. Giovanni Battiste, 1757-1764,
Cangnano

Teatro Regio, 1738-1740, Turin

**ALGARDI, ALESSANDRO,
1595-1654**

S. Ignazio di Loyola, 1626-1650,
Rome

S. Maria della Scala Chapel,
ca. 1650, Rome

ALVINO, ENRICO, 1809-1972

Cathedral, 1877-1905, Naples

Railway Station, 1867 & later,
Naples

**AMADEO, GIOVANNI ANTONIO,
ca. 1447-1522**

Cathedral, 1487-1490, Milan

Certosa di Pavia, 1429-1473,

Pavia

S. Maria Maggiore Capella Colleoni (Colleoni Chapel), 1470-1473, Bergamo

AMATI, CARLO, 1776-1852

Cathedral, 1806-1813, Milan

S. Carlo al Corso, 1836-1847, Milan

AMMANATI, BARTOLOMEO, 1511-1592

Collegio Romano, 1582, Rome

Palazzo della Preettura (Palazzo della Signoria, Palazzo de Governo), 1550, Lucca

Palazzo di Firenze, 1550, Rome

Palazzo Micheletti, ca. 1550, Lucca

Palazzo Pitti, 1558-1570, Florence

Ponte Santa Trinità, 1567-1570, Florence

Villa Barbaro, 1560-1568, Maser

Villa Barbaro Nymphaeum, 1560-1568, Maser

Villa Giulia (Villa of Julia), 1550-1555, Rome

Villa Giulia Nymphaeum, 1552, Rome

AMOROSO, FRANCESCO, 20th c.

Zen Quarter Project, 1969, Palermo

ANDREANI, ALDO, 20th c.

Apartment House, Via Serbelloni, 1924-1930, Milan

Palazzo Fidia, 1924-1930, Milan

ANDREANI, CLAUDIO, 20th c.

Residential Quarter, Forte di Quezzi, 1956 & later, Genoa

ANGELLINI, FRANCESCO MARIA

Palazzo Aldrovandi-Montanari, Bologna

ANSELMI, ALESSANDRO, 1934-

Cemetery, Parabita, 1967-1982

See also G. R. A. U.

ANTELAMI, BENEDETTO, 1150?-1230?

Baptistery, 1196-1270, Parma

S. Andrea, 1219-1225/1226, Vercelli

ANTINORI, GIOVANNI, 1734-1792

Foro Bonaparte Project, 1801-1806, Milan

Trinità dei Monti Obelisk, 1786-1789, Rome

ANTOLINI, GIOVANNI, 1756-1841

Piazza S. Marco Napoleanic Wing, 1810-1811, Venice

ANTONELLI, ALESSANDRO, 1798-1888

Cathedral, 1854-1869, Novara

Mole Antonelliana, 1863-1888, Turin

S. Gaudenzio, 1841-1888, Novara

Santuario, 1830 & later, Boca

ANTONELLI, FRANCO, 20th c.

I. N. A. Casa Residential Complex, Galatina, 1958, Lecce

ANVERSA, LUISA, 20th c.

Church Project, 1970, Gibellina

APIRLE, NELLO, 20th c.

Monument of the Fosse
Ardeatine, 1944-1947, Rome

APOLLODORUS, 2nd c.

Column of Trajan, Forum of
Trajan, 113, Rome

Forum of Trajan (Forum
Traianus), ca. 113-117, Rome

Markets of Trajan, Trajan's
Forum, 2nd c., Rome

ARATA, GIULIO ULISSE, 1885-?

Palazzo Berri-Meregalli, 1914,
Milan

ARMANNI, OSVALDO, 1855-1929

Synagogue, 1889, Rome

**ARNOLFO DE CAMBIO,
ca. 1245-ca. 1310**

Cathedral, ca. 1310 & later,
Orvieto

Cathedral, ca. 1500, Florence

City Planning, ca. 1250-1300,
Florence

Palazzo Vecchio (Palazzo dei
Priori), 1298-1314 & later,
Florence

S. Croce, 1294-1442, Florence

S. Maria del Fiore (Il Duomo),
1296-1462, Florence

ARRIGHI, ANTONIO, 18th c.

Palazzo Dati, 1769, Cremona

ASCHIERI, PIETRO, 20th c.

Casa de Salvi, 1930, Rome

Work House for Blind War
Veterans, 1930-1931, Rome

ASCIONE, ERRICO, 20th c.

Palazzo Municipale Project,

1974, Legnano

ASPRUCCI, ANTONIO, 1723-1808

Villa Borghese, ca. 1787, Rome

Villa Borghese Gardens,
ca. 1787, Rome

Villa Borghese Temple of
Esculapius, 1785-1792, Rome

ASPRUCCI, MARIO, 1764-1804

Villa Borghese, ca. 1787, Rome

Villa Borghese Gardens,
ca. 1787, Rome

Villa Borghese Temple of
Esculapius, 1785-1792, Rome

ASTENGO, GIOVANNI, 20th c.

Community Center, Falchera
Residential Unit, 1950-1951,
Turin

AULENTI, GAE, 1927-

Casa Agnelli (Lamb House),
1968-1969, Milan

Fiat Lingotto, 1983, Turin

House for an Art Lover,
1969-1970, Milan

AVERLINO, ANTONIO. *See*
FILARETE

AYMONINO, CARLO, 1926-

Hospital, 1984, Mestre

I. N. A. Housing Development,
Tiburtina Quarter (Casa
Tiburtina), 1950-1954, Rome

Marconi School of Science,
1970, Pesaro

Palace of Justice, 1977, Ferrara

Residential Units, Gallaretese
Quarter, 1969-1970, Milan

Small Palace, Arbia Street,
1960-1961, Rome

**AZZURRI, FRANCESCO,
1827-1901**

Palace of Government,
San Marino

**B. B. P. R. (Banfi, Gian Luigi;
Barbiano di Belgiojoso,
Ludovico; Peressutti, Enrico;
Rogers, Ernesto N.)**

Chase Manhattan Bank Building,
1969, Milan

Grotosoglio Housing District,
1963, Milan

Office Building, Meda Square,
Milan

Sun Therapy Colony, 1939,
Legnano

Torre Velasca (Velasca Tower),
1957-1960, Milan

Triennale, 10th Labyrinth of
Youth, 1951, Milan

See also B. P. R.

**B. P. R. (Barbiano di Belgiojoso,
Ludovico; Rogers, Ernesto N.)**

Biennale, 24th Canada Pavilion,
1958, Venice

I. N. A. Casa Quarter, Cesate,
1950 & later, Milan

Immobiliare Cagisa Office
Building, 1958-1969, Milan

Monument to the Victims of
Concentration Camps
(Cimitero Monumentale),
1946, Milan

Palazzo del Littorio Project,
1933, Rome

Sforzesco Castle Museums,
1954-1956, Milan

See also B. B. P. R.

**BALDESSARI, LUCIANO,
1896-1982**

Bar Craja, 1930, Milan

Biennale, 4th Exposition
Installation, 1930, Monza

Frua De Angeli Factory, 1931,
Milan

Milan Fair Breda Pavilion,
1953-1954, Milan

Silk Trade Fair Exposition
Installation, 1927, Como

BANFI, GIAN LUIGI, 1910-1945

Palazzo del Littorio Project,
1933, Rome

See also B. B. P. R.

**BARABINO, CARLO FRANCESCO,
1768-1835**

Chiesa della Santissima
Annunziata, 1830, Genoa

S. Annunziata, 1587; facade
ca. 1830, Genoa

Staglieno Cemetery, 1825,
Genoa

Teatro Carlo Felice, 1826-1828,
Genoa

**BARBIANO DI BELGIOJOSO,
LUDOVICO, 1909- .**
See B. B. P. R.

BARBIERI, GIUSEPPE, 1777-1838

Cemetery, 1828 & later, Verona

Palazzo Municipale, 1830s,
Verona

**BARONCELLI, GIAN
FRANCESCO, ?-1694**

Palazzo Barolo, 1692, Turin

BARONI, GIORGIO, 20th c.

Alfa-Romeo Works Storage,
1937, Milan

BARTOLI, ENRICO, 19th c.

S. Croce, 1887, Parma

BARTOLOMEO, MICHELOZZO DI. *See* **MICHELOZZO DI BAROLOMEO**

BASILE, ERNESTO, 1857-1932

Palazzo del Parlamento Nazionale Project, 1890, Rome

Palazzo di Giustizia Project, 1885, Rome

Palazzo Montecitorio, 1902 & later, Rome

Villa Igiea, 1901, Palermo

Villino Florio, 1899-1903, Palermo

BASILE, GIOVANNI BATTISTA, 1825-1891

Teatro Massimo, 1875-1897, Palermo

BATTAGIO, GIOVANNI, 15th c.

S. Maria della Croce, 1493, Crema

BATTISTI, EMILIO, 1938-

Cemetery Project, 1981, Lissone

BAZZANI, CESARE, 1878-1939

Biblioteca Nazionale Centrale, 1911, Florence

Galleria Nazionale d'Arte Moderna, 1911, Rome

Minstero dell' Educazione, 1913-1928, Rome

BEDONI, CRISTIANA, 20th c.

M. P. S. Offices, 1958, Messina

BELGIOJOSO, LUDOVICO. *See* **B. B. P. R.**

BELTRAME, PIERO, 1944-

Primary School, 1984, Pordenone

BELTRAMI, LUCA, 1854-1933

Castello Sforza, Milan

Cathedral, 1886, Milan

Palazzo Marino, 1890, Milan

BENCI DI CIONE, 14th c.

Loggia dei Lanzi, 1376-1382, Florence

BENEDETTI, ELPIDIO, 17th c.

Piazza di Spagna Project, 1660s, Rome

BENEDETTO DA MAIANO, 16th c.

Palazzo Strozzi, 1489-1539, Florence

BENONI, GIUSEPPE, 17th c.

Punta della Goana (Dogana da Mar), 1677, Venice

BERARDI, PIER N., 20th c.

S. Maria Novella Railroad Station, 1932-1934, Florence

BERLAM, RUGGIERO, 1854-1920

Synagogue, Trieste

BERNASCONI, GIUSEPPE

Sanctuary Fourth Chapel, Varese

BERNINI, GIAN LORENZO, 1598-1680

Barcaccia Fountain, Piazza di Spagna, 1627, Rome

Fountain of the Four Rivers, 1648-1651, Rome

Palazzo Barberini, 1628-1633, Rome

Palazzo Chigi Odescalchi, 1664, Rome

Palazzo del Vaticano Scala Regia, Vatican City

Palazzo di Montecitorio (Chamber of Deputies, Palace of Justice), 1650-1694, Rome

Piazza del Popolo, 1662-1679, Rome

S. Andrea al Quirinale, 1658-1670, Rome

S. Bibiana, 1624-1626, Rome

S. Maria dei Miracoli, 1662-1679, Rome

S. Maria dell'Assunzione, 1662-1664, Ariccia

S. Maria della Vittoria Cornaro Chapel, 1645-1646, Rome

S. Maria di Montesanto, 1662-1679, Rome

S. Peter's Baldacchino, ca. 1655-1657, Vatican City

S. Peter's Square (Piazza San Pietro), 1655-1657, Vatican City

S. Tommaso di Villanova, 1658-1661, Castel Gandolfo

Triton Fountain, Piazza Barberini, 1641, Rome

BIANCHI, L. GROSSI, 20th c.

I. N. A. Casa Residential Unit, Villa Bernabo Brea, 1953, Genoa

BIANCHI, MARCO

S. Francesco da Paola, Milan

BIANCHI, PIETRO, 1787-1849

S. Francesco di Paola, 1817-1846, Naples

BIANCHI, SALVATORE, 1821-1884

Central Station, 1867 & later, Rome

Porta Nuova Station, 1866-1868, Turin

BIANCO, BARTOLOMEO, ca. 1590-1657

Palazzo del'Universita, 1634-1636, Genoa

Palazzo Durazzo-Pallavicini, 1619 & later, Genoa

Porta Pia, 1633, Genoa

University, 1630, Genoa

BIBIENA, GIUSEPPE GALLI. *See* **GALLI BIBIENA, GIUSEPPE**

BIGIO, NANNI DI BACCIO, ?-1568

Porta del Popolo, 1561-1564, Rome

BINAGO, LORENZO, 1556-1629

S. Alessandro in Zebedia, 1601, Milan

BISOGNI, SALVATORE, 20th c.

Zen Quarter Project, 1969, Palermo

BITONTO, GIOVANNI MARIA DA, 17th c.

Palazzo Spada, 17th c., Rome

BOFFA, SANDRO MOLLI, 20th c.

Community Center, Falchera Residential Unit, 1950-1951, Turin

BOITO, CAMILLO, 1836-1914

Casa Verdi, 1899, Milan

Cemetery, 1865, Gallarate

Hospital, 1871 & later, Gallarate

Municipal Museum, 1879, Padua

Palazzo Cavalli Franchetti, 1818-1880, Venice

Palazzo delle Debite, 1872, Padua

BOLLATI, GUSEPPE, 1819-1869

Piazza dello Statuto, 1864, Turin

BOLLI, BARTOLOMEO

Palazzo Litta, Milan

BON, BARTOLOMEO, 15th c.

Doge's Palace L'Arco Foscari,
ca. 1345-1438, Venice

**BONSIGNORE, FERDINANDO,
1760-1843**

Chiesa della Gran Madre di Dio,
1818-1831, Turin

Church of Gran Madre de Dio,
1818-1831, Turin

**BORROMINI, FRANCESCO,
1599-1667**

Collegio di Propaganda Fide,
1662-1664, Rome

Collegio di Propaganda Fide
Chapel of the Three Kings
(Capella dei Re Magi),
1662-1664, Rome

Oratory of S. Phillip Neri
(Oratorio di S. Filippo Neri),
1637-1650, Rome

Palazzo Barberini, 1628-1633,
Rome

Palazzo Falconieri, 1646-1649,
Rome

Palazzo Spada, Rome

S. Agnese in Agone (S. Agnese in
Piazza Navona), 1652-1666,
Rome

S. Andrea delle Fratte,
1653-1665, Rome

S. Carlo alle Quattro Fontane,
1638-1667, Rome

S. Giovanni in Laterano,
1646-1649, Rome

S. Girolamo della Carita Capella
Spada, 1662, Rome

S. Ivo della Sapienza,
1642-1650, Rome

S. Maria dei Sette Dolori,
ca. 1650, Rome

S. Maria in Vallicella (Chiesa
Nuova): Oratory of the
Filippini, 1637-1640, Rome

BOTTA, MARIO, 1943-

Casa Rotonda, 1981, Stabio

House, 1975-1976, Ligorno

House, 1972-1973,
Riva San Vitale

House, 1980, Viganello

Villa, 1970-1971, Cadenza

BOTTONI, PIERO, 20th c.

Biennale, 4th Casa Elettrica,
1930, Monza

City Planning (Master Plan),
1945, Milan

Housing, San Siro Project, 1932,
Milan

Triennale, 5th Public Housing
Pavilion, 1933, Milan

BRAGHIERI, GIANNI, 1945-

Cemetery Project, 1971,
Modena

Elementary School, 1972,
Fagnano Olona

**BRAMANTE, DONATO,
1444?-1514**

Cathedral, 1488, Pavia

Cortile del Belvedere,
1505 & later, Vatican City

Nympaeum (Ninfeo), Genazzano

Palazzo Belvedere, Vatican Spiral
Staircase, 1540-1550,
Vatican City

Palazzo Caprini, ca. 1514, Rome

Palazzo dei Tribunali, ca. 1512,
 Rome

Palazzo Ducale Capella del
 Perdono (Perdono Chapel),
 ca. 1444-1482,

Piazza Ducale, ca. 1492-1494,
 Vigevano

S. Casa, 1509, Loreto

S. Lorenzo in Damaso, 380;
 rebuilt; ca. 1500, Rome

S. Maria della Pace Cloister,
 1500-1504, Rome

S. Maria delle Grazie,
 1492-1497, Milan

S. Maria Nascente, ca. 1497,
 Abbiategrasso

S. Maria Presso S. Satiro,
 ca. 1480, Milan

S. Peter's Project, 1506,
 Vatican City

S. Peter's Project, ca. 1514,
 Vatican City

S. Pietro in Montorio Tempietto,
 1502, Rome

S. Satiro, Milan

BRASINI, ARMANDO, 1879-1965

Convent of Buon Pastore,
 1930, Rome

BREGA, GIUSEPPE, 20th c.

Villa Ruggeri, 1902-1907,
 Pesaro

BREGLIA, NICOLA

Railway Station, 1867 & later,
 Naples

BREGNO, ANDREA, 15th-16th c.

Palazzo della Cancelleria Papale,
 1485-1513, Rome

S. Maria del Popolo, 1472-1480,
 Rome

**BRENTANO, GIUSEPPE,
1862-1889**

Cathedral, 1888, Milan

BRIGIDINI, DANIELE, 20th c.

City Hall (Civic Center),
 1963-1966, Segrate

Civic Center, Pieve Emanuele,
 1968-1982, Milan

BRITTO, GIOVANNI, 19th c.

Cimitero Monumentale,
 1890-1896, Padua

BROCCA, GIOVANNI, 19th c.

S. Eustorgio, 1863-1865, Milan

BROGGI, LUIGI, 1851-1926

Magazzino Contratti, 1903,
 Milan

Palazzo del Parlamento Nazionale
 Project, 1890, Rome

Palazzo del Parlamento Nazionale
 Project, 1890, Rome

**BRUNELLESCHI, FILIPPO,
1377-1446**

Ospedale degli Innocenti
 (Foundling Hospital),
 1421-1445, Florence

Palazzo di Parte Guelfa, ca. 1420,
 Florence

Palazzo Pitti, 1458 & later,
 Florence
S. Croce Pazzi Chapel (Cappella
 de'Pazzi), ca. 1429-1446,
 Florence

S. Lorenzo (Basilica di
 S. Lorenzo), 1421-1460,
 Florence

S. Lorenzo Old Sacristy
 (Sacrestia Vecchia),
 1421-1428, Florence

S. Maria degli Angeli,

1434-1437, Florence

S. Maria del Fiore Dome,
1420-1434, Florence

S. Maria del Fiore Lantern,
1445-1462, Florence

S. Spirito, 1445-1482, Florence

BRUNO, NICCOLO, ?-1889

Palazzo Comunale, 1869-1871,
Trieste

BUFALINI, FRANCESCO, 17th c.

S. Maria delle Fornace,
1694 & later, Rome

BUONARROTI, MICHELANGELO.
See **MICHELANGELO BUONARROTI**

**BUONTALENTI, BERNARDO,
1531-1608**

Boboli Gardens,
ca. 1550 & later, Florence

S. Lorenzo Capella dei Principi,
1603 & later, Florence

S. Trinità, 1594, Florence

Villa Medicea, Artimino

Villa Medicea, Petraia

**BUORA, GIOVANNI DI ANTONIO,
15th c.**

Dormitory & Cloister of the Bay
Leavers, 1494-1540, Venice

Scuola Grande di San Marco
(Ospedale Civile), 1485-1495,
Venice

BURATTI, BENEDETTO, 18th c.

Bell Tower, S. Giorgio, 1791,
Venice

**BURELLI, AUGUSTO ROMANO,
1938-**

Church of Empress S. Elena,

1983-1986, Montenars

City Hall, 1979-1980, Cercivento

BUZZI, L., 17th c.

Biblioteca Ambrosiana,
1603-1609, Milan

**CACCIA-DOMINIONI, LUIGI,
20th c.**

Office & Residential Building,
Corso Monforte, 1965, Milan

Orphanage & Convent, 1955,
Milan

Villa, Via XX Settembre,
1954-1955, Milan

CACIALLI, GIUSEPPE, 1770-1828

Palazzo Pitti, 1812 & later,
Florence

Villa Poggio Imperiale,
1804 & later, Florence

CADUCCI, MAURO, 15th c.

S. Zaccaria Chancel Chapel,
1463-ca. 1471, Venice

CAFIERO, VITTORIO, 20th c.

I. N. C. I. S. Quarter, near
E. U. R., 1958 & later, Rome

CAGNOLA, LUIGI, 1762-1833

Arco del Sempione, 1806-1838,
Milan

Porta Ticinese, 1801-1814,
Milan

La Rotonda, 1834, Ghisalba

Villa Cagnola d'Adda,
1813-1833, Inverigo

CALCAGNI, LUIGI, 20th c.

Hospital, 1984, Mestre

CALCAPRINA, CINO, 20th c.

Monument of the Fosse
Ardeatine, 1944-1947, Rome

**CALDERINI, GUGLIELMO,
1837-1916**

Cathedral, 1880-1886, Savona

Palazzo di Giustizia, 1886-1910,
Rome

S. Paolo fuori le Mura,
1893-1910, Rome

CALINI, LEO, 20th c.

Stazione Termini (Railway
Station Terminal), 1947-1951,
Rome

**CAMPORESE, PIETRO,
1792-1873**

Palazzo Wedekind Portico di
Veio, 1838, Rome

CAMPORESI, G., 18th c.

Museo Pio-Clementino,
ca. 1773-1780, Rome

CAMUS, RENATO, 20th c.

Triennale, 5th Steel-Framed
Residence, 1933, Milan

CANCELLOTTI, GINO, 20th c.

City Planning, 1933, Sabaudia

CANALI, GUIDO, 1935-

Parmesan Cheese Cooperative
Headquarters, 1983,
Reggio Emilia

CANELLA, GUIDO, 1932

City Hall, 1976-1981,
Seggiano di Pioltello

City Hall (Civic Center),
1963-1966, Segrate

Civic Center, Pieve Emanuele,
1968-1982, Milan

I. A. C. P. Quarter, Bollate,
1974-1981, Milan

Secondary School, Monaca di
Cesano Boscone, 1975-1983,
Milan

**CANEVARI, RAFFAELE,
1825-1900**

Ministero delle Finanze,
1870-1877, Rome

**CANIGGIA, GIANFRANCO,
1933-1987**

Biblioteca Nazionale Project,
1957, Rome

Palazzo di Giustizia, 1968-1981,
Teramo

CANINA, LUIGI, 1795-1856

Villa Borghese Egyptian
Propylea, 1820s, Rome

Villa Borghese Fountain of
Esculapius, 1818-1828, Rome

Villa Borghese Piazzale Flaminio
Gates, 1825-1828, Rome

Villa Borghese Triumphal Arch,
1818-1828, Rome

CANONICA, LUIGI, 1762-1844

Arena Triumphal Gate,
1806-1813, Milan

CANTAFORA, ARDUINO, 20th c.

Elementary School, 1972,
Fagnano Olona

CANTONI, SIMONE, 1736-1818

Palazzo Servelloni, 1794, Milan

CAPOBIANCO, MICHELE, 1921-

Mental Hospital, 1966-1978,
Girifalco

CAPPAI, IGINIO, 1932-

Swimming Pool, 1974-1983, Mirano

CAPPONI, GIUSEPPE, 20th c.

Casa Nebbiosi, 1929-1930, Rome

University of Rome Botany Building, 1932-1935, Rome

CARDELLI, ALDO, 20th c.

Monument of the Fosse Ardeatine, 1944-1947, Rome

Stazione Termini Project, 1947, Rome

CARDUCCI, ACHILLE

S. Matteo, Lecce

CARE, ARRIGO, 20th c.

Stazione Termini Project, 1947, Rome

CARESALE, ANGELO, 18th c.

Teatro S. Carlo, 1737, Naples

CARIMINI, LUCA, 1830-1890

Palazzo Brancaccio, 1885-1896, Rome

Palazzo di Giustizia Project, 1886, Rome

CARMASSI, MASSIMO, 1943-

Junior High School, 1983, Putignano

CARMINATI, ANTONIO, 20th c.

Palazzo del Littorio Project, 1933, Rome

CARNELIVARI, MATTEO, 15th c.

Palazzo Abatellis, 15th c., Palermo

Palazzo Aiutamicristo, 15th c., Palermo

S. Maria della Catena, 15th c., Palermo

CASTELLAMONTE, AMEDEO DI, ca. 1550-1639/40

Palazzo Beggiono di S. Albano (Palazzo Lascaris), 1665, Turin

Venaria Reale, 1660-1678, Turin

Via Po, 1673 & later, Turin

CASTELLAMONTE, CARLODI, 17th c.

Piazza S. Carlo, 1621 & later, Turin

CASTELLI, ANNA, 20th c.

Alfa-Romeo Works Technical Offices, Arese, 1968-1972, Milan

CASTELLO, GIAMBATTISTA, ca. 1509-1569

Scuola di S. Rocco, ca. 1515 & later, Venice

CASTIGLIONE, ACHILLE, 1918-

Fine Arts Society Exhibition, 1952, Milan

Office Tower Building, 1952, Milan

CASTIGLIONI, ENRICO, 20th c.

Istituto Tecnico Industriale, 1968, Busto Arsizio

Scuola, 1964, Busto Arsizio

Technical High School, 1964, Milan

CATONI, SIMONE, 18th c.

Palazzo Ducale, 1771, Genoa

CATTANEO, RAFFAELE, 1860-1889

S. Lorenzo fuori le Mura, 1878 & later, Rome

CAVALLARI, AUGUSTO, 20th c.

High School, Valletti Quarter, 1964, Turin

CECCHINI, ANGELO, 20th c.

I. N. A. Casa Residential Complex, Galatina, 1958, Lecce

CELER, 1st c.

Domus Aurea (Golden House of Nero), after 64, Rome

CELLI, CARLO, 1936- .
See Studio Celli & Tognon

CELLI, LUCIANO, 1940- .
See Studio Celli & Tognon

CELLINI, FRANCESCO, 1944-

Casa 'Aleph', 1972-1977, Ciampino

Piazza della Repubblica Project, 1982, Turin

CEPPI, CARLO, 1829-1921

Casa delle Imprese Bellia, 1894-1898, Turin

Palazzo Ceriani-Peyron, 1878-1879, Turin

Railroad Station, 1866-1868, Bologna

CERADINI, GIULIO, 20th c.

Stazione Termini Project, 1947, Rome

CERCATO, PAOLO, 20th c.

Residential Building, Via Campania, 1963-1965, Rome

CERUTI, GIOVANNI, 1842-1907

Chiesa dell' Assunta, 1891-1896, Sacro Monte

Museo Civico di Storia Naturale, 1892 & later, Milan

CERUTTI, EZIO, 20th c.

City Planning (Master Plan), 1945, Milan

CERVETTO, DOMENICO, 19th c.

Chiesa dell' Immacolata, 1856-1873, Genoa

CHIARINI, CARLO, 20th c.

I. N. A. Housing Development, Tiburtina Quarter (Casa Tiburtina), 1950-1954, Rome

Residential Complex, Tor Sapienza, 1982-1985, Milan

CHIARINI, UMBERTO, 20th c.

I. A. C. P. Quarter, Via della Barca, 1957-1962, Bologna

CHIORINO, MARIO ALBERTO, 20th c.

University of Cagliari Project, 1972, Cagliari

CINO, GIUSEPPE

Seminary Palace, Lecce

CIOLLI, GIACOMO, 18th c.

S. Paolo all Regola, ca. 1686-1721, Rome

COCCONCELLI, CIRO, 20th c.

I. N. A. Casa Residential Complex, Galatina, 1958, Lecce

CODUCCI, MAURO, ca. 1440-1504

Palazzo Vendramin Calergi (Palazzo Loredan),

ca. 1500-1509, Venice

Palazzo Zorzi, 1500, Venice

Procuratie Vecchie & Clock Tower, 1500-1532, Venice

S. Giovanni Crisostomo, 1497, Venice

S. Maria Formosa, 1492, Venice

S. Michele in Isola, ca. 1470, Venice

S. Zaccaria, ca. 1488-1500, Venice

Scuola di S. Giovanni Evangelista, 1349-1512, Venice

Scuola Grande di San Marco (Ospedale Civile), 1485-1495, Venice

Torre dell'Orologio (Clock Tower), 1496-1499, Venice

COLA DA CAPRAROLA, 16th c.

S. Maria della Consolazione, 1508-1604, Todi

COLA DALL' AMATRICE, 1489-ca. 1547

S. Bernardino, 1525, Aquila

COLLAMARINI, EDOARDO, 1864-1928

Sacro Cuore, 1912 & later, Bologna

Villa Doria Pamphili Chapel, 1896-1902, Rome

COLOMBINI, LUIGI, 20th c.

Rifugio Pirovano, 1949-1951, Cerinia

COMENCINI, GIOVANNI BATTISTA, 20th c.

Hotel Santa Lucia, 1906, Naples

CONTINO, ANTONIO, 17th c.

Bridge of Sighs, 1564-1614, Venice

CONTINO, TOMMASO, 17th c.

Prisons, 1563-1614, Venice

COPER STUDIO, 20th c.

Le Grazie Cooperative Quarter, 1972-1975, Ancona

COPPEDE, GINO, 1866-1927

Apartments, Via Maragliano, 1907, Genoa

Apartments, Via Po, 1921, Rome

Castello Mackenzie, 1890s, Genoa

Villino Piaggio, ca. 1895, Genoa

CORINTI, CORINTO, 19th c.

Housing, ca. 1888, Florence

Monument to Victor Emanuel II Project, 1884, Rome

CORTONA, PIETRO B. DA, 1596-1669

Palazzo Barberini Theater, ca. 1640, Rome

Palazzo Chigi in Piaza Colonna, Rome

S. Luca e Martina, 1635-1650, Rome

S. Maria della Pace, 1656-1657, Rome

S. Maria in Via Lata, 1658-1662, Rome

S. Martina e Luca, Rome

Villa del Pigneto, ca. 1630, Rome

Villa Sacchetti, 1625-1630, Rome

COSENTINO, NICOLETTA, 20th c.

Piazza della Repubblica Project, 1982, Turin

COSENZA, LUIGI, 1905-1984

Olivetti Plant, 1951 & later, Pozzuoli

University of Naples Faculty of Technology Building, 1957, Naples

COSTA, LUIGI, 19th c.

Synagogue, 1889, Rome

COSTANTINI, MAURIZIO, 20th c.

Residential Building, Via Campania, 1963-1965, Rome

CREMONA, LUIGI, 20th c.

Residential Complex, Tor Sapienza, 1982-1985, Milan

IL CRONACA, 1457-1508

Palazzo Gondi, 1490, Florence

Palazzo Strozzi, 1489-1539, Florence

S. Francesco al Monte (S. Salvatore), 1480-1504, Florence

S. Salvatore al Monte, ca. 1480, Florence

D'ARDIA, GIANGIACOMO, 20th c.

Church Project, 1970, Gibellina

D'ARONCO, RAIMONDO, 1857-1932

D' Aronco Tomb, 1898, Udine

Exhibition of Decorative Arts Central Pavilion, 1902, Turin

Exposition of Decorative Arts Main Building, 1902, Turin

D'ESTE, ERCOLE

Via Mortara, Ferrara

D'ISDA, AIMARO OREGLIA, 20th c.

High School, Valletti Quarter, 1964, Turin

D'OLIVO, MARCELLO, 1921-

Hotel Manacore, 1962, Gargano

Villa Spezzotti, 1958, Lignano Pineta

Youth Village, 1948-1957, Turin

DA PONTE, ANTONIO, 16-17th c.

Prisons, 1563-1614, Venice

DANERI, LUIGI CARLO, 1900-1972

I. N. A. Casa Residential Unit, Villa Bernabo Brea, 1953, Genoa

Residential Quarter, Forte di Quezzi, 1956 & later, Genoa

DANUSSO, ARTURO, 20th c.

Pirelli Building (Torre Pirelli), 1955-1960, Milan

DE CARLO, ADOLFO, 20th c.

Chiesa della Sacra Famiglia, 1956 & later, Genoa

DE CARLO, GIANCARLO, 1919-

Matteotti Quarter, 1969-1975, Terni

University of Pavia Laboratories & Scientific Department Building, 1974-1976, Pavia

University of Urbino, 1963-1966, Urbino

University of Urbino Dormitory Complex, 1962-1966, Urbino

University of Urbino Facolà di Magistero, 1968-1976, Urbino

University of Urbino Faculty of Education, 1976, Urbino

DE FABRIS, EMILIO, 1808-1883

Cathedral, 1867-1887, Florence

DE FEO, VITTORIO, 1928-

I. R. F. I. S. Center Project, 1979, Palermo

Palazzo Municipale Project, 1974, Legnano

Technical Institute for Geometry, 1968-1969, Terni

University of Rome Faculty of Engineering, 1982-1986, Rome

DE FINETTI, GIUSEPPE, 20th c.

Casa della Meridiana (Sundial House), 1925, Milan

Piazza Fontana, 1944-1946, Milan

Strada Lombarda, 1944-1946, Milan

DE HEMPTINE, HILDEBRAND, 19th c.

S. Anselmo, 1890-1896, Rome

DE ROSSI, GIOVANNI ANTONIO. *See* **ROSSI, GIOVANNI ANTONIO DE**

DE ROSSI, MARCANTONIO, 17th c.

Porta Portese in Trastevere, 1643, Rome

DE ROSSI, MATTIA, 1637-1695

Palazzo Muti Bussi, 1675, Rome

DEL GRANDE, ANTONIO. *See* **GRANDE, ANTONIO DEL**

DEL VAGA, PIERIN

Palazzo della Cancelleria Cappella del Pallio, Rome

DELLA PORTA, GIACOMO, 16th c.

Chiesa del Gesù (Il Gesù), 1568-1584, Rome

S. Andrea della Valle, 1591-1665, Rome

S. Annunziata, 1587; facade ca. 1830, Genoa

S. Luigi dei Francesci, ca. 1580-1585, Rome

S. Maria dei Monti (Madonna dei Monti), 1580-1581, Rome

S. Maria Maggiore Capella Sforza (Sforza Chapel), ca. 1560-1573, Rome

S. Trinità dei Monti, ca. 1580, Rome

DELLA ROCCA, ROBADLO MOROZZO, 20th c.

Residential Quarter, Forte di Quezzi, 1956 & later, Genoa

DELLEANI, VICIO, 20th c.

Office District, 1967-1970, Rome

DEROSSI, PIETRO, 1933-

Nursery School, 1980-1982, Turin

DERIZER, ANTOINE, 18th c.

S. Claudio dei Borgognoni, 1728-1731, Rome

DI BARTOLOMEO, MICHELOZZO. *See* **MICHELOZZO DI BARTOLOMEO**

DI CAMBIO, ARNOLFO. *See* **ARNOLFO DI CAMBIO**

DI CASTELLAMONTE, AMEDEO.
See **CASTELLAMONTE,
AMEDEO DI**

DI FALCO, MARIELLA, 20th c.

University of Cagliari Project,
1972, Cagliari

DI VINCENZO, ANTONIO.
See **ANTONIO DI VINCENZO**

DIEDO, ANTONIO, 1772-1847

Cathedral, 1805-1820, Schio

**DIGNY, LUIGI DE CAMBRAY,
19th c.**

Puccini Gardens, Scornio

Temple of Pythagoras,
1821-1827, Pistoia

**DOLCEBUONO, GIOVANNI
GIACOMO, 1440-1506**

Cathedral, 1487-1490, Milan

DONATELLI, R., 20th c.

Apartment House, 1952, Milan

DORI, ALESSANDRO, 18th c.

Palazzo Rondinini, 1754, Rome

DOTTI, CARLO FRANCESCO

Arco del Meloncello, Bologna

Madonna di S. Luca, Bologna

DROCCO, GUIDO, 20th c.

Residential Building, Via
S. Agostino, 1980-1983, Turin

DUCA, GIACOMO DEL, 16th c.

S. Maria in Trivio, 1575, Rome

DUCCIO, AGOSTINO DI, 15th c.

S. Bernardino, 1461-1466,
Perugia

DUFOURNEY, LEON, 18th c.

Orto Botanico, 1789-1792,
Palermo

Villa Giulia Gardens, 1790s,
Palermo

DUPUY, ALFONSO, 19th c.

Chiesa delle Sacramentine,
1846-1850, Turin

ERNESTO DI MAURO, 19th c.

Galleria Umberto I, 1887-1890,
Naples

EROLI, PIERLUIGI.
See **G. R. A. U.**

ESPOSITO, GABRIELLA, 20th c.

Chamber of Deputies Office
Building Project, 1967, Rome

FABRINI, MARIANO, 19th c.

Piazza Vittorio Emanuele,
1893-1895, Florence

Synagogue, 1874-1882, Florence

**FALCONETTO, GIOVANNI MARIA,
1458?-before 1540**

Loggia Cornaro, 1524, Padua

Porta S. Giovanni, 1528, Padua

Villa dei Vescovi, ca. 1530,
Luvigliano

FALORNI, ENRICO, 20th c.

Residential Building, Via
Campania, 1963-1965, Rome

FANCELLI, GIUSEPPE, 19th c.

Castello dei Visdomini, ca. 1855,
Vincigliata

FANCELLI, LUCA, ca. 1430-1495?

Domus Nova, ca. 1480, Mantua

FANZAGO, COSIMO, 1620-1688

Certosa di S. Martino Cloister, ca. 1630, Naples

S. Maria degli Angeli alle Croce, Naples

S. Maria Egiziaca, 1651-1717, Naples

FEHN, SVERRE, 20th c.

Biennale, 27th Nordic Pavilion, 1962, Venice

FENOGLIO, PIETRO, 1865-?

Fenoglio (Pietro Fenoglio) House, 1902, Turin

Villa Scott, 1902, Turin

FERRAR, LUIGI, 19-20th c.

Bourse, 1893 & later, Naples

FERRI, GAETANO, 19th c.

Palazzo Carignano, 1863-1871, Turin

FIGINI, LUIGI, 1903-1984

Bar Craja, 1930, Milan

Biennale, 4th Casa Elettrica, 1930, Monza

Chiesa della Madonna dei Poveri, 1952-1954, Milan

Figini (Luigi Figini) House, 1934-1935, Milan

Frua De Angeli Factory, 1931, Milan

Olivetti Complex, 1954-1957, Ivrea

Palazzo del Littorio Project, 1933, Rome

Triennale, 5th Villa-Studio for an Artist, 1933, Milan

See also Gruppo 7.

FILARETE (AVERLINO, ANTONIO), ca. 1400-ca. 1469

City Planning (Ideal City), ca. 1460-1464, Sforzinda

Ospedale Maggiore (Albergo de Poveri), ca. 1460 & later, Milan

FIORENTINO, MARIO, 1918-1982

I. N. A. Housing Development, Tiburtina Quarter (Casa Tiburtina), 1950-1954, Rome

Monument of the Fosse Ardeatine, 1944-1947, Rome

Office District, 1967-1970, Rome

Residential Unit Project, Lazio, 1979-1981, Florence

S. Basilio Quarter, 1956, Rome

Stazione Termini Project, 1947, Rome

Tower Building, Ethiopia Street, 1957-1962, Rome

FIORESE, GIORGIO, 20th c.

Civic Center, Pieve Emanuele, 1968-1982, Milan

FOLLINA, TONI, 1941-

Follina Residence, 1978, Nervesa

FONTANA, CARLO, 1634-1714

Palazzo Bigazzini, Rome

S. Marcello al Corso, 1519, 1682-1683, Rome

S. Maria dei Miracoli, 1662-1679, Rome

S. Michele Prison, 1703-1704, Rome

S. Rita, Rome

S. Teodoro, 18th c., Rome

FONTANA, DOMENICO, 1543-1607

Fontana Felice, Piazza S. Bernardino, 1585, Rome

Library, 1587-1589, Rome

Palazzo del Laterano, 1586, Vatican City

Palazzo Reale, 1600-1602, Naples

S. Maria di Montesanto, 1662-1679, Rome

S. Maria Maggiore Capella Sistina (Sistine Chapel), 1585, Rome

Villa Montalto, 1570, Rome

FONTANA, GIOVANNI, 17th c.

Acqua Paola, 1610-1614, Rome

FORNAROLI, ANTONIO, 20th c.

Montecatini Office Building, 1939, Milan

Pirelli Building (Torre Pirelli), 1955-1960, Milan

FOSCHINI, ARNALDO, 20th c.

Banca d'Italia, 1949 & later, Naples

FRANCESCO DEL GIORGIO, 15th c.

Cathedral, 1487-1490, Milan

FRANCESCO DI GIORGIO MARTINO

S. Bernardino degli Zoccolanti, 1482-1490, Urbino

FRANCO, GIACOMO, 1818-1895

Cathedral, 1877-1895, Lonigo

FRANKL, WOLFGANG, 1907-

A. G. I. P. Motel Project, 1968, Rome

Apartment Building, Via Villa Massima, 1934, Rome

I. N. A. Residential Towers, Viale Etiopia, 1950-1954, Rome

Palazzo Zaccardi, Via De Rossi, 1950-1951, Rome

U. N. R. R. A.-Casas Development, 1950, Popoli

FRASSINELLI, GIAMIPIERO, 20th c.

Cassa Rurale e Artigiana, 1978-1983, Alzate Brianza

FRETTE, GUIDO, 20th c.

Biennale, 4th Casa Elettrica, 1930, Monza

FRIGIMELICA, GIROLAMO, 15th c.

Palazzo Pisani Moretta (Music Conservatory), 15th c., Venice

Villa Pisani Park, Stra

FROSALE, NARCISO, 19th c.

Apartments, Piazza delle Mulina, 1880, Florence

FUGA, FERDINANDO, 1699-1781

Albergo dei Poveri, 1751 & later, Naples

Palazzo Cenci-Bolognetti, Rome

Palazzo della Consulta, 1732-1737, Rome

Palazzo Petroni, mid. 18th c., Rome

S. Apollinaire, 1742-1748, Rome

S. Maria dell' Orazione e della Morte, 1733-1737, Rome

S. Maria Maggiore, 1714-1743, Rome

FUIN, G., 19th c.

Salizzada S. Moisè Buildings, 1853, Venice

FUSELLI, EUGENIO, 20th c.

Residential Quarter, Forte di Quezzi, 1956 & later, Genoa

G. R. A. U. (Gruppo Romano Architetti Urbanisti: Anselmi, Alessandro; Eroli, Pierluigi; Pierluisi, Franco)

Park, Lecce

State Archives of Florence Project, 1972, Florence

GABETTI, ROBERTO, 1925-

Boarding School of Bishop, 1966-1969, Mondovi

Bottega d'Erasmo, 1953 & later, Turin

City Hall, 1975-1979, Bagnolo Piemonte

Dairy Factory 'La Tuminera', 1980-1982, Bagnolo Piemonte

High School, Valletti Quarter, 1964, Turin

Ippica Torinese Society Center, Nichelino

Olivetti Complex Residential Center, 1969-1970, Ivrea

Residential Building, Via S. Agostino, 1980-1983, Turin

GAGLIARDI, ROSARIO, 1698?-1762?

S. Chiara, Noto

S. Giorgio, 1750s, Modica

S. Giorgio, 1746-1766, Ragusa Ibla

GALILEI, ALESSANDRO, 1691-1737

S. Giovanni in Laterano,

1733-1736, Rome

S. Giovanni in Laterano Corsini Chapel, 1732-1735, Rome

GAMBELLA, ANTONIO, 15th c.

Arsenal Archway, 1460, Venice

S. Zaccaria, ca. 1488-1500, Venice

S. Zaccaria Chancel Chapel, 1463-ca. 1471, Venice

GAMBIRASIO, GIUSEPPE, 1930- . *See* **GAMBIRASIO, ZENONI, BARBERO, & CIAGA**

GAMBIRASIO, ZENONI, BARBERO, & CIAGA (Gambirasio, Giuseppe)

Convento dei Frati Francescani (Franciscan Monastery & School), 1972, Bergamo

Società Cattolica di Assicurazione, 1967-1971, Bergamo

GARDELLA, IGNAZIO, 1905-

Alfa-Romeo Works Technical Offices, Arese, 1968-1972, Milan

Anti-Tuberculosis Clinic (Dispensario Antituberolare), 1938, Allesandria

Apartment House, Zattere, 1954-1958, Venice

Chiesa di S. Enrico, Metanopoli, 1963-1966, Milan

City Planning (Master Plan), 1945, Milan

Hotel Punta S. Martino, 1958, Genoa

I. A. C. P. (Mangiagalli) Quarter, 1950-1951, Milan

I. N. A. Casa Quarter, Cesate, 1950 & later, Milan

Olivetti Complex Refectory,
1955-1959, Ivrea

Teatro Carlo Felice, 1981-1982,
Genoa

Terme Regina Isabella,
1950-1953,
Lacco Ameno d'Ischia

Theater Project, 1968, Vicenza

GARDELLA, JACOPO, 20th c.

Alfa-Romeo Works Technical
Offices, Arese, 1968-1972,
Milan

**GAROVE, MICHELANGELO,
1650-1713**

Palazzo Asinari, 1686 & later,
Turin

GAUDI, ANTONI, 1852-1926

Villa for Diaz de Quijano,
1883-1885, Como

GENGA, BARTOLOMEO, 15th c.

Palazzo Ducale, ca. 1472, Pesaro

GENGA, GIROLAMO, 1476-1551

Palazzo Ducale, ca. 1472, Pesaro

Villa Imperiale, Pesaro

GIACOMO DELLA PORTA.
See **DELLA PORTA, GIACOMO**

GIGLIOTTI, VITTORIO, 20th c.

Casa Papanice, 1969-1970,
Rome

Chiesa della Sacra Famiglia,
1969-1973, Salerno

GILDOI, COSTANTINO, 19th c.

Galleria Umberto I, 1887-1890,
Naples

Galleria Nazionale, 1890, Turin

**GIOCONDO, FRA GIOVANNI,
15th c.**

Loggia del Consiglio, 1476-1492,
Verona

GIOFFREDO, MARIO

Church of the Spirito Santo,
Naples

**GIOTTO DI BONDONE,
1276?-1337**

Campanile, 1334-1359, Florence

**GIULIANO DA MAIANO,
1432-1490**

Basilica, ca. 1470-1495, Loreto

Cathedral, 1474, Faenza

Palazzo Quaratesi (Palazzo Pazzi),
1460-1472, Florence

Poggioreale, 1487, Naples

Porta Capuana, 1485, Naples

Palazzo Cuomo, 1464-1490,
Naples

GIULIANO DA SANGALLO

Palace for the King of Naples,
ca. 1490, Naples

GIULIO DE ANGELIS, 19th c.

Magazzini Boccioni, ca. 1895,
Rome

GIULIO ROMANO, 1499?-1546

Cathedral, ca. 1540-1545,
Mantua

Giulio Romano House, ca. 1540,
Mantua

Palazzo del Te, 1525-1535,
Mantua

Palazzo del Te Giardino Segreto,
1525-1535, Mantua

S. Benedotto al Polirone, 1540,
Mantua

Villa Madama, ca. 1516 & later, Rome

GIULLIANO DA MAIANO, 16th c.

Palazzo Strozzi, 1489-1539, Florence

GIUNTALODI, DOMENICO.
See **GIUNTI, DOMENICO**

GIUNTI, DOMENICO, 1505-1560

S. Angelo, 1552-1555, Milan

S. Paolo alle Monache, 1549-1551, Milan

Villa Simonetta, 1547, Milan

GORIO, FEDERICO, 20th c.

I. N. A. Housing Development, Tiburtina Quarter (Casa Tiburtina), 1950-1954, Rome

La Martella Village, 1951 & later, Matera

GRANDE, ANTONIO DEL, 17th c.

Carceri Nuove, Rome

Galleria Colonna, ca. 1675, Rome

GRAPIGLIO, A. , 17th c.

S. Pietro di Castello, 1596-1619, Venice

GRASSI, GIORGIO, 1935-

Laboratory Project, 1969, Paullo

Secondary School, 1975, Tolli

GRECO, ROMANO, 20th c.

Palazzo di Giustizia, 1968-1981, Teramo

GREGORINI, DOMENICO, 1690/95-1777

S. Croce in Gerusalemme (Basilica Sessoriana), 1741-1743, Rome

GREGOTTI, VITTORIO, 1927-

Office Building, 1959-1960, Novara

University of Calabria Project, 1973, Matera

University of Palermo New Science Department Building, 1969-1985, Palermo

Zen Quarter Project, 1969, Palermo

GREPPI, GIOVANNI, 20th c.

Collini House, Via Statuto, 1919, Milan

GRIFFINI, ENRICO, 20th c.

Housing, San Siro Project, 1932, Milan

Triennale, 5th Public Housing Pavilion, 1933, Milan

GRIMALDI, FRANCESCO, 17th c.

S. Andrea della Valle, 1591-1665, Rome

GRISOTTI, MARCELLO, 20th c.

Milan Fair Breda Pavilion, 1953-1954, Milan

GRIZZI, GIUSEPPE, 19th c.

Piazza Vittorio Veneto, 1818 & later, Turin

GRUPPO 7, 20th c.

Biennale, 3rd Dopolavoro, 1927, Monza

Biennale, 3rd Garage, 1927, Monza

Biennale, 3rd Gas Works, 1927, Monza

Biennale, 3rd Office Building Project, 1927, Monza

GRUPPO ROMANO ARCHITETTI URBANISTI. *See* **G. R. A. U.**

GUARINI, GUARINO, 1624-1683

Church of the Immmaculate Conception, 1672-1697, Turin

Palazzo Carignano, 1679-1692, Turin

S. Filippo Neri, 1679, Turin

S. Giovanni Battista Chapel of S. Sindone (Chapel of the Holy Shroud), 1667-1694, Turin

S. Giovanni Battista Chapel of S. Sindone Dome, 1667-1694, Turin

S. Lorenzo, 1668-1687, Turin

S. Lorenzo Dome, 1668-1687, Turin

Somaschi Church, 1660-1662, Messina

GUARNIERO, DANIEL, 20th c.

Triennale, 6th Exhibition of Vernacular Architecture, 1936, Milan

GUERRA, ALFONSO, 1845-1900

Bourse, 1893 & later, Naples

GUGLIELMELLI, MARCELLO

S. Angelo a Nilo, Naples

GUIDETTI, GUIDETTO, 16th c.

S. Caterina dei Funari, ca. 1564, Rome

S. Maria dell' Orto, 1566, Rome

GUIDI, IGNAZIO, 20th c.

I. N. C. I. S. Quarter, near E. U. R., 1958 & later, Rome

GUSSONI, GOTTARDO, 20th c.

Apartment Block, Via Palmieri, 1912, Turin

HELG, FRANCA, 20th c.

Rinascente Department Store, 1957-1961, Rome

S. Lorenzo Treasury Museum (Tesoro di S. Lorenzo), 1952-1956, Genoa

HENNEBIQUE, FRANCOIS, 20th c.

Ponte del Risorgimento, 1910, Rome

HOFFMANN, JOSEF, 20th c.

Biennale, 24th Austria Pavilion, 1934, Venice

HOLZNER, ENRICO, 19th-20th c.

Cimitero Monumentale, 1890-1896, Padua

IMPERATO, GAETANO, 20th c.

Palazzo di Giustizia, 1968-1981, Teramo

INGAMI, RAFFAELE, 19th c.

S. Gioacchino, 1870s, Rome

IORIO DA ERBA, 19th c.

S. Croce, 1887, Parma

ISOLA, AIMARO, 1925-

Boarding School of Bishop, 1966-1969, Mondovi

Bottega d'Erasmo, 1953 & later, Turin

City Hall, 1975-1979, Bagnolo Piemonte

Dairy Factory 'La Tuminera', 1980-1982, Bagnolo Piemonte

Ippica Torinese Society Center, Nichelino

Olivetti Complex Residential Center, 1969-1970, Ivrea

Residential Building, Via S. Agostino, 1980-1983, Turin

ITALIAN CIAM GROUP, 20th c.

City Planning (Master Plan),
1945, Milan

JACOPO, MASTRO, 20th c.

S. Maria dei Miracoli, 1488,
Brescia

JADOT, JEAN-NICOLAS, 18th c.

Triumphal Arch, 1739-1745,
Florence

JAPELLI, GIUSEPPE, 1783-1852

Caffè Pedrocchi, 1816-1842,
Padua

Meat Market, 1821, Padua

Villa dei Conti Cittadella
Vigodarsere Chapel, ca. 1817,
Saonara

JUVARRA, FILIPPO, 1678-1736

Chiesa del Carmine, 1732-1735,
Turin

Palazzo Madama, 1718-1721,
Turin

Palazzo Martini de Cigala,
1716-1719, Turin

Quartieri Militari, 1716-1728,
Turin

S. Cristina, 1715, Turin

S. Filippo, 1730s-1890s, Turin

S. Girolamo della Carita Capella
Antamori, 1708, Rome

Superga, 1717-1731, Turin

Villa Reale di Stupinigi (Royal
Hunting Lodge), 1729-1733,
Stupinigi

KOCH, GAETANO, 1849-1910

Banca d'Italia, 1885-1892, Rome

Palazzi della Piazza dell' Esedra,
1888 & later, Rome

Palazzo Amici, Via XX Settembre,
1900, Rome

Palazzo De Parente, Piazza
Cavour, 1899, Rome

Palazzo Margherita (U. S.
Embassy), 1886-1900, Rome

Palazzo Pacelli, 1880s, Rome

Piazza Vittorio Emanuele II,
1870 & later, Rome

LANDINI, TADDEO, 16th c.

Fountain of the Tortoises
(Fontana delle Tartarughe),
Piazza Mattei, 1584, Rome

LANZA, MAURIZIO, 20th c.

I. N. A. Housing Development,
Tiburtina Quarter (Casa
Tiburtina), 1950-1954, Rome

LARCO, SEBASTIANO.
See **GRUPPO 7**

**LAURANA, LUCIANO,
1420/25-1479**

Palazzo Ducale (Ducal Palace),
ca. 1444-1482, Urbino

Palazzo Ducale Courtyard,
ca. 1450, Urbino

Palazzo Ducale Sala del Trono,
ca. 1444-1482, Urbino

LAZZARI, LAURA, 20th c.

City Hall (Civic Center),
1963-1966, Segrate

LENCI, SERGIO, 20th c.

I. N. A. Housing Development,
Tiburtina Quarter (Casa
Tiburtina), 1950-1954, Rome

LEONARDO DA VINCI, 1452-1519

City Planning, Imola

LEVI-MONTALCINI, GINO, 20th c.

Palazzo Gualino, 1929, Turin

LIBERA, ADALBERTO, 1903-1963

Aventino Post OFfice, 1933, Rome

Biennale, 4th Casa Elettrica, 1930, Monza

I. N. C. I. S. Quarter, near E. U. R., 1958 & later, Rome

Residential Unit, Tuscolano Quarter, 1950-1951, Rome

Tenth Anniversary of the Fascist Revolution Exhibition Sacrario, 1932, Rome

Trentino-Alto Adige Regional Hall, 1954-1962, Trento

LIGORIO, PIRRO, ca. 1500-1583

Casino of Pius IV, Vatican Gardens, 1559, Vatican City

Lancellotti Palace, ca. 1560, Rome

Villa d'Este, ca. 1565-1572, Tivoli

Villa d'Este Gardens, ca. 1565-1572, Tivoli

LINGERI, PIETRO, 20th c.

Casa Rustica, 1933-1935, Milan

Palazzo del Littorio Project, 1933, Rome

LIPPI, ANNIBALE, ?-1580

Villa Medici, 1574-1580, Rome

LOCATI, SEBASTIANO GIUSEPPE, 19-20th c.

Casa Reininghaus, ca. 1898, Milan

Exposition, 1906 Palazzo delle Belle Arti, 1906, Milan

LOMBARDO, PIETRO, ca. 1435-1515

Palazzo Corner-Spinelli, ca. 1480, Venice

Palazzo Gussoni, S. Lio, 15th c., Venice

Palazzo Vendramin ai Carmini (Ca' Vendramin), 1481, Venice

S. Maria dei Miracoli (S. Maria Nuova), 1481-1489, Venice

Scuola Grande di San Marco (Ospedale Civile), 1485-1495, Venice

LONGHENA, BALDASSARE, 1598-1642

Palazzo Belloni-Battagia, 1648-1660?, Venice

Palazzo Pesaro (Ca' Pesaro), 1663-1679, Venice

Palazzo Rezzonico (Ca' Rezzonico), 1667 & later, Venice

S. Maria della Salute, 1631-1632, Venice

S. Maria della Salute Dome, 1631-1632, Venice

Scuola dei Carmini, Venice

LONGHI, MARTINO, THE ELDER

Palazzo Borghese, ca. 1560-1607, Rome

LONGHI, MARTINO, THE YOUNGER, 1602-1660

S. Adriano, ca. 1656, Rome

S. Antonio dei Portoghesi, Rome

S. Carlo al Corso (S. Ambrogio e Carlo al Corso), ca. 1672, Rome

S. Vincenzo e S. Anastasio, 1646-1650, Rome

LONGHI, ONORIO, 1569-1619

S. Carlo al Corso (S. Ambrogio e Carlo al Corso), ca. 1672, Rome

LONGHI, PIETRO, 17th c.

S. Carlo al Corso (S. Ambrogio e Carlo al Corso), ca. 1672, Rome

LONZI, MARTA, 20th c.

Chamber of Deputies Office Building Project, 1967, Rome

LUGLI, PIERO MARIA, 20th c.

La Martella Village, 1951 & later, Matera

I. N. A. Housing Development, Tiburtina Quarter (Casa Tiburtina), 1950-1954, Rome

LUIGI, PIER, 20th c.

Palazzo del Lavoro, 1960, Turin

LURAGO, ROCCO, 16th c.

Palazzo Municipale (Palazzo Tursi, Palazzo Comunale), 1564-1566, Genoa

LUZI, ELIO, 20th c.

Viale Pitagora Towers, 1964, Turin

MACIACHINI, CARLO, 1818-1899

Cimitero Monumentale, 1863-1866, Milan

Cimitero Monumentale Chapel, 1863-1866, Milan

MADERNO, CARLO, 1556-1629

Fountain, Piazza S. Pietro, 1613, Vatican City

Palazzo Barberini, 1628-1633, Rome

S. Andrea della Valle, 1591-1665, Rome

S. Gregorio Magno: Capella Salviata, 1600, Rome

S. Susanna, 795; rebuilt 1475; 1597-1603, Rome

Villa Aldobrandini Water Theater, Frascati

MAGGI, PAOLO

S. Trinità de' Pellegrini, Rome

MAGISTRETTI, LUDOVICO, 20th c.

L' Abeille Society Building, Via Leopardi, 1959-1960, Milan

MAGNI, GIULIO

Palazzo di Giustizia Project, 1890, Rome

MAITANI, LORENZO, 1270?-1330

Cathedral, ca. 1310 & later, Orvieto

MALAGRICCI, DOMENICO, 20th c.

A. G. I. P. Motel Project, 1968, Rome

MALVITA DA COMO, TOMMASO, 15th c.

S. Gennaro Cappella del Soccorso (Cathedral), 1497, Naples

MANETTI, GIROLAMO, 19th c.

Palazzo Cavalli Franchetti, 1818-1880, Venice

MANFREDI, MANFREDO, 1859-1927

Monument to Victor Emanuel II Project, 1884, Rome

MANGIAROTTI & MORASSUTTI

Chiesa Mater Misericordiae, 1956-1958, Milan

MANGIAROTTI, ANGELO, 1921-

Houses with Prefabricated Elements, 1962, Caserta

Snaidero Industrial Complex Office Building, 1978, Udine

Warehouse, 1958, Padua

MANGONE, FABIO, 1587-1629

Palazzo del Senato (Collegio Elvetico), 1608-1627, Milan

MANTEGNA, ANDREA, 15th c.

Casa de Mantegna (Mantegna [Andrea Mantegna] House), la. 15th c., Mantua

MAR, GIAMPAOLO, 20th c.

Hospital, 1984, Mestre

MARANDONO, B. C., 19th c.

Cathedral, ca. 1825, Biella

MARCHESE, GIUSEPPE, 19th c.

University of Pavia Great Hall, ca. 1845-1850, Pavia

MARCHI, VIRGILIO, 20th c.

S. Maria Novella Railroad Station, 1932-1934, Florence

MARCHIS, TOMMASO DE, 1693-1759

Collegio Calasanzio, 1747, Rome

S. Alessio sul Aventino, 18th c., Rome

MARCHIONNI, CARLO, 1702-1786

Chapel of the Sacrament (Capella del Sacramento, S. Peter's Sacristy), 1776, Rome

Villa Albani, ca. 1760, Rome

Villa Albani Gardens, ca. 1760, Rome

MARCONI, PAOLO, 20th c.

Biblioteca Nazionale Project, 1957, Rome

MARCUCCI, EMILIO, 19th c.

Cathedral, 1887, Milan

MARESCOTTI, FRANCO, 20th c.

Grandi e Bartacchi (Social Cooperative Center), 1951-1953, Rome

MARINONI, GIUSEPPE, 20th c.

Accademia Bridge, 1984-1985, Venice

MARTINI, FRANCESCO DI GIORGIO

Palazzo Comunale Courtyard, ca. 1490-1500, Jesi

S. Maria del Calcinaio, 1484-1490, Cortona

MARTINOZZI, MARTINORI, 19th c.

Ministero delle Finanze, 1870-1877, Rome

MARVUGLIA, GIUSEPPE VENANZIO, 1729-1814

Villa Belmonte, 1801 & later, Palermo

Villa della Favorita Fountain of Hercules, ca. 1814, Palermo

MASCHERINO, OTTOVIANO, 1536-1606

Palazzo del Quirinale, 1577-1585, Rome

S. Caterina della Ruota,

la. 16th c., Rome

S. Maria in Traspontina, Rome

S. Maria in Trastevere, 3rd c.; rebuilt 1130-1143; restored 1702, 1870, Rome

S. Salvatore in Lauro, Rome

MASSARI, GIORGIO, ca. 1686-1766

Gesuati (S. Maria del Rosario), 1726-1743, Venice

Palazzo Grassi (Palazzo Stucky), 1749, Venice

Pietà Church, Riva degli Schiavoni, 1744-1760, Venice

MATAS, NICOLA, 1798-1872

S. Croce, 1847 & later, Florence

MATSUI, HIROMICHI, 20th c.

Zen Quarter Project, 1969, Palermo

MATTE-TRUCCO, 20th c.

Fiat Works, 1915-1921, Turin

MAZENTA, GIOVANNI AMBROGIO

S. Salvatore, Bologna

MAZZA, LUIGI, 20th c.

Fiat Lingotto, 1983, Turin

MAZZANTI, RICCARDO, 1850-1910

Cathedral, 1880, Savona

Office Building, ca. 1880, Rome

MAZZOLINI, GIUSEPPE, 20th c.

Triennale, 5th Steel-Framed Residence, 1933, Milan

MAZZONI, ANGIOLO, 20th c.

S. Maria Novella Railroad Station;

Powerhouse, 1932-1934, Florence

MAZZUCHETTI, ALESSANDRO, 19th c.

Railroad Station, 1866-1868, Bologna

MEDRANO, G. A., 18th c.

Teatro S. Carlo, 1737, Naples

MEDUNA, G. B., 19th c.

Palazzo Giovanelli Staircase, 1849, Venice

MEDUNA, TOMMASO, 19th c.

Railway Bridge, 1841-1846, Venice

MELANESI, ITALO, 20th c.

Residential Complex, Tor Sapienza, 1982-1985, Milan

MELGRANI, CARLO, 20th c.

I. N. A. Housing Development, Tiburtina Quarter (Casa Tiburtina), 1950-1954, Rome

MENEGHETTI, LUDOVICO, 20th c.

Office Building, 1959-1960, Novara

MENGONI, GIUSEPPE, 1829-1877

Galleria Vittorio Emanuele II, 1865-1877, Milan

Palazzo della Cassa di Risparmio, 1868-1876, Bologna

MENICHETTI, GIANCARLO, 20th c.

I. N. A. Housing Development, Tiburtina Quarter (Casa Tiburtina), 1950-1954, Rome

MEO DEL CAPRINO, 15th-16th c.

S. Giovanni Battista (Cathedral), 1491-1498, Turin

S. Maria del Popolo, ca. 1500, Rome

MERISI DA CARAVAGGIO, GIULIO 20th c.

Palazzo Spada, Rome

MEZZANI, GIUSEPPE, 19th c.

Harbor Buildings, S. Giorgio, 1810-1815, Venice

MEZZANOTTE, PAOLO, 1878-?

Giudici Tomb, 1906, Milan

MICHELA, COSTANZA, 18th c.

S. Marta, 1739, Agle

MICHELANGELO BUONARROTI, 1475-1564

City Planning, 1500s, Rome

Palazzo Farnese (Farnese Palace), ca. 1515, Rome

Piazza del Campidoglio (Capitoline Hill): Palazzo dei Conservatori, ca. 1592, Rome

Piazza del Campidoglio (Capitoline Hill): Palazzo dei Senatori, ca. 1592, Rome

Porta Pia, 1561-1564, Rome

S. Giovanni dei Fiorentini Project, ca. 1559, Rome

S. Lorenzo Laurentian Library (Biblioteca Laurenziana), 1542 & later, Florence

S. Lorenzo New Sacristy (Medici Chapel, Capella Medici), 1521-1534, Florence

S. Maria degli Angeli, 1561-1564, Rome

S. Maria Maggiore Capella Sforza (Sforza Chapel),

ca. 1560-1573, Rome

S. Peter's (Basilica di S. Pietro), 1546-1564, Vatican City

S. Peter's Dome, 1546-1551; 1588-1591, Vatican City

S. Peter's Dome Model, 1558-1561, Vatican City

S. Peter's Project, 1547, Vatican City

Strada Pia, 1559-1565, Rome

MICHELAZZI, GIOVANNI, 1879-1920

House, Via Borgognissanti, 1896-1915, Florence

Villino Broggi-Caraceni, 1911, Florence

MICHELE, VINCENZO, 19th c.

Hotel Savoy, 1890s, Florence

Synagogue, 1874-1882, Florence

MICHELOZZO DI BARTOLOMEO, 1396-1472

Palazzo Medici-Riccardi, 1444-1460, Florence

S. Agostino, ca. 1430, Montepulciano

S. Angelo a Nilo Carinale Brancacci Sepulchral Monument, Naples

S. Annunziata, ca. 1450, Florence

S. Marco, ca. 1430, Florence

S. Marco Library (Biblioteca di S. Marco), ca. 1430-1438, Florence

S. Maria delle Grazie, ca. 1452, Pistoia

MICHELUCCI, GIOVANNI, 1891-?

Cassa di Risparmio, 1964-1966, Pistoia

Central Railway Station, 1936, Florence

Church, 1954, Collina

Osteria del Gambero Rosso (Tavern 'Red Lobster'), 1961-1963, Collodi

Ponte Vecchio Area Development, 1945, Florence

S. Giovanni Battista (S. John the Baptist), Autostrada del Sole, Campi Bisenzio, 1964, Florence

S. Maria Novella Railroad Station, 1932-1934, Florence

MILANI, GIOVANNI BATTISTA, 1876-1940

Galleria d'Arte Moderna Project, 1900, Milan

MILLS, MARK, 20th c.

Solimene Ceramics Factory, 1953, Salerno

MINARDI, BRUNO, 1946-

Municipal Housing Complex Expansion, 1979, Cesena

MINNUCCI, GAETANO, 20th c.

Minnucci House, 1926, Rome

MINOLETTI, GIULIO, 20th c.

Triennale, 5th Steel-Framed Residence, 1933, Milan

MOLLARI, ANTONIO, 19th c.

Bourse, 1802-1806, Trieste

MOLLINO, CARLO, 1905-1973

Regio Theater, 1964 & later, Turin

Sled-Lift Station, Val di Susa, 1946 & later, Lake Nero

MONESTIROLI, ANTONIO, 1940-

Secondary School, 1975, Tolli

MONTUORI, EUGENIO, 20th c.

City Planning, 1933, Sabaudia

Stazione Termini (Railway Station Terminal), 1947-1951, Rome

MOR, ANDREA, 20th c.

Chiesa della Sacra Famiglia, 1956 & later, Genoa

MORAGLIA, GIACOMO, 19th c.

Porta Comasina (Porta Garibaldi), 1826, Milan

MORANDI, RICCARDO, 1902-

Automobile Exhibit Pavilion, 1960, Turin

Bridge over the Tiber at Magliana, 1967, Rome

Cavalcavia Viaduct over the Via Olimpica, 1960, Rome

Leonardo da Vinci Airport, 1961-1962, Fiumicino

Leonardo da Vinci Airport Boeing Hangar, 1970, Fiumicino

Office District, 1967-1970, Rome

MORETTI, GAETANO, 1860-1938

Exposition of Decorative Arts, 1902, Turin

MORETTI, LUIGI, 1907-1973

Casa del Girasole (Sunflower House), Viale Buozzi, 1947-1950, Rome

I. N. C. I. S. Quarter, near E. U. R., 1958 & later, Rome

Office & Residential Complex, Corso Italia, 1952-1956, Milan

Palestra per la Scherma, 1934-1936, Rome

Villa Pignatelli (La Saracena), Santa Marinella, 1952-1954, Rome

MORONI, ANDREA, 16th c.

S. Giustina, 1532, Padua

MUCCHI, GABRIELE, 20th c.

City Planning (Master Plan), 1945, Milan

MURATORI, SAVERIO, 1910-1973

Christian Democratic Party Headquarters, 1955-1958, Rome

E. M. P. A. S. Office Building, 1952-1957, Bologna

S. Giovanni al Gatano, 1947, Pisa

MUTTONI, FRANCESCO

Villa Trissino da Porto (Villa Marzotto) Gardens, Trissino

MUZIO, GIOVANNI, 1893-1982

Apartment House, Via Moscova, 1923, Milan

Ca' Brutta, 1919-1922, Milan

Catholic University of the Sacred Heart, 1929, Milan

Catholic University of the Sacred Heart Men's Dormitory, 1934, Milan

S. Antonio Church, 1955, Varese

S. Giovanni Battista alla Creta Church, 1956-1958, Milan

NAPOLI, TOMMASO MARIA, ?-1723

Villa Palagonia, 1715, Bagheria

Villa Valguarnera, 1721, Bagheria

NATALINI, ADOLFO, 1941-

Cassa Rurale e Artigiana, 1978-1983, Alzate Brianza

NATALINI, FABRIZIO, 20th c.

Cassa Rurale e Artigiana, 1978-1983, Alzate Brianza

NENOT, PAUL-HENRI, 19th c.

Monument to Victor Emanuel II Project, 1882, Rome

NERVI, ANTONIO, 20th c.

Palazzo del Lavoro, 1960, Turin

NERVI, PIER LUIGI, 1891-1979

Berta (Giovanni Berta) Stadium, 1930-1932, Florence

Cartiere Burgo (Burgo Paper Factory), 1960-1962, Mantua

Exhibition Hall (Salone Agnelli), 1948-1949, Turin

Flaminio Stadium, 1960, Rome

Gatti Wool Factory, 1953, Rome

Hangar, 1939-1940, Orbetello

Italia '61 Exhibition Palace of Labor (Palazzo del Lavoro), 1961, Turin

Palazzetto dello Sport, 1956-1957, Rome

Palazzo dello Sport, 1956-1957, Rome

Pirelli Building (Torre Pirelli), 1955-1960, Milan

NICCOLINI, ANTONIO, 1772-1850

Teatro San Carlo, 1810-1844, Naples

NICOLIN, PIER LUIGI, 1941-

Accademia Bridge, 1984-1985, Venice

NIGETTI, MATTEO, 17th c.

Church of the Ogrissanti, Florence

S. Lorenzo Capella dei Principi, 1603 & later, Florence

NIZZOLI, MARCELLO, 1887-1968/69

E. N. I. Office Building, San Donato Milanese, 1958, Milan

Italian Aeronautics Exhibition Sala delle Medaglie d'Oro, 1934, Milan

Triennale, 6th Salone d'Onore, 1936, Milan

NOBILE, PIETRO, 19th c.

S. Antonio, 1826-1849, Trieste

NOLLI, GIOVANNI BATTISTA, 1692-1756

City Planning, 1748, Rome

S. Dorotea in Trastevere, 1751-1756, Rome

NONO, ANDREA

S. Trinità, Cremona

OLIVERI, MARIO, 20th c.

E. N. I. Office Building, San Donato Milanese, 1958, Milan

PAGANO, GIUSEPPE, 20th c.

Bocconi University Faculty of Economics, 1937-1940, Milan

Palazzo Gualino, 1929, Turin

Triennale, 5th Steel-Framed Residence, 1933, Milan

Triennale, 6th Exhibition of Vernacular Architecture, 1936, Milan

Triennale, 6th Exhibition of Construction Technology, 1936, Milan

University of Rome Physics Building, 1932-1935, Rome

PAGLIARI, NICOLA, 20th c.

Maiorino Museum, 1981, Noceri Inferiore

PALAGI, PELAGIO, 1775-1860

Palazzo Reale, 1834-1839, Racconigi

PALANTI, GIANCARLO, 20th c.

City Planning (Master Plan), 1945, Milan

Triennale, 5th Steel-Framed Residence, 1933, Milan

PALANTI, MARIO, 20th c.

Palazzo del Littorio Project, 1933, Rome

PALLADIO, ANDREA, 1508-1580

Basilica Palladiana (Palazzo della Ragione), 1549, Vicenza

Casa Civena, Vicenza

Casa del Diavolo, 1571, Vicenza

Chapel, 1560s, Maser

Church of the Zitelle, 1582-1586, Venice

Convento della Carita, 1552, Venice

Loggia del Capitanio, 1571, Vicenza

Palazzo Chiericati (Museo Civico), 1550-1580, Vicenza

Palazzo Thiene (Banco di Popolare), ca. 1542, Vicenza

Palazzo Valmarana (Palazzo Braga), 1566, Vicenza

Il Redentore, Venice

S. Francesco della Vigna Facade, ca. 1570, Venice

S. Giorgio Maggiore, 1565, Venice

Teatro Olimpico, 1580-1584, Vicenza

Villa Badoer, Fratta Polesine, 1554-1563, Rovigo

Villa Barbaro, 1560-1568, Maser

Villa Cornaro, 1551-1553, Piombino Dese

Villa Emo, 16th c., Fanzolo

Villa Foscari, 1549, Mira

Villa Godi, ca. 1540, Lonedo

Villa Grissino, Meledo

Villa of Vettor Pisani, 1542-1544, Bagnolo Piemonte

Villa Piovene, Lugo

Villa Pisani, Montagnana

Villa Poiana, Poiana Maggiore

Villa Rotunda (Villa Capra), 1550 & later, Vicenza

Villa Sarego, Santa Sofia di Pedemonte

Ville Cerato, Montecchio

PALMA, ANDREA, 18th c.

Cathedral, 1728, Syracuse

PALMA, GIUSEPPE, 20th c.

Chiesa della Sacra Famiglia, 1969-1973, Salerno

PANZARIN, FRANCESCO, 20th c.

Market, S. Michele al Tagliamento, 1980, Bibione

PASSALACQUA, PIETRO, 18th c.

Oratory of SS. Anunziata, Rome

S. Croce in Gerusalemme (Basilica Sessoriana), 1741-1743, Rome

PASSARELLI, FAUSTO, 20th c.

Office District, 1967-1970, Rome

Residential Building, Via Campania, 1963-1965, Rome

PASSARELLI, LUCIO, 20th c.

Office District, 1967-1970, Rome

Residential Building, Via Campania, 1963-1965, Rome

PASSARELLI, VINCENZO, 20th c.

Office District, 1967-1970, Rome

Residential Building, Via Campania, 1963-1965, Rome

PATERI, MARIO, 20th c.

Residential Quarter, Forte di Quezzi, 1956 & later, Genoa

PATERNOSTRO, ITALO, 20th c.

Cemetery Project, 1912, Monza

PATRICOLA, GIUSEPPE, 18th-19th c.

Villa della Favorita Palazzina Cinese, 1799-1802, Palermo

PELLEGRIN, LUIGI, 1925-

I. N. A. Casa Residential Complex, Galatina, 1958, Lecce

PEREGO, GIOVANNI, 19th c.

Palazzo Rocca Saporiti, 1812, Milan

**PERESSUTTI, ENRICO,
1908-1976.** *See* **B. B. P. R.**

PERSICO, EDOARDO, 20th c.

Italian Aeronautics Exhibition
Sala delle Medaglie d'Oro,
1934, Milan

Triennale, 6th Salone d'Onore,
1936, Milan

PERUGINI, GIUSEPPE, 20th c.

Monument of the Fosse
Ardeatine, 1944-1947, Rome

**PERUZZI, BALDASSARE,
1481-1536**

Casa Pollini, ca. 1527, Siena

Palazzo Massimo alle Colonne,
1532-1536, Rome

S. Peter's Project, ca. 1520,
Vatican City

Villa Farnesina, 1509-1511,
Rome

Villa Farnesina Loggia di Psiche,
1509-1511, Rome

PETERNOSTRO, ITALO, 20th c.

Cemetery Project, 1912, Monza

PETITI, ENRICO, 19th c.

Synagogue, 1880-1885, Turin

PIACENTI, MARCELLO, 20th c.

Monument to Victor Emanuel II
Project, 1882, Rome

University of Rome, 1933, Rome

PIACENTI, PIO, 1846-1928

Palazzo dell' Esposizione,
1878-1882, Rome

PICCINATO, LUIGI, 20th c.

City Planning, 1933, Sabaudia

PIERLUISI, FRANCO.
See **G. R. A. U.**

**PIERMARINI, GIUSEPPE,
1734-1808**

Palazzo Reale, 1769-1778, Milan

La Scala, 1776-1778, Milan

Villa Reale, 1777-1780, Monza

**PIRANESI, GIOVANNI BATTISTA,
1720-1778**

Piazza di S. Maria del Priorata,
1765, Rome

S. Maria Aventina, 1764-1766,
Rome

S. Maria del Priorato, 1765,
Rome

S. Maria del Priorato Entrance
Gate, 1765, Rome

PIROVANO, ERNESTO, 1866-?

House, Via Spadari, ca. 1903,
Milan

Villa Crespi, ca. 1890,
Capriate d'Adda

PIRRONE, GIANNI. 1924-

Apartment House, 1972,
Palermo

Favorita Swimming Pool,
1965-1970, Palermo

PISANO, ANDREA

S. Maria del Fiore (Il Duomo),
1296-1462, Florence

PISANO, GIOVANNI, 1248?-1314?

Cathedral, ca. 1226-1380, Siena

**PIURI, GIOVANNI BATTISTA,
19th c.**

Palazzo Besana in Piazza
Belgioioso, ca. 1815, Milan

PIVA, ANTONIO, 20th c.

Subway, 1963, Milan

PIZZIGONI, PINO, 20th c.

Pizzigoni House, 1925-1927,
Bergamo

**PLANTERY, GIAN GIACOMO,
1680-1756**

Palazzo Cavour, 1729, Turin

Palazzo Saluzzo-Paesana,
1715-1722, Turin

Santuario di Vicoforte,
1728-1733, Mondovi

PLANTI, GIANCARLO, 20th c.

Triennale, 6th, Salone d'Onore,
1936, Milan

**POCCIANTI, PASQUALE,
1774-1858**

Il Cisternone, 1829-1842,
Leghorn

Villa Medicea Orangery,
ca. 1825, Poggio a Caiano

Villa Poggio Imperiale Chapel,
ca. 1812, Florence

PODESTI, GIULIO, 1857-1909

Grande Albergo, 1890s, Rome

POGGI, GIUSEPPE, 1811-1901

Apartments, Piazza delle Mulina,
1880, Florence

Piazza Beccaria, 1860s, Florence

S. Niccolò, 1865 & later,
Florence

Viale G. Matteotti, 1868 & later,
Florence

Villino Favard, 1857, Florence

POLESELLO, GIANUGO, 1930-

Market, S. Michele al

Tagliamento, 1980, Bibione

POLETTI, LUIGI, 1792-1869

S. Paolo fuori le Mura,
1823 & later, Rome

POLLACK, LEOPOLD, 1751-1806

Villa Reale-Belgioioso,
1790-1793, Milan

POLLAIUOLO, SIMONE, 15th c.

Palazzo Guadagni, 1490-1506,
Florence

POLLINI, GINO, 1903-

Bar Craja, 1930, Milan

Biennale, 4th Casa Elettrica,
1930, Monza

Chiesa della Madonna dei Poveri,
1952-1954, Milan

Figini (Luigi Figini) House,
1934-1935, Milan

Olivetti Complex, 1954-1957,
Ivrea

Palazzo del Littorio Project,
1933, Rome

Triennale, 5th Villa-Studio
for an Artist, 1933, Milan

See also Gruppo 7

PONTE, ANTONIO DA

Rialto Bridge, Venice

PONTELLI, BACCIO, 1450-1492

Fortress, 1483-1486, Ostia

Ospedale di Santo Spirito in
Sassia, 1474-1482 & later,
Rome

S. Maria del Popolo, 1472-1480,
Rome

S. Pietro in Montorio,
ca. 1480-1500, Rome

Ponte Sisto, 1474, Rome

PONTI, GIO, 1891-1979

Italia '61 Exhibition Palace of
Labor (Palazzo del Lavoro),
1961, Turin

Montecatini Office Building,
1939, Milan

Pirelli Building (Torre Pirelli),
1955-1960, Milan

**PONZIO, FLAMINIO,
ca. 1559-1613**

Acqua Paola, 1610-1614, Rome

Palazzo Borghese,
ca. 1560-1607, Rome

Palazzo Borghese Courtyard,
1605-1614, Rome

S. Maria Maggiore Capella
Paolina (Pauline Chapel),
1605-1611, Rome

S. Sebastiano, ca. 400-450;
rebuilt,1609-1613, Rome

PORTA, GIACOMO DELLA.
See **DELLA PORTA, GIACOMO**

PORTOGHESI, PAOLO, 1931-

Academy of Fine Arts,
1978-1982, Aquila

Asquini Residence, 1968,
Tarquinia

Batti Residence, 1959-1962,
Rome

Biblioteca Nazionale Project,
1957, Rome

Casa Baldi, 1959-1962, Rome

Casa Papanice, 1969-1970,
Rome

Chiesa della Sacra Famiglia,
1969-1973, Salerno

Corso Venezia Building,
1926-1930, Milan

Culture Center, 1970-1982,
Avezzano

E. N. P. A. S. Headquarters,
1958-1960, Florence

E. N. P. A. S. Headquarters,
1958-1961, Lucca

Enel Workers Housing, 1981,
Tarquinia

Fortezza da Basso Project, 1983,
Florence

Mosque & Islamic Center Model,
1976, Rome

Thermal Bath Building, 1981,
Canino

PRAMPOLINI, ENRICO, 20th c.

Exposition,1928 Futurist
Pavilion, 1928, Turin

War Memorial, 1933, Como

**PRETI, FRANCESCO MARIA,
1701-1774**

Villa Pisani, 1735-1756, Stra

PROMIS, CARLO, 1808-1872

Piazza Vittorio Veneto,
1818 & later, Turin

PROVAGLIA, BARTOLOMEO

Palazzo Davia-Bargellini, Bologna

PUCCI, MARIO, 20th c.

City Planning (Master Plan),
1945, Milan

PUGLIELLI, EMILIO, 1947-

Residential Complex, 1984,
Provaglio d'Iseo

PULITZER, GUSTAVO, 20th c.

Residential Quarter, Forte di
Quezzi, 1956 & later, Genoa

PURINI, FRANCO, 1941-

Zen Quarter Project, 1969,
Palermo

PUTELLI, ALDO, 20th c.

City Planning (Master Plan), 1945, Milan

QUAGLIA, PIERO PAOLO, 1856-1898

Piazza Nicola Amore, 1892, Naples

QUARENGHI, GIACOMO, 1744-1817

Monastero di Santa Scolastica Chapel, 1777, Subiaco

QUARONI, LUDOVICO, 1911-1987

Chamber of Deputies Office Building Project, 1967, Rome

Chiesa della Sacra Famiglia, 1956 & later, Genoa

Church Project, 1970, Gibellina

City Planning (Barene di S. Giuliano), 1959, Venice

I. N. A. Housing Development, Tiburtina Quarter (Casa Tiburtina), 1950-1954, Rome

La Martella Village, 1951 & later, Matera

Office District, 1967-1970, Rome

Savings Bank Tax Collection Office, 1962-1965, Ravenna

Stazione Termini Project, 1947, Rome

QUISTELLI, ANTONIO, 20th c.

Chamber of Deputies Office Building Project, 1967, Rome

RABIRIUS, 1st c.

Domus Augustana (Flavian Palace, Palace of Domitian, Palatium), ca. 92, Rome

RAFFIN, GIORGIO, 1944-

Primary School, 1984, Pordenone

RAGUZZINI, FILIPPO, ca. 1680-1771

Piazza di S. Ignazio, 1727-1728, Rome

S. Filippo Neri, 1728 & later, Rome

S. Gallicano Hospital, 1724 & later, Rome
S. Maria della Quercia, 1727, Rome

RAIMONDI, ELVISO, 15th c.

Palazzo Raimondi, 1496-1499, Cremona

RAINALDI, CARLO, 1611-191

Il Gesù e Maria, Rome

Piazza del Popolo, 1662-1679, Rome

S. Agnese in Agone (S. Agnese in Piazza Navona), 1652-1666, Rome

S. Andrea della Valle, 1591-1665, Rome

S. Marcello, 1682, Milan

S. Maria dei Miracoli, 1662-1679, Rome

S. Maria del Sudario Project, Milan

S. Maria di Montesanto, 1662-1679, Rome

S. Maria in Campitelli (S. Maria in Portico), 1663-1667, Rome

S. Maria in Montesanto, Rome

RAINALDO, GIROLAMO, 1570-1655

S. Agnese in Agone (S. Agnese in Piazza Navona), 1652-1666,

Rome

S. Teresa, 1620, Caprarola

RAINERI, GIORGIO, 20th c.

Elementary School Addition,
1957-1958, Turin

Noviziato delle Suore de Carita,
1965, Turin

RAINERI, GIUSEPPE, 20th c.

Silos on the Stura, 1956, Turin

RAPHAEL SANZIO, 1482-1520

Palazzo Pandolfini,
ca. 1520-1527, Florence

S. Eligio degli Orefici,
ca. 1509-1516, Rome

S. Maria del Popolo Cappella
Chigi Chapel (Chigi Chapel),
ca. 1513, Rome

Villa Madama, ca. 1516 & later,
Rome

Palazzo Vidoni Caffarelli,
ca. 1515-1520, Rome

RATTI, 19th c.

Railroad Station, 1871, Turin

RAVA, CARLO ENRICO.
See **GRUPPO 7**

RE, LUCIANO, 20th c.

Olivetti Complex Residential
Center, 1969-1970, Ivrea

**RECALCATI, GIACOMO ONORATO,
18th c.**

S. Agata in Trastevere, ca. 1710,
Rome

REICHLINK, BRUNO, 20th c.

Casa Tonini, 1972-1974, Tonini

Villa Sartori, 1975-1977, Riveo

REINHART, FABIO, 20th c.

Casa Tonini, 1972-1974, Tonini

Teatro Carlo Felice, 1981-1982,
Genoa

Villa Sartori, 1975-1977, Riveo

RENACCO, NELLO, 20th c.

Community Center, Falchera
Residential Unit, 1950-1951,
Turin

RICCARDI, GIUSEPPE

Il Sedile, Lecce

**RICCHINO, FRANCESCO MARIA,
17th c.**

Palazzo del Senato (Collegio
Elvetico), 1608-1627, Milan

S. Giuseppi, 1607, Milan

Seminario Maggiore, ca. 1640,
Milan

RICCI, LEONARDO, 1918-

Goti Factory, Prato

Sorgane Quarter Building,
1963-1966, Florence

RICCIO, CAMILLO, 19th c.

Galleria Nazionale, 1890, Turin

Galleria Umberto I, 1887-1890,
Naples

RIDOLFI, MARIO, 1904-1984

A. G. I. P. Motel Project, 1968,
Rome

Apartment Building,
Via Villa Massima, 1934, Rome

Apartment House, Via
S. Valentino, 1936-1937,
Rome

I. N. A. Housing Development,
Tiburtina Quarter (Casa
Tiburtina), 1950-1954, Rome

I. N. A. Residential Towers,
Viale Etiopia, 1950-1954,
Rome

Lina House, Marmore, 1966,
Terni

Nomentana Post Office, 1933,
Rome

Palazzo Zaccardi, Via De Rossi,
1950-1951, Rome

Post Office, Piazza Bologna,
1933, Rome

Stazione Termini Project, 1947,
Rome

U. N. R. R. A.-Casas
Development, 1950, Popoli

RIETVELD, GERRIT, 1888-1964

Biennale, 24th Holland Pavilion,
1954, Venice

RINALDI, GIULIO, 20th c.

I. N. A. Housing Development,
Tiburtina Quarter (Casa
Tiburtina), 1950-1954, Rome

RIVA, UMBERTO, 1928-

De Palma Residence, 1972,
Stintino

RIVAS, F. P., 19th c.

Palazzo di Giustizia Project,
1885, Rome

RIZZO, ANTONIO, 1430-1498?

Doge's Palace L'Arco Foscari,
ca. 1345-1438, Venice

Doge's Palace Scala dei Giganti,
1483, Venice

RIZZOTTI, ALDO, 20th c.

Community Center, Falchera
Residential Unit, 1950-1951,
Turin

ROCCHI, CRISTOFORO, 15th c.

Cathedral Model, 1490, Pavia

ROGERS, ERNESTO N.,
See **B. B. P. R.**

ROGGERO, MARIO, 20th c.

I. N. A. Casa Residential
Complex, Galatina, 1958,
Lecce

ROSATI, ROSATO, 17th c.

S. Carlo ai Catinari, 1612-1620,
Rome

ROSSELLI, ALBERTO, 20th c.

Pirelli Building (Torre Pirelli),
1955-1960, Milan

**ROSSELLINO, BERNARDO,
1409-1464**

Badia Chiostro degli Aranci,
1436-1437, Florence

Cathedral, ca. 1460, Pienza

Fraternita di S. Maria della
Misericordia, 1433, Arezzo

Palazzo Comunale, 1460s, Pienza

Palazzo Piccolomini, ca. 1461,
Pienza

Palazzo Piccolomini Cortile,
ca. 1461, Pienza

Palazzo Spannocchi,
1469 & later, Siena

Palazzo Vescovile, ca. 1460s,
Pienza

Piazza Pio II, 1460-1462, Pienza

S. Miniato al Monte Chapel of
the Cardinal of Portugal,
1461-1466, Florence

ROSSETTI, BIAGIO, 1447?-1516

Casa Rossetti, 1490, Ferrara

Palazzo dei Diamanti,

1493 & later, Ferrara

Palazzo di Ludovico il Moro
Cortile, 15th c., Ferrara

S. Cristoforo, 1498, Ferrara

S. Francesco, 1494, Ferrara

Via Mortara, Ferrara

ROSSI, ALDO, 1931-

Cemetery Project, 1971,
Modena

Elementary School, 1972,
Fagnano Olona

Monument to Resistance
Project, 1962, Cuneo

Regional Administration Building
Project, 1974, Trieste

Teatro Carlo Felice, 1981-1982,
Genoa

ROSSI, DOMENICO, 1657-1737

Church of Gesuiti, 1715-1728,
Venice

S. Stae, 1710-1712, Venice

**ROSSI, GIOVANNI ANTONIO
DE, 1616-1695**

Palazzo Altieri, 1650-1660,
Rome

Palazzo d'Aste, Rome

Palazzo Misciatelli (Palazzo
d'Aste-Bonaparte),
1658-1665, Rome

S. Giovanni in Laterano Capella
Lancellotti, ca. 1675, Rome

S. Maria in Campomarzio
Courtyard, 1682-1695, Rome

S. Maria Maddalena in Campo
Marzio, 1695, Rome

ROSSI, MATTIA DE, 17th c.

Ospizio di S. Michele, ca. 1688,
Rome

S. Croce dei Lucchesi, ca. 1670,
Rome

ROSSI, PIERO DE, 20th c.

Viale Pitagora Towers, 1964,
Turin

ROTA, ITALO, 20th c.

Fiat Lingotto, 1983, Turin

ROVELLI, LUIGI, 19th-20th c.

Sacro Cuore, 1892 & later,
Genoa

ROVETTA, FRANCESCO, 1928-

Armi Museum, Castle, 1976,
Brescia

RUDI, ARRIGO, 20th c.

Banca Popolare di Verona,
1974-1981, Verona

RUSCONI, GIOVANNI ANTONIO

Prisons, 1563-1614, Venice

SABBATINI, INNOCENZO, 20th c.

Garbatella Housing Block, 1927,
Rome

SACCONI, GIUSEPPE, 1853-1905

Monument to Victor Emanuel II
Project, 1884, Rome

Monument to Victor Emanuel II,
1885-1911, Rome

SACRIPANTI, MAURIZIO, 1916-

Teatro Comunale Project, 1978,
Forli

SADA, CARLO, 1809-1873

S. Massimo, 1845-1853, Turin

Teatro Bellini, 1870-1890,
Catania

SAGGIORO, CARLA, 20th c.

Palazzo Municipale Project, 1974, Legnano

SALIVA, ERNESTO, 20th c.

Palazzo del Littorio Project, 1933, Rome

SALVADORI, GIUSEPPE, 19th c.

Slaughterhouse, 1841, Venice

SALVI, DIOTISALVI, 12th-13th c.

Baptistery, 1153-1265, Pisa

SALVI, NICOLA, 1697-1751

Fountain of Trevi (Fontana di Trevi), 1732-1736, Rome

Monte di Pietà, ca, 1740, Rome

SAMONA, ALBERTO, 20th c.

Banca d'Italia Headquarters, 1968-1974, Padua

Chamber of Deputies Office Building Project, 1967, Rome

Teatro Popolare Project, 1974, Sciacca

SAMONA, GIUSEPPE, 1898-1983

Banca d'Italia Headquarters, 1968-1974, Padua

Chamber of Deputies Office Building Project, 1967, Rome

City Hall, Cadoneghe

I. N. A. I. L. Center, S. Simeone, 1950-1956, Venice

M. P. S. Offices, 1958, Messina

Teatro Popolare Project, 1974, Sciacca

University of Cagliari Project, 1972, Cagliari

SANCTIS, FRANCESCO DE, 1693?-1731/40

Piazza di Spagna (Scala di Spagna, Spanish Steps, Spanish Staircase), 1723-1725, Rome

SANFELICE, FERDINANDO, 18th c.

Palazzo di Maio, Naples

Palazzo Sanfelice, 1728, Naples

SANGALLO, ANTONIO DA, THE ELDER, 16th c.

Palazzo Tarugi, ca. 1530, Montepulciano

S. Biagio, 1518-1529, Montepulciano

SANGALLO, ANTONIO DA, THE YOUNGER, 1483-1546

Palazzo Baldassini, ca. 1520, Rome

Palazzo Farnese (Farnese Palace), ca. 1515, Rome

S. Giovanni dei Fiorentini Project, ca. 1520, Rome

S. Maria di Loreto, 1510-1585, Rome

S. Peter's Project, 1539 & later, Vatican City

S. Spirito in Sassia, 1538-1544, Rome

Zecca, ca. 1530, Rome

SANGALLO, GIULIANO DA, ca. 1413-1516

Ardeatine Bastions, 1537-1546, Rome

Palazzo Gondi, 1490, Florence

Palazzo Scala Court, 1472-1480, Florence

Palazzo Venezia, ca. 1455-1471,

Rome

S. Lorenzo Project, 1516,
Florence

S. Maria delle Carceri,
1485-1492, Prato

S. Maria Maddalena de Pazzi,
1490 & later, Florence

Villa Medici, ca. 1480-1485,
Poggio a Caiano

**SANMICHELE, MICHELE,
1483-1559**

Chiesa della Madonna di
Campagna, 1559, Verona

Forte S. Andrea (Castel Nuovo),
1543, Venice

Palazzo Bevilacqua, ca. 1530,
Verona

Palazzo Canossa, ca. 1532,
Verona

Palazzo Cornaro-Mocenigo,
ca. 1540, Venice

Palazzo Corner Mocenigo, 1559,
Venice

Palazzo Grimani, ca. 1556,
Venice

Palazzo Pompeii, 1530 & later,
Verona

Porta Nuova, 1533-1540, Verona

Porta Palio, 1542-1555, Verona

S. Domenico Petrucci Chapel,
ca. 1516, Orvieto

**SANSOVINO, JACOPO (Jacopo
d'Antonio Tatti), 1486-1570**

Palazzo Corner (Ca' Corner della
Ca' Grande), 1537-1556,
Venice

S. Francesco della Vigna, 1534,
Venice

S. Marcello al Corso, 1519,
1682-1683, Rome

S. Marco Libreria Vecchia di

S. Marco, 1536-1553, Venice

Scuola di S. Maria in Val Verde,
1523-1583, Venice

Villa Garzone, mid. 16th c.,
Pontecasale

Zecca, 1536, Venice

**SANT' ELIA, ANTONIO,
1888-1916**

Cemetery Project, 1912, Monza

Citta Nuova Project,
ca. 1913-1915, Citta Nuova

Società de Commessi
Headquarters Project,
ca. 1916, Como

SANTI, DANILO, 20th c.

Apartment Building, Via della
Piagentina, 1964, Florence

SANTI, LORENZO, 1783-1839

Caffè (Società Canottieri
Bucintoro), 1838, Venice

Palazzo Patriarcale, 1837-1850,
Venice

Piazza S. Marco Napoleanic
Wing, 1810-1811, Venice

SANZIO, RAPHAEL.
See **RAPHAEL SANZIO**

SARDI, GIUSEPPE, 20th c.

Palazzo Savorgnan, ca. 1715,
Venice

S. Lorenzo in Lucina Baptistery,
1721, Rome

S. Maria del Rosario, Marino

S. Maria Maddalena (La
Maddalena), 1735, Rome

S. Paolo all Regola,
ca. 1686-1721, Rome

SARTI, ANTONIO, 1797-1880

Manifattura dei Tabacchi, 1859-1863, Rome

Villa Torlonia, ca. 1840, Rome

Villa Torlonia Orangery, ca. 1840, Rome

SARTORIS, ALBERTO

Biennale, 3rd Sion Theater Project, 1927, Monza

New Urban Development Project, 1923, Turin

SAVIOLI, LEONARDO, 1917-1981

Apartment Building, Via della Piagentina, 1964, Florence

SCALA, ANDREA, 1820-1892

Accademia Musicale, 1860s, Conegliano

Teatro Bellini, 1870-1890, Catania

SCALFAROTTO, GIOVANNI ANTONIO, 1700-1764

S. Simeone Piccolo, ca. 1718-1730, Venice

SCAMOZZI, VINCENZO, 1548-1616

Church of the Tolentini, 1591; 1706-1714, Venice

Palazzo Nuovo (Municipal Library), 16th c., Bergamo

Procuratie Nuove, 1581-1599, Venice

Teatro all' Antica (Teatro Olimpico), 1588-1590, Sabbioneta

Teatro Olimpico, 1580-1584, Vicenza

SCANNAVINI, ROBERTO

Mercato Ortofrutticolo, 1984, Bologna

SCARPA, CARLO, 1902-1978

Banca Popolare di Verona, 1974-1981, Verona

Biblioteca Querini-Stampalia Restoration, 1961-1963, Venice

Biennale, 24th Venezuela Pavilion, 1956, Venice

Brion Family Tomb, 1970-1972, San Vito d'Altivole

Castelvecchio Museum, 1956 & later, Verona

Possagno Plaster-Cast Gallery, 1955-1959, Possagno

Villa Veritti, 1956-1961, Udine

SCARPAGNINO, ANTONIO

S. Sebastiano, 1508-1548, Venice

Scuola di S. Rocco, ca. 1515 & later, Venice

SCIMEMI, GABRIELE

Office District, 1967-1970, Rome

SELVA, GIOVANNI ANTONIO, 1753-1819

Fenice Theater, 1790-1792, Venice

Teatro La Fenice, 1790-1792, Venice

Tempio Canova, 1819-1833, Possagno

SELVATICO, PIETRO E., 1803-1880

S. Pietro, 1848-1850, Trento

SEMERANI, LUCIANO, 1933-

City Planning, 1969, Trieste

Nuovo Ospedale, Cattinara, 1965-1983, Trieste

State Hospital of Cattenara, 1965 & later, Trieste

SEREGNI, VINCENZO, ca. 1504-1594

S. Vittore al Corpo, 1560-ca. 1580, Milan

SERRA, ANTONIO, 19th c.

Cathedral, 1826-1836, San Marino

SEVERUS, 1st c.

Domus Aurea (Golden House of Nero), after 64, Rome

SFONDRINI, ACHILLE, 1836-1900

Teatro dell' Opera, 1878-1880, Rome

SGRELLI, EGIO, 20th c.

Apartment House, 1952, Milan

Montesud Administration Buildings, 1964, Brindisi

SIBILLA, ANGELO, 20th c.

Chiesa della Sacra Famiglia, 1956 & later, Genoa

Residential Quarter, Forte di Quezzi, 1956 & later, Genoa

SILVANI, GHERARDO, 17th c.

Palazzo Fenzi, Florence

S. Gaetano, 1645, Florence

SIMONETTI, MICHELANGELO, 18th c.

Museo Pio Clementino, 1776 & later, Vatican City

SIMONITTI, VINCENZO, 20th c.

Hotel Manacore, 1962, Gargano

SINATRA, VINCENZO, 1707?-?

Palazzo del Municipio, Naples

S. Giorgio, 1750s, Modica

SIXTUS V, POPE, 17th c.

City Planning, 1602, Rome

SMERALDI, FRANCESCO, 16th-17th c..

S. Pietro di Castello, 1596-1619, Venice

SOLARI, GIOVANNI, ?-1484/85

Certosa di Pavia, 1429-1473, Pavia

SOLARI, GUINIFORTE, 1429-1481

Certosa di Pavia, ca. 1473, Pavia

S. Maria delle Grazie, 1465-1490, Milan

SOLERI, PAOLO, 1919-

Solimene Ceramics Factory, 1953, Salerno

SOLI, GIUSEPPE MARIA, 1745-1822

Piazza San Marco, 1810 & later, Venice

Piazza S. Marco Napoleanic Wing, 1810-1811, Venice

SOMMARUGA, GIUSEPPE, 1867-1917

Aletti Tomb, 1898, Varese

Campo dei Fiori Hotel, 1909-1912, Varese

Casa Castiglione, 1900-1903, Milan

Clinica Colombo, 1909, Milan

Hotel Tre Croci, 1908-1911, Varese

Palazzino Comi, 1906, MIlan

Palazzo Castiglioni, 1901-1903, Milan

Palazzo del Parlamento Nazionale Project, 1890, Rome

Villa Romeo, 1908, Milan

SONCINE, EUGENIO, 20th c.

Montecatini Office Building, 1939, Milan

SORIA, GIOVANNI BATTISTA, 1581-1651

S. Caterina a Magnapoli, Rome

S. Gregorio Magno, 1629-1633, Rome

S. Maria della Vittoria, 1626, Rome

SPAVENTI, GIORGIO, 16th c.

S. Salvatore, 1507-1534, Venice

SPECCHI, ALESSANDRO, 1688-1729

Palazzo Pichini, 18th c., Rome

Piazza di Spagna (Scala di Spagna, Spanish Steps, Spanish Staircase), 1723-1725, Rome

Porta di Ripetta, 1703, Rome

SPEZIA, ANTONIO, 19th c.

S. Maria Ausiliatrice, 1865-1888, Turin

STACCHINI, ULISSE, 1871-?

Apartments, Via Gioberti, ca. 1906, Milan

Central Station, 1912, 1925-1931, Milan

STELLA, FRANCO, 1943-

Estel Office Building, 1972-1986, Thiene

STERN, RAFFAELLO, 1774-1820

Braccio Nuovo, 1806-1823, Rome

STOPPINO, GIOTTO, 20th c.

Office Building, 1959-1960, Novara

STREET, GEORGE EDMUND, 1824-1881

All Saints, 1880-1937, Rome

S. Paul's American Church, 1873-1876, Rome

STUDIO CELLI & TOGNON (Celli, Carlo; Celli, Luciano; Tognon, Dario)

I. A. C. P. Residential Complex, 1970-1983, Trieste

STUDIO PASSARELLI, 20th c.

Aerhotel, 1978, Rome

Fiat Administration Building, 1982, Turin

Polyfunctional Building, 1964, Rome

Vatican Museum New Wing, 1970, Vatican City

TALENTI, FRANCESCO, 15th c.

S. Maria del Fiore (Il Duomo), 1296-1462, Florence

TALENTI, SIMONE, 1341?-1381?

Loggia dei Lanzi, 1376-1382, Florence

TAMARO, GIGETTA, 20th c.

City Planning, 1969, Trieste

Hospital, 1984, Mestre

Nuovo Ospedale, Cattinara,
1965-1983, Trieste

TEMANZA, TOMMASO,
1705-1789

Maddalena Church, 1760,
Venice

S. Maria Maddalena, 1748,
Venice

TEODOLI, GIROLAMO, 18th c.

S. Marcellino e Pietro,
1731-1732, Rome

TEODOLI, MARCHESE,
1677-1766

Teatro Argentina, 1732, Rome

TERRAGNI, GIUSEPPE,
1904-1943

Casa del Fascio (Casa del
Popolo), 1936, Como

Casa Rustica, 1933-1935, Milan

Novocomum Apartment House,
1929, Como

Palazzo del Littorio Project,
1933, Rome

Sant'Elia Kindergarten,
1936-1937, Como

Tenth Anniversary of the Fascist
Revolution Exhibition March
on Rome Room, 1932, Rome

Vitrum Store, 1930, Como

War Memorial, 1933, Como

War Memorial, 1928-1932, Erba

See also Gruppo 7

TESAURO, A., 17th c.

Biblioteca Ambrosiana,
1603-1609, Milan

TIBALDI, PELLEGRINO,
1527-1596

Cappella del Lazzaretto, Milan

Collegio Borromeo, 1564, Pavia

Palazzo Arcivescovile Canonica,
1564, Milan

S. Fedele, 1569, Milan

S. Gaudenzio, Noto

S. Sebastiano, 1577, Milan

Santuario della Madonna dei
Miracoli, 1596-1612, Saronno

TIRALI, ANDREA, ca. 1660-1737

Church of the Tolentini, 1591;
1706-1714, Venice

Palazzo Priuli-Manfrin,
Rio di Cannaregio, 1735,
Venice

S. Maria del Soccorso, 1723,
Venice

San Niccolò dei Tolentini,
1706-1714, Venice

TOGNON, DARIO.
See also Studio Celli & Tognon

TONCA, EDGARDO, 20th c.

Residential Building, Via
Campania, 1963-1965, Rome

TRAMELLO, ALESSIO,
1460-1550?

Madonna di Campagna, 1522,
Piacenza

TRAVAGLINI, FEDERICO, 19th c.

S. Domenico Maggiore,
1850-1853, Naples

TREVES, MARCO, 1814-1897

Synagogue, 1874-1882, Florence

**VASANZIO, GIORGIO,
ca. 1550-1621**

Villa Borghesi on the Pincio,
1613-1615, Rome

VASARI, GIORGIO, 1511-1574

Boboli Gardens, ca. 1550
& later, Florence

S. Lorenzo Laurentian Library
(Biblioteca Laurenziana),
1542 & later, Florence

S. Maria Nuova, ca. 1562,
Cortona

Uffizi (Palazzo degli Uffizi),
1560-1580, Florence

Villa Giulia (Villa of Julia),
1550-1555, Rome

VASENZIO, GIOVANNI, 17th c.

S. Sebastiano, ca. 400-450,
rebuilt, 1609-1613, Rome

VASSALLETTO, PIETRO, 13th c.

S. Paolo fuori le Mura Cloister,
ca. 1205-1214, Rome

**VELATI-BELLINI, GIUSEPPE,
20th c.**

House, Via Bezzecca, 1904,
Turin

VENEZIA, FRANCESCO, 1944-

Museum of Gibellina,
1981-1984, Gibellina

VENEZIOANI, GUIDO, 20th c.

L' Abeille Society Building, Via
Leopardi, 1959-1960, Milan

Hotel Punta S. Martino, 1958,
Genoa

**VESPIGNANI, FRANCESCO,
1842-1899**

S. Anselmo, 1890-1896, Rome

**VESPIGNANI, VIRGILIO,
1808-1882**

Porta Pia, 1852, Rome

S. Giovanni Laterano,
1874-1886, Rome

VIETTI, LUIGI, 20th c.

Palazzo del Littorio Project,
1933, Rome

VIGANO, VITTORIANO, 1919-

Istituto Marchiondi (Boarding
School), 1953-1959, Milan

Marchiondi Spogliardi Institute,
1952-1957, Milan

**VIGNOLA, GIACINTO BAROZZI
DA, 1507-1573**

S. Anna dei Palafrenieri, 1565,
Vatican City

Chiesa del Gesù (Il Gesù),
1568-1584, Rome

Palazzo Borghese,
ca. 1560-1607, Rome

Palazzo Farnese Gardens,
ca. 1560, Rome

S. Andrea di Via Flaminia,
1550-ca. 1554, Rome

S. Anna dei Palafrenieri, 1565,
Vatican City

S. Maria dell' Orto, 1566, Rome

Villa Farnese (Palazzo Farnese),
1547-1549, Caprarola

Villa Farnese Garden Pavilion,
1547-1549, Caprarola

Villa Giulia (Villa of Julia),
1550-1555, Rome

Villa Lante, 1566, Bagnaia

Villa Lante Fountain of the
Moors, Bagnaia

Villa Lante Garden, la. 16th c.,
Bagnaia

VITOZZI, ASCANIO, 1539-1615

Piazza Castello, 1584 & later,
Turin

S. Maria, 1596,
Vicoforte di Mondovi

S. Maria al Monte dei
Cappuccini, 1585-1596, Turin

S. Trinità, 1598, Turin

VITTONE, BERNARDO ANTONIO, 1702-1770

Parish Church (S. Michele),
1770 & later, Borgo d'Ale

Parish Church of the Assunta,
1750 & later, Grignasco

Pilgrimage Church of the
Visitation (Santuario della
Visitazione di Maria),
1738-1739, Vallinotto

Pilgrimage Church of the
Visitation Dome, 1738-1739,
Vallinotto

S. Chiara, 1742, Bra

S. Chiara, ca. 1745, Turin

S. Chiara, 1750-1756, Vercelli

S. Croce, Villanova di Mondovi

S. Gaetano, ca. 1745, Nizza

S. Luigi Gonzaga, ca. 1740,
Corteranzo

S. Maria della Piazza, Milan

S. Maria di Piazza, 1751-1768,
Turin

S. Michele, 1759, Rivarola
Canavese

VITTORIA, ALESSANDRO, 1525-1608

Palazzo Barbi, 1582-1590,
Venice

VOLTERRA, FRANCESCO CAPRIANI DA, 16th c.

Palazzo Gaetoni Project, 1581,
Rome

S. Giacomo degli Incurabili
(S. Giacomo in Augusta),
1592, Rome

S. Gregorio Magno, Capella
Salviata, 1600, Rome

ZACCAGNI, G. F., 16th c.

Madonna della Steccata, 1521,
Parma

ZAGUIR, DIEDO, 19th c.

S. Maurizio, 1806-1828, Venice

ZANINI, GIGIOTTI, 20th c.

Piazza Duse Office Building,
1933-1935, Milan

ZANOIA, GIUSEPPE, 1752-1817

Cathedral, 1806-1813, Milan

Porta Nuova, 1810-1813, Milan

ZANUSO, MARCO, 1916-

Hotel Punta S. Martino, 1958,
Genoa

Venezia-Giulia Regional Congress
Hall, 1974, Grado

ZAPPA, GIULIO, 20th c.

I. N. A. Casa Residential Unit,
Villa Bernabo Brea, 1953,
Genoa

ZARETTI, SERGIO, 20th c.

Viale Pitagora Towers, 1964,
Turin

ZERMANI, PAOLO, 1958-

Delizia Pavilion, 1983-1986,
Varano

ZEVI, BRUNO, 1918-

Office District, 1967-1970,
Rome

ZIMBALO, GIUSEPPE, 20th c.

Church of the Rosary, Lecce

ZORZI, SILVANO, 20th c.

Arno Bridge, Autostrada
del Sole, 1963, Florence

PART III
Chronological Index

**PREHISTORIC ERA--
 CAMPOFATTORE**
Hut Urn, ea. Iron Age

PREHISTORIC ERA--LUNI
Apennine Hut Reconstruction,
 Bronze Age

PREHISTORIC ERA--TAVOLIERE
Settlement, Neolithic Age

PREHISTORIC ERA--VELLETRI
Vigna d'Anrea, ea. Iron Age

9TH C. B. C.--ROME
Pozzo Tomb, ca. 800 B. C.

8TH C. B. C.--FIESOLE
Temple, 750-100 B. C.

8TH C. B. C.--NEMI
Temple Roof Terracotta Model,
 750-100 B. C.

8TH C. B. C.--PAESTUM
City Planning, 8th-6th c. B. C.

8TH C. B. C.--POMPEII
Strada dei Teatri,

ca. 750-100 B. C.

8TH C. B. C.--ROME
Hut, Palatine Village,
 8th c. B. C.

8TH C. B. C.--SOVANA
Gabled Tomb with Prodomus,
 750-100 B. C.

8TH C. B. C.--TARQUINIA
Ara della Regina Temple,
 750-100 B. C.

8TH C. B. C.--VEII
City Planning, 750-100 B. C.
Portonaccio Temple,
 750-100 B. C.

8TH C. B. C.--VETULONIA
City Planning, 750-100 B. C.

7TH C. B. C.--CASAL MARITTIMO
Tholos Tomb, ca. 600 B. C.

7TH C. B. C.--CERVETERI
Banditaccia Cemetery,
 7th c. B. C.
Regolini Galassi Tomb,

ca. 650 B. C.

Tomb of the Thatched Roof,
ea. 7th c. B. C.

7TH C. B. C.--LUNI

Tomb of the Caryatids, 600s B. C.

7TH C. B. C.--SAN GIOVENALE

Etruscan Houses, ca. 600 B. C.

Etruscan Tombs Model,
ca. 600 B. C.

House K, ca. 600 B. C.

Porzarago Cemetery,
ca. 600 B. C.

7TH C. B. C.--SELINUS

Megaron Temple, ca. 600 B. C.

7TH C. B. C.--SYRACUSE

Temple of Apollo, ca. 600 B. C.

7TH C. B. C.--VEII

House, ca. 600 B. C.

6TH C. B. C.--ACQUAROSSA

Zone F Building, la. 6th c. B. C.

6TH C. B. C.--AGRIGENTO

Temple of Castor & Pollux,
6th-5th c. B. C.

Temple of Juno Lacinia
(Temple D), 6th-5th c. B. C.

6TH C. B. C.--BOLSENA

Poggio Casetta Temple,
ea. 6th c. B. C.

6TH C. B. C.--CERVETERI

Tomb of the Doric Columns,
6th c. B. C.

Tomba dei Capitelli, 6th c. B. C.

Tumulus Tomb, ca. 500 B. C.

6TH C. B. C.--CHIUSI

Ash Urn with Arched Door,

6th c. B. C.

6TH C. B. C.--METAPONTUM

Temple of Hera, 6th-5th c. B. C.

6TH C. B. C.--ORVIETO

Crocefisso del Tufo, 6th c. B. C.

6TH C. B. C.--PAESTUM

Basilica, ca. 530 B. C.

Temple of Athena, ca. 510 B. C.

6TH C. B. C.--POMPEII

City Planning, North,
East Quarters, 520-450 B. C.

6TH C. B. C.--ROME

Capitolium, 6th-1st c. B. C.

Forum Romanum,
ca. 6th-1st c. B. C.

Temple of Jupiter
Capitolinus, 509 B. C.

Tomb of Princess Margrethe of
Denmark, 6th c. B. C.

Tomba della Regina, 6th c. B. C.

6TH C. B. C.--SELINUS

Temple C, ca. 550 B. C.

Temple D, ca. 536 B. C.

Temple E (Temple of Hera),
6th-5th c. B. C.

Temple F, ca. 525 B. C.

Temple G, ca. 520-450 B. C.

6TH C. B. C.--VELLETRI

Temple Model, 6th c. B. C.

6TH C. B. C.--VIGANELLO

Tomb, ca. 500 B. C.

5TH C. B. C.--AGRIGENTO

City Planning, 5th c. B. C.

Temple of Concord
(Temple F),ca. 430-400 B. C.

1ST C. B. C.--OSTIA

Piazzale of the Corporations,
ca. 12 B. C.

1ST C. B. C.--PALESTRINA

Basilica, ca. 80 B. C.

Sanctuary of Fortuna Primigenia,
Temple, ca. 80 B. C.

1ST C. B. C.--POMPEII

Amphitheater, ca. 80 B. C.

Forum Baths, ca. 80 B. C.

Stabian Baths, 1st c. B. C.

Temple of Apollo, 1st c. B. C.

Theater (Small Theater),
1st c. B. C.

1ST C. B. C.--RIMINI

Arch of Augustus, 27 B. C.

1ST C. B. C.--ROME

Ara Pacis, 13-9 B. C.

Arch of Titus, ca. 82

Basilica Aemilia, Forum
Romanum, 78 B. C.

Basilica Giulia (Julia),
Forum Romanum, 46 B. C.

Curia (Senate), Forum
Romanum, 6-1 B. C.

Domus Augustana (Flavian
Palace, Palace of Domitian,
Palatium), ca. 92

Forum Augustum, 10-2 B. C.

Forum Julium (Forum of
Caesar), 1st c. B. C.

Pons Aelius, ca. 1st c. B. C.

Ponte di Nona on Via
Praenestina, ca. 80 B. C.

Ponte Fabrico (Pons Fabricius),
62 B. C.

Porta Tiburtina, 5 B. C.

Pyramid of Caius Cestius,
ca. 18-12 B. C.

Servian Wall, 87 B. C.

Tabularium, Forum Romanum,
78 B. C.

Temple of Castor & Pollux,
Forum Romanum,
7 B. C.-6 A. D

Temple of Concord,
7 B. C.-10 A. D

Temple of Divus Julius,
Forum Romanum, ca. 29 B. C.

Temple of Mars Ultor,
Forum Augustum, ca. 14-2 B. C.

Temple of Portunus (Round
Temple), ca. 31 B. C.

Temple of Venus Genetrix,
Forum Julium, ca. 46 B. C.

Temple of Vesta, Forum
Boarium (Round Temple),
ca. 50 B. C.

Mausoleum of Augustus,
ca. 25 B. C.

Theater of Marcellus,
ca. 46-10 B. C.

Tomb of C. Poplicius Bibulus,
ca. 60 B. C.

Tomb of Caecilia Metella,
ca. 20 B. C.

Tomb of Eurysaces, ca. 30 B. C.

1ST C. B. C.--SEGUSIO

Arch of Augustus, 9-8 B. C.

1ST C. B. C.--SUSA

Arch of Augustus, ca. 8 B. C.

1ST C. B. C.--TERRACINA

Insula on Via dei Sanniti,
1st c. B. C.

Temple of Jupiter Anxur,
ca. 80 B. C.

1ST C. B. C.--TERRACINA

Via dei Sanniti, 1st c. B. C.

Porta dei Borsari, ca. 79-81

2ND C. --ANCONA

Arch of Trajan, 113-115

2ND C. --BAIA

Temple of Venus, ca. 125

2ND C. --BENEVENTO

Arch of Trajan, 114

2ND C. --CAPUA

Mausoleum (Carceri Vecchie),
ca. 125

2ND C. --OSTIA

City Planning, ca. 125

Fire Brigade Headquarters
(Barracks of the Vigiles),
117-138

House of Diana, 2nd c.

House of the Fortuna
Annonaria, la. 2nd c.

House of the Lararium, ca. 125

Insula of the Muses, ca. 130

2ND C. --POZZUOLI

Market, 2nd c.

Tomb on Via Celle, 2nd c.

2ND C. --ROME

Apartment Blocks, 2nd-3rd c.

Basilica Ulpia, Forum of
Trajan, ca. 110

Baths of Trajan, 104-109

Castel Sant'Angelo (Hadrian's
Mausoleum), ca. 135

Column of Marcus Aurelius, 174

Column of Trajan, Forum of
Trajan, 113

Forum of Trajan (Forum
Traianus), ca. 113-117

Markets of Trajan, Trajan's
Forum, 2nd c.

Pantheon (La Rotonda), 118-125

Temple of Antoninus & Faustina,
Forum Romanum, ca. 140 A. D

Temple of Divus Traianus,
Forum of Trajan, ea. 2nd c.

Temple of Venus & Rome,
125-135

Tomb of Annia Regilla, ca. 143

Villa of Sette Bassi, ca. 140-160

2ND C. --SULMONA

Aqueduct in Piazza Garibaldi,
2nd c.

2ND C. --TIVOLI

Hadrian's Villa, ca. 124-135

Hadrian's Villa, Canopis
(Canal of Canopo), ca. 124-135

Hadrian's Villa, Circular
Casino, ca. 123-135

Hadrian's Villa, Great Baths,
ca. 124-135

Hadrian's Villa, Greek Library,
ca. 120-125

Hadrian's Villa, Piazza d'Oro,
125-135

Hadrian's Villa, Teatro
Marittimo, 118-125

3RD C. --ROME

Arch of Septimius Severus,
Forum Romanum, 203

Arch of the Goldsmiths, 204

Aurelian Walls, 270-275

Baths of Caracalla, 211-217

Baths of Diocletian, 298-306

Catacomb of S. Panfilo,
ca. 200-350

City Planning (Forma Urbis),
3rd c.

Porta Appia (Porta
S. Sebastiano), 275;
remodeled 400

Porta Ostiensis (Porta

S. Sabina, 422-432

S. Sebastiano, ca. 400-450;
rebuilt, 1609-1613

S. Stefano Rotonda, 468-483

S. Vitale Reconstruction,
401-417

5TH C. --SEGESTA

Temple, la. 5th c.

5TH C. --VICENZA

S. Felice e Fortunato, 5th c.

6TH C. --GRADO

Cathedral, 571-579

6TH C. --RAVENNA

Mausoleum of Theodoric,
ca. 526

S. Apollinare in Classe,
ca. 543-539

S. Francesco, 560

S. Vitale, 526-547

6TH C. --RIVA SAN VITALE

Baptistery, ca. 500

6TH C. --ROME

S. Lorenzo fuori le Mura,
579-590; 1220

S. Maria in Cosmedin, 6th c.;
8th c. & later

7TH C. --FLORENCE

S. Lorenzo fuori le Mura,
7th-13th c.

7TH C. --ROME

S. Agnese fuori le Mura, 625-638

7TH C. --VENICE

S. Maria Assunta, 7th-12th c.

8TH C. --CIVIDALE

S. Maria in Valle, Tempietto,

ca. 762-776

8TH C. --RAVENNA

Palace of the Exarchs,
ca. 712-752

8TH C. --ROME

S. Susanna, 795

8TH C. --SUSA

Ribat of Sussa, la. 8th c.

9TH C.--AGLIATE

S. Pietro, ca. 875

9TH C. --ROME

S. Maria in Dominica,
Celio Hill, 9th c.

S. Prassede, 817-824

9TH C. --VENICE

S. Giovanni dall' Orio, 9th c.

10TH C. --IVREA

Cathedral of L'Assunta, 10th c.

11TH C. --ALBEROBELLO

Houses, 11th c.

**11TH C. --ALMENNO SAN
BARTOLOMEO**

S. Tomaso in Lemine, 11th c.

11TH C. --BARI

S. Nicola, ca. 1085-1132

11TH C. --COMO

S. Abbondio, ca. 1063-1095

S. Fedele, 11th-12th c.

11TH C. --FLORENCE

S. Miniato al Monte, 1018-1062,
1062-1090 & later

11TH C. --LOMELLO

S. Maria Maggiore, ca. 1040

1493 & later

Palazzo di Ludovico il Moro,
S. Cristoforo, 1498

S. Francesco, 1494

Via Mortara, 1490s

15TH C. --FIESOLE

Badia Fiesolana, 1461

15TH C. --FLORENCE

Badia, Chiostro degli Aranci,
1436-1437

City Planning, 1471-1482

Ospedale degli Innocenti
(Foundling Hospital),
1421-1445

Palazzo Antinori, 1470s

Palazzo di Parte Guelfa,
ca. 1420

Palazzo Gerini-Neroni, 1460

Palazzo Gondi, 1490

Palazzo Guadagni, 1490-1506

Palazzo Medici-Riccardi,
1444-1460

Palazzo Pitti, 1458 & later

Palazzo Quaratesi (Palazzo
Pazzi), 1460-1472

Palazzo Rucellai, 1446-1451

Palazzo Rucellai, Cortile,
1446-1451

Palazzo Scala, Court,
1472-1480

Palazzo Strozzi, 1489-1539

S. Annunziata, ca. 1450

S. Croce, Pazzi Chapel
(Cappella de' Pazzi),
ca. 1429-1446

S. Francesco al Monte
(S. Salvatore), 1480-1504

S. Lorenzo (Basilica di
S. Lorenzo), 1421-1460

S. Lorenzo, Old Sacristy
(Sacrestia Vecchia),

1421-1428

S. Marco, ca. 1430

S. Marco, Library (Biblioteca
di S. Marco), ca. 1430-1438

S. Maria degli Angeli,
1434-1437

S. Maria del Fiore, Dome,
1420-1434

S. Maria del Fiore, Lantern,
1445-1462

S. Maria della Croce, 1493

S. Maria Maddalena de Pazzi,
1490 & later

S. Miniato al Monte, Chapel of
the Cardinal of Portugal,
1461-1466

S. Pancrazio, Chapel of the
Holy Sepulchre (Rucellai
Chapel), ca. 1455-1460

S. Salvatore al Monte, ca. 1480

S. Spirito, 1445-1482

15TH C. --GENOA

Palazzo Andrea Doria
in Piazza S. Matteo
Reconstruction, ca. 1486

Palazzo Doria, Vico d'Oria,
ca. 1450

15TH C. --JESI

Palazzo Comunale, Courtyard,
ca. 1490-1500

15TH C. --LORETO

Basilica, ca. 1470-1495

15TH C. --MACERATA

Loggia dei Mercanti, 15th c.

15TH C. --MANTUA

Casa de Gioanni Boniforte da
Concorezzo, 1455

Casa via Frattini 5,
ca. 1460-1470

15TH C. -- ROCCA DI MONDAVIO

Rocca di Mondavio,
1479 & later

15TH C. -- ROCCA DI SAN LEO

Rocca di S. Leo, 1479 & later

15TH C. -- ROCCA DI SASSOCORVARO

Rocca di Sassocorvaro,
1479 & later

15TH C. --ROME

Ospedale di Santo Spirito
in Sassia, 1474-1482 & later

Palazzo della Cancelleria
Papale, 1485-1513

Palazzo Venezia, ca. 1455-1471

Palazzo Venezia, Courtyard,
ca. 1455-1471

Ponte Sisto, 1474

S. Agostino, 1479-1483

S. Giacomo degli Spagnuoli
(Sacro Cuore di Maria),
ca. 1450

S. Marco, Palazzo Venezia,
ca. 1460-1465

S. Maria del Popolo, 1472-1480

S. Onofrio, 1434-1444

S. Pietro in Montorio,
ca. 1480-1500

15TH C. --SAVONA

Palazzo Rovere, ca. 1490

15TH C. --SEBENICO

Cathedral, 1477

15TH C. --SIENA

Palazzo Spannocchi,
1469 & later

15TH C. --SOLETO

Cathedral, Campanile, ca. 1400

15TH C. --TURIN

S. Giovanni Battista
(Cathedral), 1491-1498

15TH C. --URBINO

City Planning, 15th c.

Palazzo Ducale (Ducal Palace),
ca. 1444-1482

Palazzo Ducale, Capela del
Perdono (Perdono Chapel),
ca. 1444-1482

Palazzo Ducale, Courtyard,
ca. 1450

Palazzo Ducale, Federico's
Study, 15th c.

Palazzo Ducale, Sala del Trono,
ca. 1444-1482

Piazza Maggiore, 1470s

S. Bernardino degli Zoccolanti,
1482-1490

15TH C. --VATICAN CITY

S. Peter's, 15th c.

S. Peter's, Project, ca. 1450

15TH C. --VEGEVANO

Piazza Ducale, ca. 1492-1494

15TH C. --VENICE

Arsenal, Archway, 1460

Ca' d'Oro, ca. 1430

Campo S. Angelo, 15th c.

Doge's Palace, Scala dei
Giganti, 1483

Dormitory & Cloister of the
Bay Leaves, 1494-1540

Palazzo Centani (Goldoni's
House), 15th c.

Palazzo Centani, Courtyard,
15th c.

Palazzo Contarini, Spiral
Staircase, 15th c.

Palazzo Corner-Spinelli,
ca. 1480

(Medici Chapel, Capella Medici), 1521-1534

S. Lorenzo, Project, 1516

S. Trinità, 1594

Uffizi (Palazzo degli Uffizi), 1560-1580

16TH C. --GENOA

City Planning, 1573

Palazzo della Meridiana (Palazzo Grimaldi), mid. 16th c.

Palazzo Municipale (Palazzo Tursi, Palazzo Comunale), 1564-1566

Palazzo Sauli, ca. 1555

S. Annunziata, 1587; facade

S. Maria Assunta de Carignano, 1549

Strada Nuova, 1558

Villa Cambiaso, 1548

Villa Grimaldi, ca. 1555

16TH C. --IMOLA

City Planning, ca. 1503

16TH C. --LECCE

S. Croce, 16th-17th c.

16TH C. --LONEDO

Villa Godi, ca. 1540

16TH C. --LORETO

S. Casa, 1509

16TH C. --LUCCA

Palazzo del Pretorio (Palazzo della Signoria, Palazzo de Governo), 1550

Palazzo Micheletti, ca. 1550

16TH C. --LUGO

Villa Piovene, 16th c.

16TH C. -- LUVIGLIANO

Villa dei Vescovi, ca. 1530

16TH C. --MANTUA

Cathedral, ca. 1540-1545

Giulio Romano House, ca. 1540

Palazzo del Te, 1525-1535

Palazzo del Te, Giardino Segreto, 1525-1535

S. Benedetto al Polirone, 1540

16TH C. --MASER

Chapel, 1560s

Palazzo Arcivescovile, Canonica, 1564

Palazzo Marino (Municipale), 1558-1560

S. Angelo, 1552-1555

S. Fedele, 1569

S. Lorenzo Maggiore, 1573

S. Maria del Carmine, 1515

S. Maria Presso S. Celso, 1570

S. Paolo alle Monache, 1549-1551

S. Paolo e Barnaba, 1561-1567

S. Sebastiano, 1577

S. Vittore al Corpo, 1560-ca. 1580

Villa Barbaro, 1560-1568

Villa Barbaro, Nymphaeum, 1560-1568

Villa Simonetta, 1547

16TH C. --MELEDO

Villa Grissino, 16th c.

16TH C. --MIRA

Villa Foscari, 1549

16TH C. --MONTECCHIO

Villa Cerato, 16th c.

ca. 1564

S. Eligio degli Orefici,
ca. 1509-1516

S. Giacomo degli Incurabili
(S. Giacomo in Augusta),
1592

S. Giovanni dei Fiorentini
Project, ca. 1520

S. Giovanni dei Fiorentini
Project, ca. 1559

S. Luigi dei Francesci,
ca. 1580-1585

S. Marcello al Corso, 1519;
1682-1683

S. Maria degli Angeli,
1561-1564

S. Maria dei Monti
(Madonna dei Monti),
1580-1581

S. Maria del Popolo, ca. 1500

S. Maria del Popolo, Cappella
Chigi (Chigi Chapel),
ca. 1513

S. Maria dell' Orto, 1566

S. Maria della Pace, Cloister,
1500-1504

S. Maria di Loreto, 1510-1585

S. Maria in Trivio, 1575

S. Maria Maggiore, Capella
Sforza (Sforza Chapel),
ca. 1560-1573

S. Maria Maggiore, Capella
Sistina (Sistine Chapel), 1585

S. Pietro in Montorio
Tempietto, 1502

S. Spirito in Sassia, 1538-1544

S. Trinità dei Monti, ca. 1580

Villa Farnesina, 1509-1511

Villa Farnesina, Loggia di
Psiche, 1509-1511

Villa Giulia (Villa of Julia),
1550-1555

Villa Giulia, Nymphaeum, 1552

Villa Madama, ca. 1516 & later

Villa Medici, 1574-1580

Villa Montalto, 1570

Zecca, ca. 1530

16TH C. --ROVIGO

Villa Badoer, Fratta Polesine,
1554-1563

16TH C. -- SABBIONETA

Teatro all' Antica
(Teatro Olimpico), 1588-1590

16TH C. -- SAN VITO D'ALTIVOLE

Villa Sarego, 1564/65

16TH C. --SARONNO

Santuario della Madonna
dei Miracoli, 1596-1612

16TH C. -- SETTIGNANO

Villa Gamberaia, ca. 1550 & later

16TH C. --SIENA

Casa Pollini, ca. 1527

**16TH C. -- SU NURAXI DI
BARUMINI**

Nuraghe, ca. 1500 B. C.

16TH C. --TIVOLI

Villa d'Este, ca. 1565-1572

Villa d'Este, Fountains, ca. 1550

Villa d'Este, Gardens,
ca. 1565-1572

16TH C. --TODI

S. Maria della Consolazione,
1508-1604

16TH C. --TRISSINO

Villa Trissino da Porto
(Villa Marzotto), Gardens,
1537-1548

18TH C. --PALERMO
Orto Botanico, 1789-1792
Park of Real Favorita, ca. 1799
Villa della Favorita, Palazzina
 Cinese, 1799-1802
Villa Giulia, Gardens, 1790s

18TH C. --RAGUSA IBLA
S. Giorgio, 1746-1766

18TH C. --REGGIO EMILIA
Town Hall, 18th c.

18TH C. --RIVAROLA CANAVESE
S. Michele, 1759

18TH C. --ROME
Chapel of the Sacrament
 (Capella del Sacramento,
 S. Peter's Sacristy), 1776
City Planning, ca. 1700
City Planning, 1723
City Planning, 1748
Fountain in Piazza della
 Rotonda, 1711
Fountain of Trevi (Fontana di
 Trevi), 1732-1736
Monte di Pietà, ca. 1740
Palazzo Cenci-Bolognetti, 1745
Palazzo della Consulta,
 1732-1737
Palazzo Doria-Pamphili,
 1730-1735
Palazzo Doria-Pamphili
 Gardens & Park, 1730-1735
Piazza di S. Maria del
 Priorata, 1765
Piazza di Spagna (Scala di
 Spagna, Spanish Steps,
 Spanish Staircase),
 1723-1725
Piazza S. Ignazio, 1727-1728
Porta di Ripetta, 1703

S. Apollinaire, 1742-1748
S. Croce in Gerusalemme
 (Basilica Sessoriana),
 1741-1743
S. Dorotea in Trastevere,
 1751-1756
S. Giovanni in Laterano,
 1733-1736
S. Giovanni in Laterano,
 Corsini Chapel, 1732-1735
S. Girolamo della Carita,
 Capella Antamori, 1708
S. Lorenzo in Lucina,
 Baptistery, 1721
S. Marcellino e Pietro,
 1731-1732
S. Maria Aventina, 1764-1766
S. Maria del Priorato, 1765
S. Maria del Priorato,
 Entrance Gate, 1765
S. Maria dell' Orazione e della
 Morte, 1733-1737
S. Maria della Quercia, 1727
S. Maria Maddalena (La
 Maddalena), 1735
S. Maria Maggiore, 1714-1743
S. Michele Prison, 1703-1704
Teatro Argentina, 1732
Trinità dei Monti, Obelisk,
 1786-1789
Villa Albani, ca. 1761
Villa Albani, Gardens, ca. 1760
Villa Borghese, ca. 1787
Villa Borghese, Gardens,
 ca. 1787
Villa Borghese, Temple of
 Esculapius, 1785-1792

18TH C. --STRA
Villa Pisani, 1735-1756

18TH C. --STUPINIGI
Villa Reale di Stupinigi (Royal

19TH C. --CAPRIATE D' ADDA
Villa Crespi, ca. 1890

19TH C. --CATANIA
Teatro Bellini, 1870-1890

19TH C. --COMO
City Planning, 1858
Villa for Diaz de Quijano,
 1883-1885

19TH C. --CONEGLIANO
Accademia Musicale, 1860s

19TH C. --FLORENCE
Apartments in Piazza delle
 Mulina, 1880
Cathedral, 1867-1887
Hotel Savoy, 1890s
House on Via Borgognissanti,
 1896-1915
Housing, ca. 1888
Palazzo Der Villa, ca. 1850
Palazzo Pitti, 1812 & later
Piazza Beccaria, 1860s
Piazza Vittorio Emanuele,
 1893-1895
S. Croce, 1847 & later
S. Niccolò, 1865 & later
Synagogue, 1874-1882
Viale G. Matteotti, 1868 & later
Villa Poggio Imperiale,
 1804 & later
Villa Poggio Imperiale, Chapel,
 ca. 1812
Villino Favard, 1857

19TH C. -- GALLARATE
Cemetery, 1865
Hospital, 1871 & later

19TH C. --GENOA
Castello Mackenzie, 1890s

Chiesa dell' Immacolata,
 1856-1873
Chiesa della Santissima
 Annunziata, 1830
Galleria Mazzini, 1871
Sacro Cuore, 1892 & later
Staglieno Cemetery, 1825
Teatro Carlo Felice, 1826-1828
Villino Piaggio, ca. 1895

19TH C. --GHISALBA
La Rotonda, 1834

19TH C. --INVERIGO
Villa Cagnola d'Adda, 1813-1833

19TH C. --LEGHORN
Il Cisternone, 1829-1842

19TH C. --LONIGO
Cathedral, 1877-1895

19TH C. --MILAN
Arco del Sempione, 1806-1838
Arena, Triumphal Gate,
 1806-1813
Casa Reininghaus, ca. 1898
Casa Verdi, 1899
Cathedral, 1806-1813
Cathedral, 1886
Cathedral, 1887
Cathedral, 1888
Cimitero Monumentale,
 1863-1866
Cimitero Monumentale,
 Chapel, 1863-1866
Foro Bonaparte Project,
 1801-1806
Galleria Vittorio Emanuele II,
 1865-1877
Museo Civico di Storia
 Naturale, 1892 & later
Palazzo Besana in Piazza

20TH C. --BELRIGUARDO

Farm Buildings

20TH C. --BERGAMO

Convento dei Frati Francescani (Franciscan Monastery & School), 1972

Società Cattolica di Assicurazione, 1967-1971

Villa Pizzigoni, 1925-1927

20TH C. --BIBLIONE

Market, S. Michele al Tagliamento, 1980

20TH C. --BOLOGNA

City Planning, 1917

E. M. P. A. S. Office Building, 1952-1957

Government Tobacco Warehouse, 1952

I. A. C. P. Quarter on Via della Barca, 1957-1962

Mercato Ortofrutticolo, 1984

Sacro Cuore, 1912 & later

20TH C. --BRESCIA

Armi Museum, Castle, 1976

Post Office in Piazza della Vittoria

20TH C. --BRINDISI

Montesud, Administration Buildings, 1964

20TH C. --BUSTO ARSIZIO

Istituto Tecnico Industriale, 1968

Scuola, 1964

20TH C. --CADENZA

Villa, 1970-1971

20TH C. --CADONEGHE

City Hall

20TH C. --CAGLIARI

University of Cagliari, Project, 1972

20TH C. --CANINO

Thermal Bath Building, 1981

20TH C. --CASERTA

Houses with Prefabricated Elements, 1962

20TH C. --CERCIVENTO

City Hall, 1979-1980

20TH C. --CERINIA

Rifugio Pirovano, 1949-1951

Municipal Housing Complex Expansion, 1979

20TH C. --CESENATICO

Health Center, 1938

20TH C. --CHIETI

Student Residences

20TH C. --CIAMPINO

Casa 'Aleph', 1972-1977

20TH C. --CITTA NUOVA

Citta Nuova Project, ca. 1913-1915

20TH C. --COLLINA

Church, 1954

20TH C. --COLLODI

Osteria del Gambero Rosso (Tavern 'Red Lobster'), 1961-1963

20TH C. --COMO

Albergo Metropole Suisse, 1927

Casa del Fascio (Casa del Popolo), 1936

City Planning, 1927

Palazzo Bianco, Communal
Galleries, 1950-1951

Palazzo Rosso Museum,
1953-1960

Residential Quarter,
Forte di Quezzi, 1956 & later

S. Agostino Museum,
1977-1986

S. Lorenzo Treasury Museum
(Tesoro di S. Lorenzo),
1952-1956

Teatro Carlo Felice, 1981-1982

20TH C. --GIBELLINA

Church, Project, 1970

Museum of Gibellina,
1981-1984

20TH C. --GIRIFALCO

Mental Hospital, 1968-1978

20TH C. --GRADO

Venezia-Giulia Regional
Congress Hall, 1974

20TH C. --IVREA

Olivetti Complex, 1954-1957

Olivetti Complex, Refectory,
1955-1959

Olivetti Complex, Residential
Center, 1969-1970

**20TH C. --LACCO AMENO
D'ISCHIA**

Terme Regina Isabella,
1950-1953

20TH C. --LAKE NERO

Sled-Lift Station,
Val di Susa,1946 & later

20TH C. --LATINO

Post Office, 1932

20TH C. --LECCE

I. N. A. Casa Residential
Complex, Galatina, 1958

20TH C. --LEGNANO

Palazzo Municipale, Project,
1974

Sun Therapy Colony, 1939

20TH C. --LIGNANO PINETA

Villa Spezzotti, 1958

20TH C. --LIGORNO

House, 1975-1976

20TH C. --LISSONE

Cemetery Project, 1981

20TH C. --LODI

Garage Barnabone, 1920s

20TH C. --LUCCA

E. N. P. A. S. Headquarters,
1958-1961

20TH C. --MANTUA

Cartiere Burgo (Burgo Paper
Factory), 1960-1962

20TH C. --MATERA

La Martella Village,
1951 & later

University of Calabria Project,
1973

20TH C. --MESSINA

M. P. S. Offices, 1958

20TH C. --MESTRE

Garage Marcon, 1907

Hospital, 1984

20TH C. --MILAN

Alfa-Romeo Works, Storage,
1937

20TH C. --PADUA

Banca d'Italia Headquarters,
 1968-1974
Cinema Altino, 1951
Cinema Arlecchino, 1948

20TH C. --PADUA

Warehouse, 1958

20TH C. --PALERMO

Apartment House, 1972
Favorita Swimming Pool,
 1965-1970
I. R. F. I. S. Center Project, 1979
University of Palermo,
 New Science Department
 Building, 1969-1985
Villa Igiea, 1901
Villino Basile, 1903
Zen Quarter, Project, 1969

20TH C. --PARABITA

Cemetery, 1967-1982

20TH C. --PARMA

I. N. A. Office Building,
 1950-1953

20TH C. --PAULLO

Laboratory Project, 1969

20TH C. --PAVIA

University of Pavia, Laboratories
 & Scientific Department
 Building, 1974-1976

20TH C. --PESARO

Marconi School of Science,
 1970
Villa Ruggeri, 1902-1907

20TH C. --PESCIA

Covered Market, 1951

20TH C. --PIEVE EMANUELE

Civic Center, 1971-1979

20TH C. --PISA

S. Giovanni al Gatano, 1947

20TH C. --PISTOIA

Cassa di Risparmio, 1964-1966

20TH C. --POPOLI

U. N. R. R. A.-Casas
 Development, 1950

20TH C. --PORDENONE

Primary School, 1984
Zanussi Factory Offices,
 1959-1961

20TH C. --PORTA AGUILA

Castello Buon Consiglio, 1921

20TH C. --POSSAGNO

Possagno Plaster-Cast Gallery,
 1955-1959

20TH C. --POZZUOLI

Olivetti Plant, 1951 & later

20TH C. --PRATO

Gatti Factory, 20th c.

20TH C. --PROVAGLIO D'ISEO

Residential Complex, 1984

20TH C. --PUTIGNANO

Junior High School, 1983

20TH C. --RAVENNA

Savings Bank Tax Collection
 Office, 1962-1965

20TH C. --REGGIO EMILIA

Parmesan Cheese Cooperative
 Headquarters, 1983

PART IV
Type Index

CASTLES. *See* **MILITARY STRUCTURES**

CATHEDRALS. *See* **RELIGIOUS BUILDINGS**

CEMETERIES. *See* **FUNERARY STRUCTURES**

CHAPELS. *See* **RELIGIOUS BUILDINGS**

CHURCHES. *See* **RELIGIOUS BUILDINGS**

CITY PLANNING--8TH C. B. C.

Paestum
City Planning, 8th-6th c. B. C.

Veii
City Planning, 750-100 B. C.

Vetulonia
City Planning, 750-100 B. C.

CITY PLANNING--6TH C. B. C.

Pompeii
City Planning, North, East Quarters, 520-450 B. C.

CITY PLANNING--5TH C. B. C.

Agrigento
City Planning, 5th c. B. C.

Rome
City Planning, 5th-2nd c. B. C.

CITY PLANNING--4TH C. B. C.

Ostia
City Planning, 4th c. B. C.

CITY PLANNING--3RD C. B. C.

Cosa
City Planning, 3rd c. B. C.

CITY PLANNING--1ST C. B. C.

Alba Fucens
City Planning, ea. 1st c. B. C.

Aosta
City Planning, 24 B. C.

Florence
City Planning, ca. 59 B. C.

CITY PLANNING--2ND C.

Ostia
City Planning, ca. 125

CITY PLANNING--3RD C.

Rome
City Planning (Forma Urbis), 3rd c.

CITY PLANNING--13TH C.

Florence
City Planning, ca. 1200-1250
City Planning, ca. 1250-1300

CITY PLANNING--14TH C.

Venice
City Planning, 1348

CITY PLANNING--15TH C.

Florence
City Planning, 1427
City Planning, 1471-1482

Naples
City Planning, 15th c.

Pienza
City Planning, 15th c.

Urbino
City Planning, 15th c.

CITY PLANNING--16TH C.

Caprarola
City Planning, ca. 1550

Ferrara
City Planning, ca. 1575-1600

Genoa
City Planning, 1573

Imola
City Planning, ca. 1503

Rome
 City Planning, 1500s

CITY PLANNING--17TH C.

Palmanova
 City Planning, 1593-1623

Rome
 City Planning, 1602

Turin
 City Planning, 1620, 1673,
 1714

CITY PLANNING--18TH C.

Avola
 City Planning, 1757

Rome
 City Planning, ca. 1700
 City Planning, 1723
 City Planning, 1748

CITY PLANNING--19TH C.

Como
 City Planning, 1858

Rome
 City Planning, 1880

CITY PLANNING--20TH C.

Abruzzo
 City Planning, 1917

Bologna
 City Planning, 1917

Città Nuova
 Citta Nuova Project,
 ca. 1913-1915

Como
 City Planning, 1927

Florence
 City Planning, 20th c.
 Ponte Vecchio Area
 Development, 1945

Matera
 La Martella Village,
 1951 & later

Milan
 City Planning, 1934
 City Planning (Master Plan),
 1945

Palermo
 Zen Quarter, Project,1969

Rome
 City Planning, Ancient Rome
 Model, 1939 reconstruction

Sabaudi
 City Planning, 1933

Terni
 Matteotti Quarter, 1969-1975

Trento
 Colonia Ridente, 1920

Trieste
 City Planning, 1969

Turin
 New Urban Development
 Project, 1923
 Youth Village, 1948-1957

Venice
 City Planning (Barene di
 S. Giuliano), 1959

COLLEGE BUILDINGS. *See*
**EDUCATION & RESEARCH
BUILDINGS**

CONVENTION CENTERS. *See*
SOCIAL & CIVIC BUILDINGS

**CORRECTIONAL INSTITUTIONS--
16TH C.**

Venice, Prisons, 1563-1614

**CORRECTIONAL INSTITUTIONS--
17TH C.**

Rome
 Carceri Nuove, 1652
 Prison, Ospizio di S. Michele,
 17th c.
 Prison, Via Giulia, 17th c.

CORRECTIONAL INSTITUTIONS --18TH C.

Rome
 S. Michele Prison, 1703-1704

COURTHOUSES. *See*
 GOVERNMENT BUILDINGS

CULTURAL CENTERS. *See*
 SOCIAL & CIVIC BUILDINGS

DAMS. *See* **WATERWORKS
& OTHER HYDRAULIC
STRUCTURES**

DEPARTMENT STORES. *See*
 MERCANTILE BUILDINGS

DWELLINGS--PREHISTORIC ERA

Luni
 Apennine Hut Reconstruction,
 Bronze Age

Tavoliere
 Settlement, Neolithic Age

Velletri
 Vigna d'Anrea, ea. Iron Age

DWELLINGS--8TH C. B. C.

Rome
 Hut, Palatine Village,
 8th c. B. C.

DWELLINGS--7TH C. B. C.

San Giovenale
 Etruscan Houses, ca. 600 B. C.
 House K, ca. 600 B. C.

Veii
 House, ca. 600 B. C.

DWELLINGS--6TH C. B. C.

Acquarossa
 Zone F Building, la. 6th c. B. C.

DWELLINGS--4TH C. B. C.

Pompeii
 House of the Surgeon,
 4th-3rd c. B. C.

Rome
 House, 4th-3rd c. B c.

DWELLINGS--2ND C. B. C.

Cosa
 Villa, 2nd c. B. C.

Ostia
 Apartment Blocks,
 2nd-3rd c. B. C.

Pompeii
 House of Lucretius Fronto,
 ca. 2nd-1st c. B. C.
 House of Menander,
 2nd c. B. C.
 House of Sallust, 2nd c. B. C.
 House of the Faun,
 ca. 2nd c. B. C.
 House of the Pansa,
 2nd c. B. C.
 House of the Silver Wedding,
 2nd c. B. C.
 Villa of the Mysteries
 (Villa Item), 2nd c. B. C.

DWELLINGS--1ST C. B. C.

Boscoreale
 Roman Country House,
 1st c. B. C.

Herculaneum
 House of Neptune &
 Amphitrite, 1st c. B. C.
 House of the Mosaic
 Atrium, ca. 1st c. B. C.
 House of the Stags, 1st c. B. C.

Rome
 Domus Augustana (Flavian
 Palace, Palace of Domitian,
 Palatium), ca. 92

DWELLINGS--1ST C.

Albano
 Villa of Pompey, ca. 1st c.

Capri
 Villa Jovis, 14-37

Ostia
 House of the Charioteers,
 ca. 1st-2nd c.

DWELLINGS--15TH C.

Brescia
 Palazzo Comunale, Loggia,
 ca. 1490-1510

Cremona
 Palazzo Raimondi, 1496-1499

Fanzola
 Villa Emo, 16th c.

Ferrara
 Casa Rossetti, 1490
 Palazzo Antinori, 1470s
 Palazzo dei Diamanti,
 1493 & later
 Palazzo di Ludovico il Moro,
 Cortile, 15th c.
 Palazzo di Parte Guelfa,
 ca. 1420
 Palazzo Gerini-Neroni, 1460
 Palazzo Gondi, 1490
 Palazzo Guadagni, 1490-1506
 Palazzo Medici-Riccardi,
 1444-1460
 Palazzo Pitti, 1458 & later
 Palazzo Quaratesi
 (Palazzo Pazzi), 1460-1472
 Palazzo Rucellai, 1446-1451
 Palazzo Rucellai, Cortile,
 1446-1451
 Palazzo Scala, Court,
 1472-1480
 Palazzo Strozzi, 1489-1539

Genoa
 Palazzo Andrea Doria in Piazza
 S. Matteo Reconstruction,
 ca. 1486
 Palazzo Doria, Vico d'Oria,
 ca. 1450

Jesi
 Palazzo Comunale,
 Courtyard, ca. 1490-1500

Lugo
 Villa Piovene, 16th c.

Mantua
 Casa de Gioanni Boniforte
 da Concorezzo, 1455
 Casa via Frattini 5,
 ca. 1460-1470

Domus Nova, ca. 1480

Meledo
 Villa Grissino, 16th c.

Mira
 Villa Foscari, 1549

Montecchio
 Villa Cerato, 16th c.

Naples
 Palace for the King of
 Naples, ca. 1490
 Palazzo Cuomo, 1464-1490
 Palazzo Diomede Carafa,
 15th c.
 Palazzo Penne, 15th c.
 Poggioreale, 1487

Palermo
 Palazzo Abatellis, 15th c.
 Palazzo Aiutamicristo, 15th c.

Pesaro
 Palazzo Ducale, ca. 1472

Pienza
 Palazzo Comunale, 1460s
 Palazzo Piccolomini, ca. 1461
 Palazzo Piccolomini,
 Cortile, ca. 1461
 Palazzo Vescovile, ca. 1460s

Piombino Dese
 Villa Cornaro, 16th c.

Poggio a Caiano
 Villa Medicea, ca. 1480-1485

Poiana Maggiora
 Villa Poiana

Rome
 Palazzo della Cancelleria
 Papale, 1485-1513
 Palazzo Venezia,
 ca. 1455-1471
 Palazzo Venezia, Courtyard,
 ca. 1455-1471

Savona
 Palazzo Rovere, ca. 1490

Siena
 Palazzo Spannocchi,
 1469 & later

Palazzina Cinese, 1799-1802

Rome
Palazzo Cenci-Bolognetti, 1745
Palazzo Cimarra, begun 1736
Palazzo del Cinque, ea. 18th c.
Palazzo della Consulta,
1732-1737
Palazzo Doria-Pamphili,
1730-1735
Palazzo Doria-Pamphili
Gardens & Park, 1730-1735
Palazzo Gentile, 18th c.
Palazzo Pichini, 18th c.
Villa Albani, ca. 1761
Villa Borghese, ca. 1787
Villa Borghese, Temple of
Esculapius, 1785-1792

Stra
Villa Pisani, 1735-1756

Stupinigi
Villa Reale di Stupinigi
(Royal Hunting Lodge),
1729-1733

Turin
Palazzo Cavour, 1729
Palazzo Madama, 1718-1721
Palazzo Martini de Cigala,
1716-1719
Palazzo Saluzzo-Paesana,
1715-1722
Superga, 1717-1731

Venice
Palazzo Grassi (Palazzo
Stucky), 1749
Palazzo Priuli-Manfrin,
Rio di Cannaregio, 1735
Palazzo Savorgnan, ca. 1715

DWELLINGS--19TH C.

Bologna
Palazzo della Cassa di
Risparmio, 1868-1876

Capriate d' Adda
Villa Crespi, ca. 1890

Como
Villa for Diaz de Quijano,
1883-1885

Florence
Apartments in Piazza delle
Mulina, 1880
House on Via Borgognissanti,
1896-1915
Housing, ca. 1888
Palazzo Der Villa, ca. 1850
Palazzo Pitti, 1812 & later
Villa Poggio Imperiale,
1804 & later
Villa Poggio Imperiale,
Chapel, ca. 1812
Villino Favard, 1857

Genoa
Castello Mackenzie, 1890s
Villino Piaggio, ca. 1895

Ghisalba
La Rotonda, 1834

Inverigo
Villa Cagnola d'Adda,
1813-1833

Milan
Casa Reininghaus, ca. 1898
Casa Verdi, 1899
Palazzo Besana in Piazza
Belgioioso, ca. 1815
Palazzo Marino, 1890
Palazzo Rocca Saporiti, 1812

Padua
Palazzo delle Debite, 1872

Palermo
Villa Belmonte, 1801 & later
Villino Florio, 1899-1903

Racconigi
Palazzo Reale, 1834-1839

Rome
Casino Valadier in Piazza
del Popolo, 1816-1824
Palazzi della Piazza dell'
Esedra, 1888 & later
Palazzo Brancaccio,
1895-1896
Palazzo de Parente in
Piazza Cavour, 1899
Palazzo del Parlamento
Nazionale, Project, 1890
Palazzo del Parlamento

Nazionale, Project, 1890
Palazzo dell' Esposizione,
1878-1882
Palazzo di Giustizia,
1886-1910
Palazzo di Giustizia, Project,
1885
Palazzo di Giustizia, Project,
1886
Palazzo di Giustizia, Project,
1888-1910
Palazzo di Giustizia, Project,
1890
Palazzo Lezzani, 1832
Palazzo Margherita (U. S.
Embassy), 1886-1900
Palazzo Pacelli, 1882
Villa Borghese, Piazzale
Flaminio Gates, 1825-1828
Villa Borghese, Triumphal
Arch, 1818-1828
Villa Doria Pamphili, Chapel,
1896-1902
Villa Torlonia, ca. 1840

Saonara
Villa dei Conti Cittadella
Vigodarsere, Chapel,
ca. 1817

Trieste
Palazzo Comunale, 1869-1871

Turin
Casa delle Imprese Bellia,
1894-1898, 1894-1898
Palazzo Carignano, 1863-1871
Palazzo Ceriani-Peyron,
1878-1879

Venice
Palazzo Cavalli Franchetti,
1818-1880
Palazzo Giovanelli, Staircase,
1849
Palazzo Patriarcale, 1837-1850

Verona
Palazzo Municipale, 1830s

Vincigliata
Castello dei Visdomini,
ca. 1855

DWELLINGS--20TH C.

Allesandria
Borsalino Employee Housing,
1952

Ancona
Le Grazie Cooperative Quarter,
1972-1975

Belluno
Casa del Balilla, 1933

Bergamo
Villa Pizzigoni, 1925-1927

Bologna
I. A. C. P. Quarter on Via della
Barca, 1957-1962

Cadenza
Houses with Prefabricated
Elements, 1962
Villa, 1970-1971

Cesena
Municipal Housing Complex
Expansion, 1979

Chieti
Student Residences

Ciampino
Casa 'Aleph', 1972-1977

Como
Novocomum Apartment
House, 1929

Corlanzone
Villa Rosa, ca. 1910

Ferrara
Palace of Justice, 1977

Florence
Apartment Building on
Via della Piagentina, 1964
Fortezza da Basso, Project,
1983
Residential Unit, Project,
Lazio, 1979-1981
Villino Broggi-Caraceni, 1911

Genoa
Apartments on Via Maragliano,
1907
Forte-Quezzi Housing

1904
Palazzo del Lavoro, 1960
Palazzo Gualino, 1929
Residential Building on Via
 S. Agostino, 1980-1983
Villa Baravalle, 1907
Villa Scott, 1902

Udine
Villa Veritti, 1956-1961

Venice
Apartment House, Zattere,
 1954-1958
I. N. A. I. L. Center,
 S. Simeone, 1950-1956

Viganello
House, 1980

**EDUCATION & RESEARCH
BUILDINGS--14TH C.**

Venice, Scuola di S. Giovanni
 Evangelista, 1349-1512

**EDUCATION & RESEARCH
BUILDINGS--16TH C.**

Venice
Scuola di S. Maria in
 Val Verde, 1523-1583
Scuola di S. Rocco,
 ca. 1515 & later

**EDUCATION & RESARCH
BUILDINGS--17TH C.**

Genoa, University, 1630

**EDUCATION & RESEARCH
BUILDINGS--19TH C.**

Conegliano
Accademia Musicale, 1860s

Pavia, University of Pavia,
 Great Hall, ca. 1845-1850

**EDUCATION & RESEARCH
BUILDINGS--20TH C.**

Aquila
Academy of Fine Arts,
 1978-1982

Busto Arsizio
Istituto Tecnico Industriale,
 1968
Scuola, 1964

Cagliari
University of Cagliari, Project,
 1972

Fagnano Olona
Elementary School, 1972

Matera
University of Calabria Project,
 1973

Milan
Boccioni University, Faculty
 of Economics, 1937-1940
Catholic University of the
 Sacred Heart, 1929
Catholic University of the
 Sacred Heart, Men's
 Dormitory, 1934
Istituto Marchiondi Boarding
 School), 1953-1959
Marchiondi Spogliardi
 Institute, 1952-1957
Secondary School, Monaca
 di Cesano Boscone,
 1975-1983
Technical High School, 1964
Università Cattolica,
 1928-1929

Mondovi
Boarding School of Bishop,
 1966-1969

Naples
University of Naples, Faculty of
 Technology Building, 1957

Palermo
University of New Science
 Department Building,
 1969-1985

Paullo
Laboratory Project, 1969

Pavia
University of Pavia,
 Laboratories & Scientific
 Department Building,
 1974-1976

Cerveteri
Regolini Galassi Tomb,
ca. 650 B. C.
Tomb of the Thatched Roof,
ea. 7th c. B. C.

Luni
Tomb of the Frame, 5th c. B. C.
Tomb of the Caryatids,
600s B. C.

San Giovenale
Porzarago Cemetery,
ca. 600 B. C.

**FUNERARY STRUCTURES
--5TH C. B. C.**

Cerveteri
Tomba dei Vasi Greci,
5th c. B. C.
Tomba della Cornice,
5th c. B. C.

San Giovenale
Tomb Facades, ca. 400 B. C.

Tarquinia
Tombs, ca. 5th c. B. C.

**FUNERARY STRUCTURES
--4TH C. B. C.**

Ardea
Tomb, ca. 300 B. C.

Cerveteri
Tomb of the Stucco Reliefs,
4th c. B. C.
Tomb of the Frame, 5th c. B. C.

Tarquinia
Tomb of the Cardinal,
ca. 300 B. C.

**FUNERARY STRUCTURES
--3RD C. B. C.**

Rome
Catacomb of S. Callisto, Chapel
of the Popes, ca. 250

**FUNERARY STRUCTURES
--2ND C. B. C.**

Perugia
Tomb of the Volumnii,

2nd c. B. C.

Rome
Tomb of S. Supicius Galba,
ca. 100 B. C.
Tumuli on Via Appia,
ca. 100 B. C.

Sovana
Tomba Ildebranda, 2nd c. B. C.

Tarquinia
Tomb of the Giglioli,
2nd c. B. C.
Tomb of the Marcareccia,
2nd c. B. C.

**FUNERARY STRUCTURES
--1ST C. B. C.**

Rome
Mausoleum of Augustus,
ca. 25 B. C.
Mausoleum of Helena
(Tor Pignattara), ca. 1st c.
Tomb of C. Poplicius Bibulus,
ca. 60 B. C.
Tomb of Caecilia Metella,
ca. 20 B. C.
Tomb of Eurysaces, ca. 30 B. C.

**FUNERARY STRUCTURES
--1ST C.**

Aquileia
Tomb of the Curii, mid. 1st c.

Capua
La Conocchia (Mausoleum),
1st c.

Pompeii
Tetrakionion Tomb, before 79

**FUNERARY STRUCTURES
--2ND C.**

Capua
Mausoleum (Carceri Vecchie),
ca. 125

Pozzuoli
Tomb on Via Celle, 2nd c.

Rome
Tomb of Annia Regilla, ca. 143

Tomb of the Caetennii,
ca. 150

FUNERARY STRUCTURES --3RD C.

Rome
Catacomb of S. Panfilo,
ca. 200-350

FUNERARY STRUCTURES --4TH C.

Rome
Mausoleum of Tor de' Schiavi,
ca. 300

FUNERARY STRUCTURES --5TH C.

Ravenna
Mausoleum of Galla Placidia,
ca. 425

FUNERARY STRUCTURES --6TH C.

Ravenna
Mausoleum of Theodoric,
ca. 526

FUNERARY STRUCTURES --19TH C.

Brescia
Cemetery, 1815-1849

Gallarate
Cemetery, 1865

Genoa
Staglieno Cemetery, 1825

Milan
Cimitero Monumentale,
1863-1866
Cimitero Monumentale,
Chapel, 1863-1866

Padua
Cimitero Monumentale,
1890-1896

Udine
D' Aronco Tomb, 1898

Varese
Aletti Tomb, 1898

Verona
Cemetery, 1828 & later

FUNERARY STRUCTURES --20TH C.

Lissone
Cemetery Project, 1981

Milan
Bozzetto Tomb, 1949
Giudici Tomb, 1906

Modena
Cemetery, Project, 1971

Monza
Cemetery Project, 1912

Parabita
Cemetery, 1967-1982

San Vito d'Altivole
Brion Family Tomb,
1970-1972

GALLERIES. *See*
EXHIBITION BUILDINGS

GARDENS. *See* **PARKS &
GARDENS**

GATES & WALLS--5TH C. B. C.

Elia
Porta Rosa, ca. 5th c. B. C.

Veii
City Wall, ca. 400 B. C.

GATES & WALLS--4TH C. B. C.

Arpinum
Corbelled Gate, 305 B. C.

Perugia
Porta Marzia, ca. 4th c. B. C.

Perugia,
Porta Romana, ca. 4th c. B. C.

Signia
City Wall, 4th c. B. C.

GATES & WALLS--3RD C. B. C.

Cosa
 City Gate, 273 B. C.

Falerii
 Gate, 241-200 B. C.

GATES & WALLS--2ND C. B. C.

Ferentino
 Porta Sanquinaria, 2nd c. B. C.

Perugia
 Porta Augusta, 2nd c. B. C.

GATES & WALLS--1ST C. B. C.

Aosta
 Porta Praetoria, 25 B. C.

Ferentino
 Porta Maggiore, ca. 80-70 B. C.

Rome
 Porta Tiburtina, 5 B. C.

Verona
 Porta dei Leoni,
 1st c. B. C.-1st c. A. D

GATES & WALLS--1ST C.

Ostia
 Porta Marina Area, 1st c.

Turin
 Porta Palatina, ea. 1st c.

Verona
 Porta dei Borsari, ca. 79-81

GATES & WALLS--3RD C.

Rome
 Porta Appia (Porta
 S. Sebastiano), 275
 Porta Ostiensis (Porta
 Ostiense), 3rd c.

GATES & WALLS--15TH C.

Naples
 Porta Capuana, 1485

GATES & WALLS--16TH C.

Padua
 Porta S. Giovanni, 1528

Rome
 Porta del Popolo, 1561-1564
 Porta Pia, 1561-1564

Verona
 Porta Nuova, 1533-1540
 Porta Palio, 1542-1555

GATES & WALLS--17TH C.

Genoa
 Porta Pia, 1633

Rome
 Porta Portese in Trastevere,
 1643

GATES & WALLS--18TH C.

Rome
 Porta di Ripetta, 1703

GATES & WALLS--19TH C.

Milan
 Porta Comasina (Porta
 Garibaldi), 1826
 Porta Nuova, 1810-1813
 Porta Ticinese, 1801-1814
 Porta Venezia, 1827-1833

Rome
 Porta Pia, 1852

Turin
 Porta Nuova Station,
 1866-1868

**GOVERNMENT BUILDINGS
--6TH C. B. C.**

Rome
 Capitolium, 6th-1st c. B. C.

**GOVERNMENT BUILDINGS
--3RD C. B. C.**

Cosa
 Comitium & Curia, 3rd c. B. C.

Rome
 Ospedale di Santo Spirito
 in Sassia, 1474-1482 & later

Venice
 Scuola Grande di San Marco
 (Ospedale Civile), 1485-1495

HEALTH & WELFARE BUILDINGS--17TH C.

Rome
 Ospizio di S. Michele, ca. 1688

HEALTH & WELFARE BUILDINGS--19TH C.

Gallarate
 Hospital, 1871 & later

HEALTH & WELFARE BUILDINGS--20TH C.

Allesandria
 Anti-Tuberculosis Clinic
 (Dispensario Antituberolare),
 1938

Canino
 Thermal Bath Building, 1981

Cerinia
 Rifugio Pirovano, 1949-1951

Cesenatico
 Health Center, 1938

Collodi
 Osteria del Gambero Rosso
 (Tavern 'Red Lobster'),
 1961-1963

Como
 Sant'Elia Kindergarten,
 1936-1937

Girifalco
 Mental Hospital, 1968-1978

Lacco Ameno d'Ischia
 Terme Regina Isabella,
 1950-1953

Legnano
 Sun Therapy Colony, 1939

Mestre
 Hospital, 1984

Milan
 Clinica Colombo, 1909
 Orphanage & Convent, 1955

Rome
 Work House for Blind War
 Veterans on Via Parenzo,
 1930-1931

Salsomaggiore
 Luigi Zoja Baths, 1967-1970

Trieste
 Nuovo Ospedale,
 Cattinara, 1965-1983
 Noviziato delle Suore de
 Carita, 1965
 Nursery School, 1980-1982
 State Hospital of Cattenara,
 1965 & later

HOSPITALS. *See* HEALTH & WELFARE BUILDINGS

HOSTELS. *See* PUBLIC ACCOMMODATIONS

HOTELS. *See* PUBLIC ACCOMMODATIONS

HOUSES & HOUSING. *See* DWELLINGS

INDUSTRIAL BUILDINGS --19TH C.

Rome
 Manifattura dei Tabacchi,
 1859-1863

INDUSTRIAL BUILDINGS --20TH C.

Bagnolo Piemonte
 Dairy Factory ('La Tuminera'),
 1980-1982

Ivrea
 Olivetti Complex, 1954-1957
 Olivetti Complex, Refectory,
 1955-1959

Mantua
 Cartiere Burgo (Burgo Paper
 Factory), 1960-1962

Milan
 Frua De Angeli Factory, 1931

Nerviano
 Factory, 1953

Pozzuoli
 Olivetti Plant, 1951 & later

Prato
 Gatti Factory, 20th c.

Rome
 Gatti Wool Factory, 1953

Salerno
 Solimene Ceramics Factory,
 1953

Turin
 Fiat Lingotto, 1983
 Fiat Works, 1915-1921

Udine
 Snaidero Industrial Complex,
 Office Building, 1978

INNS. *See* **PUBLIC
 ACCOMMODATIONS**

JUDICIAL BUILDINGS. *See*
 GOVERNMENT BUILDINGS

LABORATORIES. *See*
 **EDUCATION & RESEARCH
 BUILDINGS**

LEGISLATIVE BUILDINGS. *See*
 GOVERNMENT BUILDINGS

**LIBRARIES & INFORMATION
 CENTERS--2ND C.**

Tivoli
 Hadrian's Villa, Greek Library,
 ca. 120-125

**LIBRARIES & INFORMATION
 CENTERS--15TH C.**

Cesena
 Biblioteca Malatestiana,

1447-1452

**LIBRARIES & INFORMATION
 CENTERS--16TH C.**

Rome
 Library, 1587-1589

**LIBRARIES & INFORMATION
 CENTERS--17TH C.**

Milan
 Biblioteca Ambrosiana,
 1603-1609

Rome
 Biblioteca Casanatense,
 ca. 1650-1700

**LIBRARIES & INFORMATION
 CENTERS--20TH C.**

Florence, Biblioteca Nazionale
 Centrale, 1911

Florence, State Archives of
 Florence Project, 1972

Noceri Inferiore, Library &
 Culture Center, 1969-1970

Rome, Biblioteca Nazionale,
 Project, 1957

Venice
 Biblioteca Querini-Stampalia,
 Restoration, 1961-1963

LODGES. *See* **PUBLIC
 ACCOMMODATIONS**

MARKETS. *See*
 MERCANTILE BUILDINGS

MAUSOLEUMS. *See*
 FUNERARY STRUCTURES

MEETING HOUSES. *See*
 RELIGIOUS BUILDINGS

MEMORIALS. *See*
 MONUMENTS & MEMORIALS

**MERCANTILE BUILDINGS
--2ND C. B. C.**

Ferentino
Market Hall on Via Latina,
ca. 100 B. C.

**MERCANTILE BUILDINGS
--2ND C.**

Pozzuoli
Market, 2nd c.

Rome
Markets of Trajan,
Trajan's Forum, 2nd c.

**MERCANTILE BUILDINGS
--13TH C.**

Venice
Albergo del Salvadego, 13th c.

**MERCANTILE BUILDINGS
--18TH C.**

Naples
Albergo dei Poveri,
1751 & later

**MERCANTILE BUILDINGS
--19TH C.**

Milan
Galleria Vittorio Emanuele II,
1865-1877

Naples
Galleria Umberto I, 1887-1890

Padua
Meat Market, 1821

**MERCANTILE BUILDINGS
--20TH C.**

Ancona
Fish Market, 1946

Biblione
Market, S. Michele al
Tagliamento, 1980

Bologna
Mercato Ortofrutticolo, 1984

Como
Albergo Metropole Suisse,
1927
Vitrum Store, 1930

Milan
Dulciora Candy Shop, 1950
Gi Vi Emme Perfume Shop,
1946
Scandale Lingerie Shop, 1948

Pescia
Covered Market, 1951

Rome
Rinascente Department
Store, 1957-1961

Salsomaggiore
Shops, 1950

Turin
Bottega d'Erasmo,
1953 & later

**MILITARY STRUCTURES
--4TH C. B. C.**

Ardea
Acropolis, Terrace Wall,
ca. 300 B. C.

Luni
Acropolis Reconstruction,
ea. 4th c. B. C.

Norba
Walls & Gate, 4th c. B. C.

**MILITARY STRUCTURES
--3RD C. B. C.**

Alatri
Terrace Wall, 3rd c. B. C.

Volterra
Etruscan Gate, 3rd c. B. C.

**MILITARY STRUCTURES
--2ND C. B. C.**

Ferentino
Acropolis, 2nd c. B. C.

MILITARY STRUCTURES --1ST C. B. C.

Amelia
Town Walls, ca. 1st c. B. C.

Rome
Servian Wall, 87 B. C.

MILITARY STRUCTURES--3RD C.

Rome
Aurelian Walls, 270-275

MILITARY STRUCTURES--4TH C.

Luni
Walls, ea. 4th c.

San Giovenale
Etruscan Wall, ea. 4th c.

MILITARY STRUCTURES--5TH C.

Ardea
Acropolis, ca. 5th c.

MILITARY STRUCTURES --12TH C.

Montagnana
Towers, 12th c.
Walls, 12th c.

Monteriggioni
Fortified Walls, 12th c.

San Gimignano
Towers, 12th-13th c.

Venice
Fondaco dei Turchi, 12th c.

MILITARY STRUCTURES --13TH C.

Castel del Monte
Castel del Monte, ca. 1240

Milan
Torre delle Milizie, 13th c.

MILITARY STRUCTURES --14TH C.

Montefiascone
Fortress, ca. 1363

Volterra
Castle, 1343

MILITARY STRUCTURES --15TH C.

Milan
Castello Sforzesco, 1455-1457

Ostia
Fortress, 1483-1486

Rocca di Mondavio
Rocca di Mondavio,
1479 & later

Rocca di San Leo
Rocca di S. Leo, 1479 & later

Rocca di Sassocorvaro
Rocca di Sassocorvaro,
1479 & later

Venice
Arsenal, Archway, 1460

MILITARY STRUCTURES --16TH C.

Rome
Ardeatine Bastions,1537-1546

Venice
Fondaco dei Tedeschi,
after 1505
Forte S. Andrea (Castel
Nuovo), 1543

MILITARY STRUCTURES --18TH C.

Turin
Quartieri Militari, 1716-1728

MILITARY STRUCTURES --19TH C.

Rome
Magazzini Boccioni, ca. 1895

MILITARY STRUCTURES --20TH C.

Milan
Magazzino Contratti, 1903

ca. 1900

Milan
Piazza Duse Office Building,
1933-1935
Piazza Fontana, 1944-1946

Rome
Forums Model, 1939
reconstruction
Piazza Benedetto Brin,
Garbatella, 1920-1922
Piazza Dempione, 1921-1923

Turin
Piazza della Repubblica,
Project, 1982

OPERA HOUSES. *See*
**PERFORMING ARTS
STRUCTURES**

PALACES. *See* **DWELLINGS**

PARKING LOTS & GARAGES

Lodi
Garage Barnabone, 1920s

Mestre
Garage Marcon, 1907

Milan
Alfa-Romeo Works, Storage,
1937
Autorimessa (Garage), 1949

Turin
International Exposition of
Decorative Arts, 3rd, Garage,
1920s

PARKS & GARDENS--4TH C.

Rome
Licinian Gardens, Pavilion,
ea. 4th c.

PARKS & GARDENS--16TH C.

Bagnaia
Villa Lante, Garden,la. 16th c.

Caprarola
Villa Farnese, Garden

Pavilion, 1547-1549

Florence
Boboli Gardens, ca. 1550
& later

Maser
Villa Barbaro, Nymphaeum,
1560-1568

Padua
Botanical Garden (Giardino
Botanico), 1550s

Tivoli
Villa d'Este, Gardens,
ca. 1565-1572

Trissino
Villa Trissino da Porto
(Villa Marzotto), Gardens,
1537-1548

PARKS & GARDENS--17TH C.

Collodi,
Villa Garzoni (Villa Gardi),
Garden, 1690s

PARKS & GARDENS--18TH C.

Caserta
Royal Palace, Gardens,
1752-1774

Palermo
Orto Botanico, 1789-1792
Park of Real Favorita, ca. 1799
Villa Giulia, Gardens, 1790s

Rome
Villa Albani, Gardens,ca. 1760
Villa Borghese, Gardens,
ca. 1787

Valsanzibio
Villa Barbarigo, Aviary,
ea. 18th c.
Villa Barbarigo, Diana Pavilion,
ea. 18th c.
Villa Barbarigo, Garden,
ea. 18th c.

PARKS & GARDENS--19TH C.

Pistoia
Puccini Gardens, Scornio

Temple of Pythagoras,
1821-1827

Poggio a Caiano
Villa Medicea, Orangery,
ca. 1825

Rome
Villa Torlonia, Orangery,
ca. 1840

PAVILIONS. *See*
EXHIBITION BUILDINGS

**PERFORMING ARTS
STRUCTURES--8TH C. B. C.**

Pompeii
Strada dei Teatri,
ca. 750-100 B. C.

**PERFORMING ARTS
STRUCTURES--2ND C. B. C.**

Gabii
Theater-Temple, 2nd c. B. C.

Pompeii
Theater (Large Theater),
2nd c. B. C.

**PERFORMING ARTS
STRUCTURES--1ST C. B. C.**

Pompeii
Amphitheater, ca. 80 B. C.
Theater (Small Theater),
1st c. B. C.

Rome
Theater of Marcellus,
ca. 46-10 B. C.

**PERFORMING ARTS
STRUCTURES--1ST C.**

Ostia
Theater, ca. 10

Pozzuoli
Amphitheater, 1st c.

Verona
Amphitheater, 1st c.

**PERFORMING ARTS
STRUCTURES--2ND C.**

Villa
Teatro Marittimo, 118-125

**PERFORMING ARTS
STRUCTURES--3RD C.**

Rome
Theater of Pompey,
ca. 205-208

**PERFORMING ARTS
STRUCTURES--16TH C.**

Sabbioneta
Teatro all' Antica (Teatro
Olimpico), 1588-1590

Vicenza
Teatro Olimpico, 1580-1584

**PERFORMING ARTS
STRUCTURES--17TH C.**

Parma
Teatro Farnese (Farnese
Theater), 1618-1628

Venice
Theater, 1654

**PERFORMING ARTS
STRUCTURES--18TH C.**

Milan
La Scala, 1776-1778

Naples
Teatro San Carlo, 1737

Rome
Teatro Argentina, 1732

Turin
Teatro Regio, 1738-1740

Venice
Fenice Theater, 1790-1792
Teatro La Fenice, 1790-1792

**PERFORMING ARTS
STRUCTURES--19TH C.**

Catania
Teatro Bellini, 1870-1890

RELIGIOUS BUILDINGS
--9TH C. B. C.

Agliate
S. Pietro, ca. 875

RELIGIOUS BUILDINGS
--8TH C. B. C.

Fiesole
Temple, 750-100 B. C.

Nemi
Temple Roof Terracotta
Model, 750-100 B. C.

Tarquinia
Ara della Regina
Temple, 750-100 B. C.

Veii
Portonaccio Temple,
750-100 B. C.

RELIGIOUS BUILDINGS
--7TH C. B. C.

Cerveteri
Banditaccia Cemetery,
7th c. B. C.

San Giovenale
Etruscan Tombs Model,
ca. 600 B. C.

Selinus
Megaron Temple, ca. 600 B. C.

Syracuse
Temple of Apollo (Temple of
Artemis), ca. 600 B. C.

RELIGIOUS BUILDINGS
--6TH C. B. C.

Agrigento
Temple of Castor & Pollux,
6th-5th c. B. C.
Temple of Juno Lacinia
(Temple D), 6th-5th c. B. C.

Bolsena
Poggio Casetta Temple,
ea. 6th century B. C.

Metapontum
Temple of Hera (Tavoline

Paladine), 6th-5th c. B. C.

Paestum
Temple of Athena (Temple of
Ceres), ca. 510 B. C.

Rome
Temple of Jupiter Capitolinus,
(Temple of Jupiter Optimus
Maximus & Minerva on the
Capitoline), 509 B. C.

Selinus
Temple C, ca. 550 B. C.
Temple D, ca. 536 B. C.
Temple E (Temple of
Hera), 6th-5th c. B. C.
Temple F, ca. 525 B. C.
Temple G, ca. 520-450 B. C.

Velletri
Temple Model, 6th c. B. C.

RELIGIOUS BUILDINGS
--5TH C. B. C.

Agrigento
Temple of Concord
(Temple F), ca. 430-400 B. C.
Temple of Zeus Olympieion,
ca. 480-470 B. C.

Lanuvium
Temple of Juno Sospita,
5th c. B. C.

Orvieto
Belvedere Temple, 5th c. B. C.

Signia
Temple, 5th c. B. C.

Veii
Temple of Minerva, 5th c. B. C.

RELIGIOUS BUILDINGS
--4TH C. B. C.

Falerii
Temple, 4th-3rd c. B. C.

Fratte
Temple, 4th c. B. C.

Rome
Largo di Torre Argentina

(Hadrian's Mausoleum),
ca. 135
Temple of Claudius, ca. 1st c.
Temple of Divus Vespasianus,
Forum Romanum, ca. 79-96
Temple of Peace,
completed 96-97
Temple of Venus Genetrix,
Forum Julium, ca. 46 B. C.

RELIGIOUS BUILDINGS--2ND C.

Baia
Temple of Venus, ca. 125

Rome
Pantheon (La Rotonda),
118-125
Temple of Antoninus
& Faustina, Forum
Romanum, ca. 140 A. D
Temple of Divus Traianus,
Forum of Trajan, ea. 2nd c.
Temple of Venus & Rome,
125-135

RELIGIOUS BUILDINGS--3RD C.

Rome
S. Maria in Trastevere,
3rd c.; rebuilt
Temple of Mithras, ca. 200
Temple of Saturn,
Forum Romanum, 284
Temple of the Sun, 275-280

RELIGIOUS BUILDINGS--4TH C.

Aquila, Twin Cathedral,
ca. 313-319 or later

Cimitile-Nola,
S. Felix Martyrium
Precinct, 4th c.; 401-402

Milan
Holy Apostles Reconstruction,
begun 382
S. Lorenzo Maggiore,
ca. 352-375
S. Simpliciano, la. 4th c.
S. Restituta, ca. 360-400
S. Crisogono Reconstruction,
ea. 4th c.

S. Lorenzo in Damaso, 380;
rebuilt; ca. 1500
S. Paolo fuori le Mura, 386;
rebuilt
Temple of Juno Moneta,
374 B. C.
Temple of Minerva,
Forum Transitorium, ca. 310

Vatican City
Old St. Peter's, ca. 324-349

RELIGIOUS BUILDINGS--5TH C.

Florence
Baptistery of S. Giovanni,
5th c.; 11th & 12th c.

Naples
S. Giorgio Maggiore, ca. 400

Paestum
Temple of Poseidon (Temple
of Hera), ca. 460 B. C.

Ravenna
Baptistery of the Orthodox,
400-450
S. Apollinare Nuovo, 493-520
S. Croce, ca. 425
S. Giovanni Evangelista,
424-434
S. Giovanni e Paolo,
ca. 410-420
S. Giovanni in Laterano,
begun ca. 313; ca. 432-440
S. Maria Maggiore, 432-440
S. Sabina, 422-432
S. Sebastiano, ca. 400-450;
rebuilt, 1609-1613
S. Stefano Rotonda, 468-483
S. Vitale Reconstruction,
401-417

Segesta
Temple, la. 5th c.

Vicenza
S. Felice e Fortunato, 5th c.

RELIGIOUS BUILDINGS--6TH C.

Grado
Cathedral, 571-579

Cefalu
Cathedral, 1131-1240

Cremona
Baptistery, 1167
Cathedral, 12th c.

Lucca
S. Michele, 1143

Molfetta
Cathedral, 1162 & later

Monreale
S. Maria La Nuova
(Cathedral), 1174-1182

Nonantola
Abbey of S. Silvestro,
ca. 1121-13th c.

Palermo
Capella Palatina, 1129-1143
Cathedral, 1170-1185 & later
Martorana (S. Maria dell'
Ammiraglio), 1143-1151
& later
S. John of the Hermits
(S. Giovanni degli Eremiti),
1132-1148

Parma
Baptistery, 1196-1270

Pavia
S. Michele, ca. 1100-1160

Pisa
Baptistery, 1153-1265
Campanile, 1174-1271

Portonovo
S. Maria, 12th c.

Venice
S. Apollonia Cloister, 12th c.
S. Donato, Murano, 12th c.
S. Niccolò dei Mendicoli,
12th c.

Verona
S. Zeno Maggiore,
ca. 1123 & later

RELIGIOUS BUILDINGS--13TH C.

Assisi
S. Francesco, 1228-1253

Florence
S. Croce, 1294-1442
S. Maria del Fiore
(Il Duomo), 1296-1462
S. Maria Novella, 1278-1350,
1456-1470, facade

Fossanova
Abbey Church, ca. 1208

Matera
S. Giovanni Battista, ca. 1200

Padua
S. Antonio, ca. 1232-1307

Pisa
Cathedral & Campanile,
1063-1118, 1261-1272

Rome
S. Giovanni in Laterano,
Cloister, 1215-1232
S. Maria d'Aracoeli, 1200s
S. Maria Sopra Minerva,
ca. 1285
S. Paolo fuori le Mura,
Cloister, ca. 1205-1214

Siena
Cathedral, ca. 1226-1380

Vercelli
S. Andrea, 1219-1225/1226

Verona
S. Anastasia, 1261 & later

RELIGIOUS BUILDINGS--14TH C.

Florence
Campanile, 1334-1359

Milan
Cathedral, ca. 1385-1485
& later

Orvieto
Cathedral, ca. 1310 & later

Venice
Madonna dell' Orto, 14th c.
S. Alvise, 1388

RELIGIOUS BUILDINGS--16TH C.

Venice
 Church of the Tolentini, 1591
 Church of the Zitelle,
 1582-1586
 Convento della Carita, 1552
 Il Redentore
 S. Fantin Scarpagnino,
 Antonio, 1507-1564
 S. Francesco della Vigna, 1534
 S. Francesco della Vigna,
 Facade, ca. 1570
 S. Giorgio dei Greci,
 1538 & later
 S. Giorgio Maggiore, 1565
 S. Marco, Libreria Vecchia di
 S. Marco, 1536-1553
 S. Pietro di Castello,
 1596-1619
 S. Salvatore, 1507-1534
 S. Sebastiano, 1508-1548
 Schola Spagnola (Synagogue),
 1555
 Schola Tedesca (Synagogue),
 1528
 Scuola Levantina (Eastern
 Synagogue), 1538
 Zecca, 1536

Verona
 Chiesa della Madonna di
 Campagna, 1559

Vicoforte di Mondovi
 S. Maria, 1596

RELIGIOUS BUILDINGS--17TH C.

Ariccia
 S. Maria dell'Assunzione,
 1662-1664

Caprarola
 S. Teresa, 1620

Castel Gandolfo
 S. Tommaso di Villanova,
 1658-1661

Florence
 S. Gaetano, 1645
 S. Lorenzo, Capella dei
 Principi, 1603 & later

Gravina
 Madonna delle Grazie,

ca. 1600

Messina
 S. Alessandro in Zebedia, 1601
 S. Giuseppi, 1607
 S. Marcello, 1682
 Seminario Maggiore, ca. 1640
 Somaschi Church, 1660-1662

Naples
 Certosa di S. Martino,
 Cloister, ca. 1630
 S. Maria Egiziaca, 1651-1717

Rome
 Collegio di Propaganda
 Fide, 1662-1664
 Collegio di Propaganda Fide,
 Chapel of the Three Kings
 (Capella dei Re Magi),
 1662-1664
 Oratory of S. Phillip Neri
 (Oratorio di S. Filippo
 Neri), 1637-1650
 S. Adriano, ca. 1656
 S. Agnese in Agone (S. Agnese
 in Piazza Navona),
 1652-1666
 S. Andrea al Quirinale,
 1658-1670
 S. Andrea delle Fratte,
 1653-1665
 S. Biagio in Campitelli,
 1653 & later
 S. Bibiana, 1624-1626
 S. Carlo ai Catinari, 1612-1620
 S. Carlo al Corso (S. Ambrogio
 e Carlo al Corso), ca. 1672
 S. Carlo alle Quattro Fontane,
 1638-1667
 S. Giovanni in Laterano,
 1646-1649
 S. Giovanni in Laterano,
 Capella Lancellotti, ca. 1675
 S. Girolamo della Carita,
 Capella Spada, 1662
 S. Gregorio Magno, 1629-1633
 S. Gregorio Magno,
 Capella Salviata, 1600
 S. Ignazio di Loyola,
 1626-1650
 S. Ivo della Sapienza,
 1642-1650

RELIGIOUS BUILDINGS--18TH C.

RELIGIOUS BUILDINGS--19TH C.

Lonigo
 Cathedral, 1877-1895

Milan
 Cathedral, 1806-1813
 Cathedral, 1886
 Cathedral, 1887
 Cathedral, 1888
 S. Carlo al Corso, 1836-1847
 S. Eustorgio, 1863-1865

Naples
 Cathedral, 1877-1905
 S. Domenico Maggiore,
 1850-1853
 S. Francesco di Paola,
 1817-1846

Novara
 Cathedral, 1854-1869
 S. Gaudenzio, 1841-1888

Parma
 S. Croce, 1887

Possagno
 Tempio Canova, 1819-1833

Rome
 All Saints, 1880-1937
 S. Anselmo, 1890-1896
 S. Giacchino, 1870s
 S. Giovanni in Laterano,
 1874-1886
 S. Pantaleo, 1806
 S. Paolo fuori le Mura,
 1823 & later
 S. Paolo fuori le Mura,
 1893-1910
 S. Paul's American Church,
 1872-1876
 S. Rocco, 1833
 Synagogue, 1889

Sabbioneta
 Chiesa dell' Assunta,
 1891-1896

San Marino
 Cathedral, 1826-1836

Savona
 Cathedral, 1880
 Cathedral, 1880-1886
 Cathedral, 1888

Schio
 Cathedral, 1805-1820

Trapani
 S. Pietro, 1848-1850

Trieste
 S. Antonio, 1826-1849

Turin
 Chiesa della Gran Madre
 di Dio, 1818-1831
 Chiesa delle Sacramentine,
 1846-1850
 Mole Antonelliana, 1863-1888
 S. Maria Ausiliatrice,
 1865-1888
 S. Massimo, 1845-1853
 Synagogue, 1880-1885

Venice
 S. Maurizio, 1806-1828

RELIGIOUS BUILDINGS--20TH C.

Bergamo
 Convento dei Frati
 Francescani (Franciscan
 Monastery & School), 1972
 Società Cattolica di
 Assicurazione, 1967-1971

Bologna
 Sacro Cuore, 1912 & later

Collina
 Church, 1954

Florence
 S. Giovanni Battista
 (S. John the Baptist),
 Autostrada del Sole,
 Campi Bisenzio, 1964
 S. Maria Novella Railroad
 Station, 1932-1934
 S. Maria Novella Railroad
 Station, Powerhouse,
 1932-1934
 S. Maria Novella, Convent,
 1902

Genoa
 Chiesa della Sacra Famiglia,
 1956 & later
 S. Agostino Museum,
 1977-1986

S. Lorenzo Treasury Museum
(Tesoro di S. Lorenzo),
1952-1956

Gibellina
Church, Project, 1970

Milan
Chiesa della Madonna dei
Poveri, 1952-1954
Chiesa di S. Enrico,
Metanopoli, 1963-1966
Chiesa Mater Misericordiae,
1956-1958
S. Giovanni Battista alla
Creta Church, 1956-1958

Montenars
Church of Empress S. Elena,
1983-1986

Pisa
S. Giovanni al Gatano, 1947

Rome
Convent of Buon Pastore, 1930
Mosque & Islamic Center
Model, 1976
S. Basilio Quarter, 1956

Salerno
Chiesa della Sacra Famiglia,
1969-1973

Varese
S. Antonio Church, 1955

RESEARCH BUILDINGS. *See*
**EDUCATION & RESEARCH
BUILDINGS**

RESIDENCES. *See* **DWELLINGS**

**RESTAURANTS & OTHER
EATING PLACES--19TH C.**

Padua
Caffè Pedrocchi, 1816-1831

Rome
Caffè Greco, 1850s

Venice
Caffè (Società Canottieri
Bucintoro), 1838

**RESTAURANTS & OTHER
EATING PLACES--20TH C.**

Milan
Bar Craja, 1930

Naples
Coffee Shop & Bar, 1951

ROADS & STREETS. *See*
**TRANSPORTATION
STRUCTURES**

SCHOOLS. *See* **EDUCATION &
RESEARCH BUILDINGS**

SEMINARIES. *See* **SCHOOLS**

SHOPS. *See* **MERCANTILE
BUILDINGS**

SHRINES. *See*
RELIGIOUS BUILDINGS

SILOS. *See* **STORAGE
FACILITIES**

**SOCIAL & CIVIC BUILDINGS
--6TH C. B. C.**

Paestum
Basilica, ca. 530 B. C.

**SOCIAL & CIVIC BUILDINGS
--2ND C. B. C.**

Ardea
Basilica, 2nd c. B. C.

Cosa
Basilica, 2nd c. B. C.

Pompeii
Basilica, ca. 120 B. C.

**SOCIAL & CIVIC BUILDINGS
--1ST C. B. C.**

Alba Fucens
Basilica, ea. 1st c. B. C.

Palestrina
Basilica, ca. 80 B. C.

PART V
Work Index